Visual Identities

Visual Identities

Jean-Marie Floch

Translated by Pierre Van Osselaer and Alec McHoul

CONTINUUM
London and New York

Continuum
The Tower Building, 11 York Road, London SE1 7NX
370 Lexington Avenue, New York, NY 10017-6503

First published 2000

British Library Cataloguing-in-Publication Data
A catalogue record for this book is available from the British Library.

ISBN 0-8264-4738-4 (hardback)
 0-8264-4739-2 (paperback)

Library of Congress Cataloging-in-Publication Data
Floch, Jean-Marie, 1947–
 [Identités visuelles. English]
 Visual identities / Jean-Marie Floch, translated by Pierre Van Osselaer and Alec McHoul.
 p. cm.
 Includes bibliographical references and index.
 ISBN 0-8264-4738-4—ISBN 0-8264-4739-2 (pbk.)
 1. Semiotics. 2. Visual communication. I. Title.

P99 .F5913 2000
302.2—dc21 00-022692

Typeset by BookEns Ltd, Royston, Herts
Printed and bound in Great Britain by Biddles Ltd,
Guildford and King's Lynn

Contents

Acknowledgements

Each of the six essays in this book on visual identity addresses a specific object of meaning: a pen, logos, typography, the 'total look', shop design, a knife. Apart from belonging to the world of design, these objects also illustrate a common type of meaning production, a common way of conceiving and affirming one's identity from a 'bricolage' of pre-existing signs. These signs are, by their nature, products of the history of their use. To recognize this semiotic process – first defined by Claude Lévi-Strauss in *La Pensée sauvage* – does not mean that this book quickly abandons material reality in favour of a general theoretical discourse. Rather, each visual identity considered here is analysed as a specific instance, and not just as a peripheral example of a merely theoretical reflection unfolding unhindered. So each identity is, as it were, only a resting place along a freeway.

But, to account for bricolage in terms of signs, I had first to establish a grounding in meaning-making practices and the semantic environment to which the signs in question belong. I was lucky enough to have the help of a number of people who shared with me their cultural knowledge and their expertise. I duly thank them for their assistance.

First, however, I must thank those without whose agreement I would simply not have been able to carry out my work on the cases of visual identity presented in this volume. I could not have analysed the Waterman advertisement without prior authorization kindly given by Mme Rolland of the Société Waterman and Mme Delangle of the McCann-Erickson agency in Paris. Similarly, I could not have referred to the 'elements for the instant identification of Chanel', drawn by Karl Lagerfeld, without authorization from Mme de Clermont-Tonnerre of the Société Chanel.

I am particularly grateful to M. Maurice Opinel, chairman of the Société Opinel, who gave me comprehensive accounts of the technological origin of the Opinel knife and of the industrial history of the company, and who agreed to put at my disposal the documents and the actual products necessary for my analysis. I am equally grateful to M. Michel Bras, the chef at Laguiole, for helping my analysis of gastronomical pleasures and for allowing a semiotic and mythological 'tasting' of his *'loup au petit-lait et à la cistre'*.

I am also indebted to a number of professionals in the areas of design, marketing and research. Their suggestions and critical observations enabled me to correct and strengthen the technical and historical comments included in my analyses. Moreover, they impressed upon me the need to write in a way that was clear and understandable to those readers who may be aware of issues of design but not necessarily versed in semiotics. I therefore thank Elisabeth Boyer, Fabienne Cammas, Alain Charrueau, Olivier Douzou, Bertrand Esclasse, Jean-Charles Gaté, Samuel Grange, Benoît Heilbrunn, Gérard Laizé, Gilles Marion, Yann Pennor's, Christian Pinson, Philippe Rasquinet, Patrick Raymond, Jean-Pierre Vitrac, Stéphane Wargnier, Jim Walters and Charles Znaty.

In the course of my specifically semiotic investigations I used and abused the readerly patience and friendly directives of two long-standing colleagues, Denis Bertrand and Eric Landowski. I also benefited from the receptivity and encouragement of Giulia Ceriani, Jacques Escande, Marie-Louise Fabre, Gilles Marion, Gianfranco Marrone, Ana-Claudia Mei Alves de Oliveira, José-Maria Nadal, Diana-Luz Pessoa de Barros, Henri Quéré, Andrea Semprini and Alessandro Zinna.

Finally, I am particularly grateful to Pierre-Yvon Carnois for his generous assistance in designing the cover and to Philippe Delmotte and Laurence Marcoux for drawing the illustrations.

For Pascal Megret

Fundamental reflection only has meaning [*sens*] for [the semiotician] in so far as it leads to a scientific practice. Knowledge underpins know-how and leads to it. Therefore, the semiotician has no qualms about borrowing the ideas of others, or using heuristic information secondhand. Think about all the things we can discover by trying to reconstruct the philosophical sources of a de Saussure or a Hjelmslev. What counts above all, for the semiotician, is how their ideas conform with what they believe to be the current state of their discipline; it is also an intimate requirement imposed by the semiotician on ideas that causes them to 'get a grip on reality' [*mordre sur la réalité*]. Primitive peoples have philosophies of language that match our own but are not developed into linguistics.

A.-J. Greimas, *Du sens*

Seen on the scale of millennia, human passions fuse. Time neither adds to nor removes anything from the loves and hates felt by people, their involvements, their struggles and their hopes. They remain the same today as they were in the past. Randomly removing ten or twenty centuries of history would not affect, in a meaningful way, our knowledge of human nature. The only irreplaceable loss would be the works of art which these centuries gave rise to: because humans only differ through their works, and even exist only through them. Just as a wooden statue attests to the prior existence of a tree, so works of art provide the proof that, throughout history, amongst people, something actually happened.

Claude Lévi-Strauss, *Regarder, écouter, lire*

Introduction: from design to 'bricolage'

Initially, my project was to put together a volume geared towards an audience that would not be restricted to semioticians and containing cases of practical analysis that would illustrate semiotics' varied interventions into the area of design. By analysing objects of meaning as diverse as bottles of mineral water, executive desks, supermarkets or trademarks and logos, I set out to demonstrate that a semiotician can help analyse product presentation, conceive of a commercial space or define a system of visual identity. I wanted to address various types of design: product design, packaging, environment design and corporate design. Such a collection would have been the natural continuation of my *Sémiotique, marketing et communication*, where I introduced semiotics' modes of intervention and fields of investigation into these areas.[1] For example, I wanted to return to and expand upon my reflections concerning the value systems of consumption[2] and the ideologies of advertising,[3] and to show that the models I had proposed there could also be applied to design, and could shed some relatively new light both on the values invested in specific products and on larger schemes of design, as far as the relationship between form and function is concerned.

But it did not take long for my project to transform itself radically. First, given that I had set myself the same goal as before, that of justifying and illustrating operational aspects of the semiotic approach, and that I had decided to present my cases in a similar 'star' or 'fan' configuration, I began to get the impression that I was simply reproducing the earlier work. This was the case, even though the subject now allowed me to limit the project to what had always been the main preoccupation of my research – aesthetics in general and visual languages in particular – and even though I now had the chance to highlight the place of design today in what is now commonly called 'material culture' and to show that

1. J.-M. Floch, *Sémiotique, marketing et communication* (Paris: Presses Universitaires de France, 1990).
2. *Ibid.*, pp. 119–52.
3. *Ibid.*, pp. 183–226.

a semiotic approach to this can be of interest to other disciplines concerned with that culture, including anthropology.[4]

However, and above all, circumstances were such that I started my research with the analyses of the Apple and IBM logos and of the Habitat sign. As I progressed with these, I found myself confronting a familiar semiotic object: *the creation of visual identity through bricolage*. That is, for about ten years I had accumulated notes and observations on the 'total look' created by Coco Chanel. It had been my intention to write, some day, a study of an identity of this kind, constructed from signs from the world of fashion, and which could be defined as a rather particular structure articulating two opposite visions of the feminine figure: one classical, the other baroque. The 'total look' was of particular interest to me for two reasons. On the one hand, it was another example among the semi-symbolic systems dealt with in a number of my previous essays. On the other, its semiotic production could be seen as a 'bricolage' in the way Lévi-Strauss uses the term in *La Pensée sauvage*.[5] It was a mode of meaning production which, while working on these semi-symbolic systems, I had recognized in the compositional logic of Kandinsky's 'Composition IV'.[6] I should also add that in my previous work on marketing and communication I had already included material on visual identity as constructed via bricolage. I showed there how the Alice agency had designed for the Presses Universitaires de France a visual identity that was both strong and very striking. This was achieved by using a number of instances of bricolage – symbols, photographs, drawings and illustrations from old encyclopaedias – in the advertising campaign.[7]

With the Apple and IBM logos and with the Habitat sign I discovered further examples of visual identity constructed from the same logic and the same mode of meaning production. So I decided, for this new book, to address this particular type of semiotic object, to focus on this one issue. Again circumstances were favourable: while preparing this volume I had the opportunity to work as a consultant and lecturer on such topics as the Waterman text, the current interest in knives, and the forceful originality of the creations of a particular designer, Yann Pennor's.

Paradoxically, changing the subject in this way made me realize that I was actually returning to my original ideas, or rather that I was now in a position

4. Recently, in the preface to the catalogue of the exhibition *Design, miroir du siècle* (Paris: Flammarion/APCI, 1993), Marc Augé argued that anthropology should concern itself with design. He pointed out 'the traditional concern for material culture found in his discipline'.
5. C. Lévi-Strauss, *La Pensée sauvage* (Paris: Plon, 1962).
6. See J.-M. Floch, *Petites Mythologies de l'oeil et de l'esprit* (Paris and Amsterdam: Hadès and Benjamins, 1985), pp. 39–77.
7. See Floch, *Sémiotique*, pp. 153–81.

that allowed me to maintain them. To undertake an analysis of these further instances of visual identity meant continuing to work on the connection between the perceptible and the intelligible, and on that between the visual and the other senses. So this was yet another opportunity to address the question of material culture and to focus on the description of works or objects with a quite practical meaning. That is, I could now try to 'get a grip on reality' [*mordre sur la réalité*], as Greimas once put it. Indeed I always tried to ensure that, within my limitations, very basic reflections would lead to a descriptive practice or that, conversely, descriptive practice would feed into theoretical reflection. This is how I managed to approach what were, at the time, uncharted territories: semi-symbolism and underlying figuration.[8] For me 'biting into reality' is actually a 'personal necessity'. It's only by submitting to reality that semiotics can question itself and progress, and so refuse to be a mere philosophy of language.

Finally, the objects of meaning that once interested me and that still remain of interest are always *works* in Lévi-Strauss's sense (see the motto at the start of this volume). These are not, therefore, relatively permanent manifestations of human nature (passion, for example) but the many instances of historical realization that illustrate the equally many avatars of the relationship between the perceptible and the intelligible.[9] Such instances testify to the diversity of cultures and modes of presencing. So I hope the reader will understand my continual references to cultural anthropology. Semiotics, in my understanding and practice, to a large extent originates from that version of anthropology.

All six essays in this volume address the notion of bricolage, central as it is to the work of Lévi-Strauss. Accordingly there will be many references to some very well-known passages from *La Pensée sauvage*, where Lévi-Strauss examines this topic and the opposition between the bricoleur and the engineer. All six essays are concerned with this topic though each takes it from a quite different angle.

Bricolage is at the core of Lévi-Strauss's work. And not just because of the centrality of *La Pensée sauvage* in particular to the elaboration and development of his aesthetics as a whole. Rather, this aesthetics as such can be seen as a tribute to bricolage itself. Indeed, his latest work – *Regarder, écouter, lire* – starts with an astonishing parallel between 'two sublime forms of bricolage': those to be found in Poussin and Proust.[10] But bricolage is also at the core of the anthropologist's work because, in his own words, he has 'built all [of his] interpretation of myths,

8. On this problem see J.-M. Floch, 'Des couleurs du monde au discours poétique', *Actes Sémiotiques*, no. **6**, 1979. Also D. Bertrand, *L'Espace et le sens: Germinal d'Emile Zola* (Paris and Amsterdam: Hadès and Benjamins, 1986).
9. This being said, one must admit that passions themselves are integrated into cultural forms that are more or less fixed by practice. For a semiotic study of these forms see A.-J. Greimas and J. Fontanille, *Sémiotique des passions* (Paris: Seuil, 1991).
10. C. Lévi-Strauss, *Regarder, écouter, lire* (Paris: Plon, 1993).

all [of his] treatment of mythology, on this fundamental notion of bricolage' and because, in the end, he sees bricolage as 'essential to the workings of human thought'.[11] For Lévi-Strauss, 'wild thought' [*pensée sauvage*] is not the only kind that makes use of bricolage; scientific thought is also the work of the bricoleur. According to him, mythological analysis too (or at least the structural analysis of myth) works from signs and, as with the bricoleur, it too starts from these signs to get to fundamental structures by removing any limited 'pre-stressed elements' ['*éléments pré-contraints*'], and by associating diverse fragments so as to provide them with extra meaning.

In fact, in Lévi-Strauss's case, there is more than an objective similarity between mythic thought, mythological analysis and bricolage. There is a profoundly personal relationship between the object of research, the researcher and the form of thought. In this respect two thinkers had a significant impact on Lévi-Strauss's 'formative years' in New York. We know how decisive the influence of the linguist Roman Jakobson was, but we must also recognize the equally important influence of the painter Max Ernst. If it can be said that Jakobson caused Lévi-Strauss to err on the side of scientific thought, it would seem that Ernst encouraged him to 'get a grip on the reality' of myths. In conversations with Didier Eribon, published under the title *De près et de loin*, the anthropologist restates what he had already made clear in *Le Regard éloigné*:

> I learned from the surrealists not to fear abrupt and unexpected associations – such as those Max Ernst indulged in in his collages. That influence can be seen in *La Pensée sauvage*. Max Ernst constructed personal myths out of images borrowed from other cultures and taken from old nineteenth-century books, and he made these images convey more than they could mean when seen by innocent eyes. In the *Mythologiques*, I also cut out mythic matter and recomposed the fragments in order to generate additional meaning of the same kind.[12]

The six essays in this volume can be read as an approach to bricolage which is less intimistic than that of Lévi-Strauss and yet which is equally concerned with illustrating the rationality and fecundity of bricolage. I use the terms 'rationality' and 'fecundity' quite deliberately in order to stress the fact that my approach is indeed a generative one, but also one that follows in the footsteps of structural semiotics and the developments of it that derive from the work of Greimas and his group.[13] Indeed, in this volume I try to identify some of the conditions for the production of visual identity as it is conceived by bricolage, and I argue that we can find, in bricolage itself, a particular form of enunciative praxis.[14]

11. C. Lévi-Strauss, interview with Pierre Bois, *Le Figaro*, 26 July 1993.
12. C. Lévi-Strauss, *De près et de loin* (Paris: Jacob, 1993).
13. For an introduction to the work of Greimas and the work of his group, see footnote 9 to Chapter 1.
14. I will expand on this concept in the chapter on Habitat (Chapter 5).

As with other enunciative practices, bricolage means calling upon a number of already established forms, some of which may be fixed forms. However, the enunciative activity involved in bricolage does not lead to the production of merely stereotyped discourse. Rather, in this case, the selection and exploitation of the facts of usage and the products of history lead to a kind of creativity that constitutes the originality of bricolage as an enunciative praxis. We can, in fact, think of this as a double creativity. For, on the one hand, bricolage leads to statements that qualify as independent entities; while, on the other hand, any such statement will give substance, and hence identity, to an enunciating subject. Let us examine these two aspects.

Again and again, we will see that the product of the bricoleur's work can be considered as a structure, as an object of meaning with its own closure and its own system – and this is due to the semi-symbolic coupling of certain of its sensory qualities with certain of its content categories. By organizing and reorganizing the materials and the images provided by the signs he or she collects, the bricoleur produces meaning by super-segmentation and by establishing paradigms found in a semi-symbolic semiosis. This means that the bricoleur makes 'new from old' by playing with the formal harmonies and disharmonies suggested by the sensory effects of the signs collected. Bricolage therefore presupposes that we must pay attention to the sensory world, a world already given by history and culture.

But the bricolaged work, because it never fully corresponds to the initial project, escapes the bricoleur's control. In fact it comes to construct identity and can reveal that identity to the bricoleur and others. Lévi-Strauss says this quite clearly: 'Although never achieving his project, the bricoleur always includes some of himself.'[15] As an enunciating subject, the bricoleur will, to start with, be revealed in the identification implied by material and images he or she chooses to 'call up'. Identity can then be understood as a relationship to signs and images which are recognizable by others, according to the degree of permanence that such readability presupposes. But the bricoleur-subject will also be revealed in the particular way he or she exploits and transforms those signs according to a coherent 'deformation' of them that is unique to him or her, by doing so in such a way as to protest against the erosion of meaning, against semantic nihilism, 'against non-sense' [*contre le non-sense*].[16] Identity can then be understood as a kind of break or innovation, perhaps even as a kind of liberation.

15. C. Lévi-Strauss, *La Pensée sauvage*, p. 32.
16. *Ibid.*, p. 33. Lévi-Strauss points out that the activity of bricolage 'is not only a prisoner of the events and experiences which it arranges and re-arranges continuously in order to uncover their meaning; it is also that which frees through the protestation that it raises against nonsense, something which science gives up on from the first moment'.

To my way of looking at things, recognizing this ambivalence of bricolage as enunciative practice can allow us to link the issue of bricolage, as it is found in cultural anthropology and mythological analysis, with the question of narrative identity, as defined by the philosopher Paul Ricoeur. When viewed as a dialectic, narrative identity also articulates, on the one hand, signs' sedimentation and innovation, permanence and recognition and, on the other, the irruption and affirmation of an ethical dimension (see Chapters 1 and 4).

The reader should be aware that, in this book, I will also try to bring together a range of other issues. The quest for identity and the enunciative praxis found in bricolage cannot, *a priori*, be imputed to individual subjects alone; it is perfectly possible for collective subjects to act as bricoleurs in their search for full self-realization and self-affirmation. In fact such collective bricoleurs can be found in the 'groups' and the 'interior environments' [*milieux intérieurs*] that interest Leroi-Gourhan, the author of *Milieu et technique*. Leroi-Gourhan, anthropologist and historian of technologies, reminds us of their 'constant efforts to assimilate inputs from the outside' and that they feel it necessary to 'make themselves more profoundly unique by increasing [their] means of action'. These tensions are not antithetical to each other; on the contrary. In Chapter 6, on the Opinel knife, I address the relationship between the notion of identity and Leroi-Gourhan's concepts of 'borrowing' and 'invention'. Ultimately only the reader will be able to decide whether it is pertinent to combine these different semiotic, anthropological and philosophical versions of identity. The reader may well conclude that I too have acted too much like a bricoleur in this respect. But I take this risk in the light of Greimas's reading of reflection (see the motto at the start of the book) to the effect that there is a right – if not a virtue – to bricolage in all research projects with a 'scientific purpose'.

It must also be said that the essays in this book are part of a project designed to establish a semiotics of aesthetics – or perhaps an aesthetics of semiotics: a 'life project', as Greimas put it; or a project 'on the same scale as a life', as Ricoeur might have said. Such a semiotics – whose goal would be to describe the various relationships between the perceptible and the intelligible – might be a part of general semiotics and contribute to its theoretical and methodological development. But it would also want to merge with research in those other disciplines whose objects of enquiry intersect with its own and whose approaches involve the same epistemological orientation. These would include, naturally, cultural anthropology, as well as some versions of aesthetics and the history of art, at least in so far as their approaches happen to be compatible with semiotics and its structuralist underpinnings.

It will not be surprising, then, to see the questions of visual identity created by bricolage lead to general aesthetic issues such as the notion of

style,[17] linguistic syncretism[18] and synaesthesia (forms of coherence between the visual and other sensory effects). Chapter 3, on Michel Bras' insignia, addresses the relationship between the visual and the gustatory, and Chapter 6 on Opinel examines the relationship between the visual aspect of the knife and the tactile values associated with its use. Other chapters, including those on Chanel and Habitat, suggest possible extensions of these cases into broader synaesthetic effects: the work of Chanel is the polysensorial manifestation of an original articulation between a classic and a baroque approach to the sensory world (such that there are baroque perfumes). And, as we shall see, the Habitat display appears to be an instance of epicureanism – of a certain quality of life, an art of seeing, touching, tasting, and so on. In the same way, in essays published elsewhere, I have tried to analyse the relationship between the practice of drawing and the musical tastes of Roland Barthes,[19] and to unveil the history of the sonata form from its musical beginnings to its use in painting by Ciurlionis.[20]

Finally, I must make two observations. From the very beginning of this Introduction I have tried to frame clearly the objects under investigation and to indicate the semiotic and aesthetic nature of the issues I am addressing. These six essays, then, are about *visual identity as it is produced by bricolage*. Instances of visual identity are diverse enough, and their mode of production complex enough, to focus on this issue. It is obvious that such a narrow framing of visual identity excludes many other issues that are of interest to semioticians. To mention just one example: I had the opportunity to work on the logos of local and regional communities as well as on the systems of visual identity of large industrial and financial groups. What is it that these logos and systems actually talk of when they don't just repeat the stereotypical language of technologism, the 'crossroads of Europe', or the happy marriage of progress and tradition? They talk of a community of values, convergence, assimilation, diversity, hierarchy, a respect for particularity; of what makes a region more than simply a collection of government departments, or what builds the coherence and power of a new financial group. In short, these instances of visual identity make statements about collective subjects and the principles by which they are constituted. Accordingly, a social semiotician concerned with the question of identity[21] will have much to

17. See Chapter 4 on Chanel.
18. See Chapter 1 on Waterman.
19. See Floch, *Petites mythologies*, pp. 99–115.
20. See J.-M. Floch, 'Vie d'une forme: approche des sonates peintes par M.K. Ciurlionis', in H. Parret and H.-G. Ruprecht (eds), *Exigences et perspectives de la sémiotique*, vol. 2 (Amsterdam: Benjamins, 1985).
21. I refer here to Eric Landowski and particularly to a number of essays he has recently published. See especially: 'Quêtes d'identité, crises d'altérité', *Sigma*, vol. 2, 1994; 'Formes de l'altérité et styles de vie', in J. Fontanille (ed.), *Les Formes de vie* (Montreal: RSSI, 1993).

say about the diverse institutional representations of conjunction and disjunction, about singularity and multiplicity, and about the variety of topological and chromatic forms of the discourses of identity and alterity. More to the point, the social semiotician analysing the identity of these collective subjects would surely encounter new instances of bricolage simply because both history and stories [*l'Histoire et les histoires*] are rich in such instances and constitute, as does bricolage, connections between disjointed elements and journeys across semiotic locations.[22]

Nevertheless, the six essays in this volume may appear to some readers to offer too aestheticist an approach to design, fashion and material culture in general. They could be read as giving too much importance to the sensorial qualities of objects which are, after all, merely commercial products. Although it was never my intention to address these objects as works of art as such, these essays may actually sustain such an interpretation. However, this risk is a small price to pay for paying careful attention to the sensory appearances of our everyday surroundings. And it is true that this involves an effect of 'freeze-framing' everyday life, an effect of interruption, a suspension of events or practices which, under normal circumstances, would carry a far greater sense of urgency and immediacy. Analysing the production of such an effect is at the core of Greimas's work on aesthetics.[23] But, in the final analysis, the cost is probably negligible when compared to the benefit: adhering to the requirement of *synthesizing descriptive practice with theoretical reflection* and, so, elaborating a semiotics of aesthetics that contributes to the development of general semiotic theory and the location of that theory within cultural anthropology.

It so happens that I am writing this Introduction and finishing this book on 27 February 1994 – the day which marks the second anniversary of the death of A.-J. Greimas. With this book I hope to honour his memory and to give testimony to the admiration and the affection I have always held for him.

22. On this aspect of identity see Chapter 1 on Waterman and also M. Serres, 'Discours et parcours', in C. Lévi-Strauss (ed.), *L'Identité* (Paris: Presses Universitaires de France, 1983), pp. 25–49.
23. A.-J. Greimas, *De l'imperfection* (Périgueux: Fanlac, 1987). See also the prolegomena to the work of H. Parret, *Le Sublime du quotidien: phénoménologie et critique du quotidien et de la sublime* (Paris and Amsterdam: Hadès and Benjamins, 1988), pp. 17–24.

1

Waterman and its doubles

In this chapter I want to do two things: to work through the problematic idea of identity and also to introduce the kind of semiotics used in the six essays that comprise this book. I decided to do this, simply and concretely, by analysing a particular Waterman advertisement that appealed to me from the first time I saw it.[1] I'm not referring, then, to its obvious charm or to its humour; rather to its narrative and linguistic richness.

Let's start by saying that the advertisement is a story: a story about the differences and similarities between two brothers. By narrating their respective careers – and the part played by a Waterman pen in marking the commonalities between their different paths – the advertisement deals with the question of identity and, in particular, with the question that interests us in this book: the question of *visual* identity. More particularly it deals with such things as school uniforms, handwriting and (very specifically) the way in which the letter 'W' is drawn – so that the letter itself becomes a symbol of 'tWinship' or 'gemellity'. But the 'message' of the advertisement is also an example of linguistic syncretism. That is, by combining writing, photography and graphics (the logo) to give meaning and value to a brand-name pen, the advertisement itself justifies the kind of semiotic analysis used here. This is because the advert's own purpose is to describe the means by which meaning [*signification*] is produced and ultimately expressed through various signs and forms of language.

1. This advertisement for Waterman was created by the McCann–Erickson agency. Christiane Delangle was the commercial director and Steve Ohler the creative director.

A segmental analysis of the advertisement

When analysing a written text, a picture or any other cultural object/event – for example, riding on the subway[2] or using a particular tool (as we will see later with the Opinel knife) – the semiotician's purpose is, first, to consider it as a whole and then to proceed with a segmental analysis of it, an analysis of the units that compose it.

One advantage of working with units is that they are manageable. But first and foremost, by working segmentally, the semiotician should not isolate details arbitrarily or for their own sake but rather should ensure that each part is always considered as a part of a whole. For once an overall 'map' can be established the object in question presents itself as a hierarchy. We will explore this below.

The Waterman advertisement (Figure 1) which I'm using to introduce the problematic of identity can, in the first instance, be divided in two more or less distinct parts. The first consists of everything that produces a perception of a concrete and material reality for the viewer. That is, we seem to have 'in front of us' a handwritten letter and, as part of the letter, an old photograph and a fountain pen. The second part consists of the typographic text of the advertisement and the trademark. This part does not give the impression of a direct or immediate reality: rather it reminds us that what we have here is, in fact, only paper, that what we have 'in front of us' is actually just a page of magazine advertising.

We can already see, then, that these two parts are manifestations of two different discourses. The first part is the manifestation of a discourse about an 'I'. The second is the discourse of brand names. Indeed, the photograph, the handwritten text and the fountain pen are part of a single enunciation: the old, unfolded photograph and the Waterman have been placed symmetrically in relation to the handwriting, and the one who calls himself 'I' has also, then, put the pen at the bottom of the letter – *Pour notre anniversaire, tu m'as offert* **ce** Waterman ... [For our birthday, you gave me *this* Waterman ...]. In other words, this 'I' has caused both the photograph and the pen to become a non-verbal part of the text addressed to his twin. This shows that a statement can be more than just verbal; it can also be visual and 'objectal', as it were. But let's stay, for a moment, with the segmentation of the advertisement rather than opening up an analysis of its contents. And – even before we proceed with the segmentation – let's equip ourselves with an initial visual representation of the combination of the different units that have been uncovered in the advertisement.[3]

2. See J.-M. Floch, *Sémiotique, marketing et communication* (Paris: Presses Universitaires de France, 1990), pp. 19–47.
3. In this instance I am not taking into account the small element functioning outside the text of the advertisement proper: the signature of the McCann agency, positioned vertically on the top right-hand corner of the advertisement.

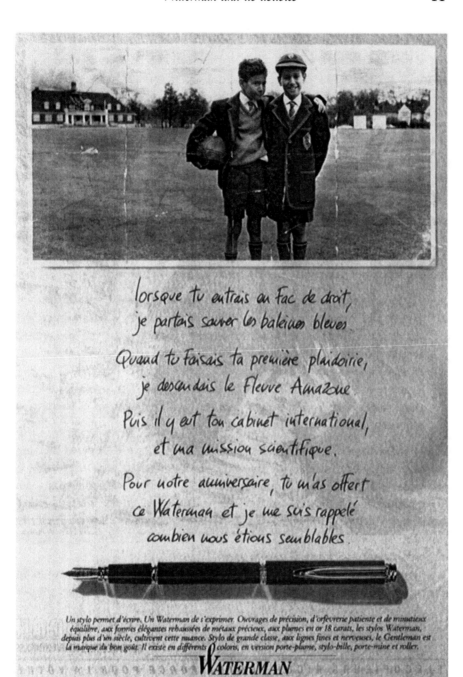

Figure 1

We must now return to our segmentation by breaking down these two text–parts of the advertisement. And let's start, arbitrarily perhaps, with part of the discourse of the brand name: the typographic text at the bottom of the page, rather than the handwritten text. The typographic text (Figure 2) can itself be broken down in three parts. Each of these focuses on the pen:

1. A pen only lets you write; a Waterman lets you express yourself.
2. A precision instrument carefully crafted by goldsmiths with a balance that comes from attention to detail, its elegant shape is enhanced by precious metals; the nibs are 18-carat gold. The Waterman pen has delivered quality of this kind for over a century.
3. A pen with class, with subtle and dynamic lines, the 'Gentleman' is a sign of good taste. It comes in various colours, as a fountain-pen, a ballpoint, a propelling pencil or a rollerball.

The first statement establishes the difference between a Waterman and any ordinary pen. The distinction between merely writing and expressing – reminiscent of the distinction that Roland Barthes makes between writing and the writer [*écrivant/écrivain*] – is how the 'philosophy' of the brand is stated, investing Waterman products with a fundamental value: identity itself. By contrast, an 'ordinary' pen could only be invested with sheer use value; the disposable ballpoint being a case in point.

The second statement is about Waterman pens in general. By returning to the distinction between writing and expressing, this statement tells the story [*récit*] of

Un stylo permet d'écrire. Un Waterman de s'exprimer. Ouvrages de précision, d'orfèvrerie patiente et de minutieux équilibre, aux formes élégantes rehaussées de métaux précieux, aux plumes en or 18 carats, les stylos Waterman, depuis plus d'un siècle, cultivent cette nuance. Stylo de grande classe, aux lignes fines et nerveuses, le Gentleman est la marque du bon goût. Il existe en différents 0 coloris, en version porte-plume, stylo-bille, porte-mine et roller.

WATERMAN
PARIS

Figure 2

how the pen is made as an object and, therefore, in the case of a Waterman pen, how it is made as an object of value: the work of the goldsmith, the attention to detail and balance, the use of precious metals, and so on.

Finally, the third statement establishes both the thematic and the figurative (or representational) levels of the pen's identity value. To explain this we could say that identity is, at least in this instance, defined by good taste. This has to do with the elaboration of the thematic level which is a matter of taste as a kind of socio-cultural identity. This identity could well have been different; it could have been, for example, public, geographical or political. But following that initial specification or realization, identity becomes figurative. It takes on the shape of a specific pen: the 'Gentleman', made by Waterman.[4] So giving details of this model and its different options brings about a progressive construction of the signifying value of the Waterman: from the abstract level of its investment in a fundamental value – identity, once again – to the figurative level (by way of references to different kinds of nib).[5] We can represent this passage, or 'rise', from abstract to figurative, in the following way:

	Figurative level	The 'Gentleman'
	Thematic level	Good taste
	Abstract level	Identity

Let us now consider the part of the advertisement made up of handwritten text: the letter written by 'I' to his brother; the letter in which he recalls their different careers. This letter gives the Waterman its narrative status, and allows us to understand why it is set in parallel to the photograph.

Once again, we can roughly divide the letter into two parts. The first goes from *Lorsque tu entrais* [When you started] to *mission scientifique* [scientific mission]. The second starts with *Pour notre anniversaire* [For our birthday] and ends with *semblables* [alike]. This first subdivision is based on a segmentation of narrative voices. That is, the first part refers to a distinction between two persons, 'you' and 'I'. It is only in the second part that the plural 'we' appears; so it would be more appropriate to refer here to a duality, rather than a plurality:

4. My analysis focuses on one of the variations of this Waterman advertisement; variations created by the McCann agency for other Waterman models. I should also point out that many more advertisements using the themes of the photograph and the pen have been created at an international level. A comparative analysis expanding on the results of my own analysis may therefore be possible.

5. I refer here to the 'generative course of signification' which tries to define objects of meaning dynamically, according to their mode of production – which is semiotic rather than technical. Indeed, 'the components involved in such a process are articulated according to a "course" running from the simpler to the more complex, from the more abstract to the more concrete'. See A.-J. Greimas and J. Courtés, *Sémiotique, dictionnaire raisonné de la théorie du langage*, vol. 1 (Paris: Hachette, 1979). For a simplified and illustrated version of this concept, and one central to semiotic theory, see Floch, *Sémiotique*, pp. 123–6. We will return to this 'course' later in the present chapter and also in the chapter on Opinel (Chapter 6).

- *Pour notre anniversaire* [For our birthday];
- *combien nous étions semblables* [how much we were alike]

But the first part of the message is itself divided in two sub-parts. The first two sentences are in the imperfect tense and begin with temporal markers — *Lorsque* and *Quand* [When] — whereas the third sentence is in the past historic tense and starts with a different temporal marker — *Puis* [Then/Thereafter]. Moreover, in the third sentence, the two persons are still distinct but they are now represented by possessive rather than personal pronouns — *ton/ma* [your/my].

In diagrammatic form this hierarchy of text units would look as follows:

When alike.
... Amazon	Then mission	For our birthday ...
you, I	your, my	our, we
Imperfect	Past historic	Perfect
Temporality by subordination (When: *Lorsque*, *Quand*)	Temporality by conjunction (Then: *Puis*)	Temporality by substantive (Birthday: *anniversaire*)

A narrative analysis of the letter: intersecting destinies

This segmental analysis of the advertisement as a whole, and the segmental analysis of the handwritten text in particular, may seem to be both tedious and gratuitous. But this may not be so. Accordingly I will now try to demonstrate how beneficial this kind of analysis can be. So let's continue with the handwritten letter and look at it in terms of a narrative analysis. And let's now look at the content level of the advertisement rather than its overall structure.

Notice that the letter ends with an emotional recognition of the similarity between the twins: *et je me suis rappelé combien nous étions semblables* [and I remembered how much we were alike]. But such a final situation contrasts with the initial situation in which someone called 'you' and someone who says 'I' are clearly distinct. Let us therefore examine how this transformation occurs.

At the start of the story [*récit*], the two characters ('you' and 'I') are the subjects of two clearly opposing narratives.

1. First, this is because 'you' enters law school [*Fac de droit*] when 'I' leaves. These two actions are countervailing movements. The first (entering) involves spatial conjunction, while the second (leaving) involves disjunction.
2. Furthermore, the places concerned are themselves invested with opposing values. The law school connotes the law itself: contracts and the passing on

of acquired knowledge. So we could say that the law school represents what is generally called culture. The blue whales [*baleines bleues*] referred to in the second line, by contrast live in the natural environment and symbolize, for many, the necessarily difficult question of environmental conservation. The blue whales and the law school therefore represent the two opposing terms of the nature/culture binary.

3. The third opposition between the two characters: this has 'you' entering law school and conjures up a universe of *knowledge*, whereas, by contrast, it is *action* that interests the 'I' who goes on a journey to save the whales.

4. Finally, the fourth opposition: to go to law school is to have chosen one's own education and is, therefore, to begin a programme of study whose end is technical competence. The 'I'-character does not have such patience or modesty: he seems to want to ignore this merely initiational phase in his life. It seems as if his enthusiasm alone, his mere participation in ecological campaigns, will change the course of history.

Everything, then, points to the first sentence of the letter being a multiplication of the reasons for differentiating between the two twins. It may even establish a strong opposition between them.

The second sentence seems to be no more than a continuation of the same narrative. It has the same oppositional logic. Two semantic units appear and, with each of them, two specific 'isotopes' develop:[6]

6. Here an 'isotope' [*une isotopie*] is a recurrence of one or more semantic units which ensure the homogeneity of a discourse. It is, in a way, the common denominator which progressively takes hold in the unfolding of a text (or a picture) and finally ensures the coherence of its contents. If one looks at it from the point of view of reception, via the reader or the viewer, it is the homogeneous level of perception and interpretation which results from partial readings of the statements and the resolution of their ambiguity. An isotope is then a semiotic event associated with the syntagmatic dimension of discourse; with the combination of units, their co-presence as well as their directional sequence. One of the objectives of describing a text or a picture is the recognition of such isotopes. It is a matter of unveiling the networks of relationships which underpin the contents of the discourse under investigation. This is achieved by starting from the contextual values adopted by the various elements of the text or the picture. Here we can turn to the following example, used by J. Courtés in *Analyse sémiotique du discours, de l'énoncé à l'énonciation* (Paris: Hachette, 1991). The verb 'to go' contains many accepted uses: it does not have the same meaning, as we say, if it is located in the sentence 'This dress goes well on her!', or in the sentence 'All goes well for Anthony and Peter', or in the sentence 'Tonight Cinderella will go to the ball in a horse-drawn carriage'. In the last sentence there is a certain semantic family resemblance (so to speak) between the three units of 'go', 'ball' and 'horse-drawn carriage'. Indeed, when analysing its definition:

– 'ball' can be characterized by several traits of meaning (or 'semes'): /movement/ + /social/ + /temporal/ + /spatial/; and
– 'horse-drawn carriage' by /social/ + /spatial/ (amongst other traits): it is a mode of transport with connotations of luxury.

The particular context in which the verb 'to go' is located is such that it realizes its possible spatial aspect. That could not have been the case with the sentence: 'Tonight Cinderella will be going much better'. Here the recurrence of the /spatial/ trait, the isotope of the spatial, has given the verb its particular contextual value.

- The isotope of the law [*droit*]: including the notion of the lawyer's first brief, a consequence of going to law school;
- The isotope of water: a place of adventure — the journey down the Amazon, a consequence of the campaign to save the whales.

And these two subjects continue to be involved in their respective isotopes: it is always 'I', for example, who prefers water, and who later gets a Water-man as a gift. But we discover that the 'you' character becomes a lawyer, and that the two brothers are now in what is commonly known as a professional partnership. So, on a closer analysis, we begin to notice a significant reduction in the differences between the two. Indeed, the one who seemed to privilege knowledge has become a man of action (through his ability to speak up in court). And, symmetrically, the man of action, the fiery ecologist, has become more contemplative, or, at least, he has become an observer. That is, he only *travels* down the Amazon; he doesn't actually transform or conquer it. Above all we can observe another major emergent connection between the two brothers (a much more profound one to which we shall return later). It turns out that the 'I' character is not the only one who wants to save things. The 'you' also saves and defends.

Puis il y eut ton cabinet international et ma mission scientifique [Then there was your international office and my scientific mission]. From here on, the twins are indeed in phase. Both acquire social recognition and both thereby enjoy what can be considered to be the fulfilment of a career.

We are left with the impression that, by substituting possessive for personal pronouns, it is life — what we call 'the way things are' — that actually brings the brothers to the same level of professional recognition. We can also notice (and this is anticipated in the second sentence of the text) an intersection between the two dimensions in which they were each separately located. It is indeed the 'I' who is now inscribed in the sphere of knowledge, as a well-known scientist. This was to be expected because, inversely, the world has also come to recognize the feats, the actions, of the 'you' as a lawyer.

There is no longer any reason, then, to be surprised that 'you' should give 'I' a pen as a present or that 'I' should see in it the extent of their similarity. Life, the great intriguer, has determined that their destinies should come to intersect; and the full realization of their parallel careers has only made more obvious the singularity of the twins' joint life project, their common aim.

cont.

It is true, however, that every example is a bad example: the latter could lead us to believe that the isotope is a phenomenon attached to the sentence. In fact, it is primarily a phenomenon beyond the level of the sentence. The homogenizing recurrence is generally found well beyond the first sentence. Moreover, it can only be captured in a retrospective movement of reading. It is recognized *a posteriori*, somewhat like the guiding line of a life. We will return to this.

At this point, let us introduce two fundamental semiotic terms. They can help us better appreciate the above-mentioned identity as a life project. That double identity can first be seen from a *syntagmatic* point of view, that is in terms of horizontal sequencing: their lives have followed the same rhythm from an early stage and their respective professional careers have, at the same time, brought them to parallel forms of recognition. But this identity can also be understood in a complementary way, in terms of vertical selection or, let's say, from a *paradigmatic* point of view. Indeed, both boys have proved themselves to be decision-makers in that they have made, as one of them says, 'life choices'. And both have shown that they enjoy commitment to a cause, that they share the same ethics.

The Waterman that 'I' has received from 'you', and that he now uses to write to him, can therefore be seen as representing that common narrative identity. In the first place, it is a product which, by virtue of its elegance and its value, testifies to the social status that both have achieved. It represents an identification with a particular social class and refers to a certain definition of identity: 'that by which you are recognized'. But, beyond that question of social identity, the pen also makes it possible for one to write in a completely individual manner: for a pen is not a typewriter or a computer keyboard. Much more than that, the pen is used to *sign*, and this means making a commitment, keeping a promise, keeping one's word. In this way, by representing the most personal and the most personally involving aspect of writing, the Waterman also represents another version of identity. This is not just an identity involving assimilation and social identification; it is more an identity defined by 'what motivates us'. It is also an identity that is manifest in a coherent distortion, through a style and through the affirmation of an ethic. We will return to this double definition of identity later when referring to the concept of 'narrative identity' developed by the philosopher Paul Ricoeur.

The photograph: return-gift for the pen

In our earlier segmental analysis we noticed that the photograph is, by virtue of the general composition of the advertisement, symmetrical to the fountain pen itself: they form parallel lines which frame the handwritten text horizontally. This visual symmetry is reinforced by the same shading effect on the paper (Figure 3). As we read the first lines of the letter the photograph does indeed appear in the right place: it refers back to the period immediately preceding the one evoked at the start of the text. But, as we finish reading the lines written by 'I', the photograph also begins to acquire a particular narrative status: it turns out to be a return-gift, a gift in exchange for a return-gift. 'I', who has received the

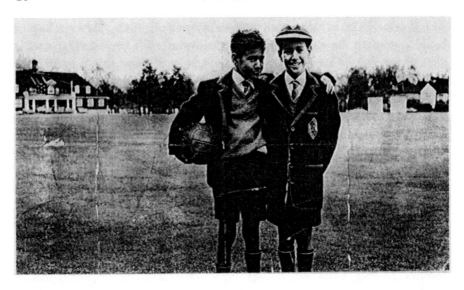

Figure 3

pen as a gift from 'you', has discovered and unfolded an old photograph. He has stuck it onto the sheet of paper and started to write a few lines below it. The photo will be there, then, in the return correspondence, to illustrate the similarity that disturbs 'I' so profoundly. Then, finally, 'I' has put the pen in place with care – or, at least with precision.

Notice here the essential role that a visual device can play in establishing relations between figurative (or representational) units and, therefore, in the construction of the meaning [*signification*] of any message. We are faced here with a topological device: it is the category of 'inserting' *versus* 'inserted' that is used here. Notice also the significance of the visual attributes given to the figures in the photograph and also to the pen. Each involves the same rendering of materials and the same use of shade. These two examples show how a particular visual treatment can constitute a definite secondary system of elaboration by taking particular content units and reorganizing them to produce

new associations and, hence, a new meaning [*signification*]; a meaning, moreover, that is more profound than that afforded by their representational (or figurative) aspect alone.[7]

This status of the photograph as a return-gift enables us to appreciate 'I''s sense of humour: he ends his letter by talking about similarity and yet includes a photo showing two children who are so different. But this return-gift status also shows that 'I' has an attachment to the photograph, for it's clearly been kept carefully folded. If it had no such value how could 'I' put it in a parallel position to a beautiful pen? But it is still just an old photo, damaged from being folded and unfolded.

Let's take a closer look at the photograph then. It's a slightly dirty black-and-white photograph, a bit stained, and unusually wide. Its composition is remarkably orthogonal. A horizon line is broken at right angles by the double figure of the boys. By means of this orthogonality, the figure and the horizon come to be perfectly integrated into the composition of the advertisement as a whole. But, as far as the other parts of the advertisement are concerned, it is not the photograph's *signifier* that is of interest to us, it is its *signified*: the way it maps the contents and, above all, its representational (or figurative) dimension. We will therefore go no further with the analysis of those visual attributes on the signifier side and confine ourselves to the signified.

Two boys pose in front of the photographer; one shows off his winning smile; the other one looks mischievously into the lens. They stand on the playing field of what must be a school or a sports club; they wear the same English-style uniform: the same tie, the same blazer, the same sweater, the same socks. Here we have a very distinct visual identity indeed. A uniform, by definition, is 'any distinctive clothing of standard cut, fabric and colour, defined by regulation': it is a 'any group's obligatory dress code'. This meaning [*sens*] can be widened: the term 'uniform' is commonly used to refer to any unvarying surface appearance, any 'clothing common to all'. These definitions make it clear enough: we are talking about an identity that is somewhat unique given that it is solely a matter of what 'must be'. Moreover, it is an identity that works through assimilation, or even through non-differentiation. It is a form of visual identity that tries to remove anything that might otherwise distinguish or individualize the members of a group. Hence the semiotic function of difference – that which makes meaning [*sens*] – becomes the exclusive property of the group as a whole, distinguishing it from other groups.

7. For more details of this problematic of secondary systems of elaboration – based on a particular treatment of the visual qualities available through the figuration of an image – see my own work on semi-symbolic visual systems. J.-M. Floch, *Petites Mythologies de l'oeil et de l'esprit* (Paris and Amsterdam: Hadès and Benjamins, 1985).

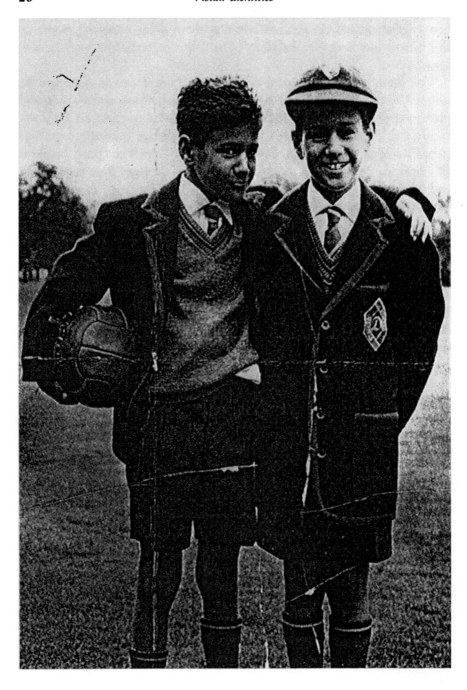

Figure 4

However, the school uniform (paradoxically?) also reveals the difference between the two boys. This arises from the way they actually wear it: the double figure of the twins is very close to the viewer and this emphasizes the contrast between them. The bottom edge of the photograph, acting like a spirit level, immediately emphasizes the fact that one of the children wears his socks impeccably pulled up straight while the other has let his right sock slip down his leg (Figure 4). Also, this boy's shirt sticks out between his shorts and his sweater – and he too is the one who has not bothered to button up his jacket and who has allowed his collar to stick out over his sweater. Nor does he wear a cap – perhaps he's lost it playing football. 'Always the same!': isn't this a typical expression of identification? So the mischievous-looking boy, the 'untidy' one perhaps, gets his identity from a double principle of difference and repetition. It is produced and captured by a set of 'or ... or ...' relations as much as by a set of 'and ... and ...' relations. In more explicitly semiotic terms, his identity, just like any other, can be understood both *paradigmatically* (via the axis of selection and system), and *syntagmatically* (via the axis of combination and process).

So, on closer inspection, as we move beyond the basic differences between the ways the two brothers dress, we can begin to see their similarities and understand the testimonial value that 'I' wants to convey by including the photograph. As we read the last lines of the letter, we know that the brothers are twins ('For our birthday ...'). But it is by examining their facial features that their twinship [*gémellité*] becomes obvious and acquires its truth and its depth. We can see that they have the same eyes, the same ears, the same nose. But more importantly we can understand why, in his memory, 'I' takes this similarity to such a degree: ' ... and I remembered how much we were alike'. For indeed, their similarity is not just physical; it is also, and primarily, gestural and behavioural. To be sure, 'I' is untidy and his brother is impeccably dressed; and, to say the least, it is also true that 'I' is much freer in his gestures than his brother. But both smile and share the same candid look, and both stand upright. In this sense, they have the same presence, and the same attitude toward each other, and toward the photographer. The mischievous one, in a protective gesture, has put his arm around the shoulder of the smarter one. The latter does not object to this; he even appears confident that his brother won't be able to stop him, by contrast, being serious and dignified. If the sporty one plays the protector, the smart one, on the other hand, is well behaved – and by standing by his brother, the 'well behaved' one affirms and represents their common high standard of education. Each one is obviously pleased to pose with the other; each one is open to life and to others. In this photograph both already show qualities of being able to affirm and defend themselves and each other.

From this point on it hardly matters if the sporty one will leave to save the whales and the serious one will become a lawyer, or if it turns out the other way. Why shouldn't it be like that? It would only be a matter of inclination, or perhaps

simply a matter of either maintaining or abandoning the particular role that each happens to take on during the photography session. So, beyond the obvious differences in how they wear their uniforms, and independently of any natural, or genetic, resemblance, 'I' has retrieved from this portrait their common way of being towards the world and a way of being towards others. This is a way of being in which the intertwining of their destinies was only ever a narrative development, an unfolding realization. From this point of view we may speculate that the letter that 'I' writes is an instance of a mythic thought [*pensée*] if one accepts Claude Lévi-Strauss's statement to the effect that 'mythic thought involves becoming conscious of certain oppositions and leads to their progressive mediation'.[8]

What is the role then played by the Waterman that 'you' offers? What is its connection with twinship (or gemellity)? And, symmetrically, why has this particular photograph been unfolded by 'I' and sent as a return-gift? Of course, as we have mentioned before, the fact that a pen is involved has some importance: a lawyer knows that a scientist too will sooner or later need to write. But the gift in question is not merely a pen; it's a Waterman, a brand-name pen, the first letter of which is also a logo. And what is the most striking aspect of that letter, of that logo? Again, it is its twinship (gemellity) (Figure 5). It is a double 'U' (or double 'V'), both literally and visually. Moreover, in Waterman's logo-initial the shape represents not only gemellity but also a kind of 'accolade'; it is made up of a line through which one form joins another identical to itself. The contrast with the handwritten 'W' in the letter by 'I' (Figure 6) is enough of an indication of this: the calligraphic 'W' of the Waterman logo – in the trademark at the bottom of the advertisement – takes on the function of the mischievous brother in the photograph, drawing the twins together in a single character.

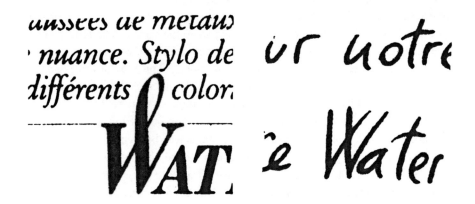

Figure 5 Figure 6

8. C. Lévi-Strauss, *Anthropologie structurale* (Paris: Plon, 1958 and 1974), p. 248.

Could 'I' be a semiotician?

So there we have the story of the Waterman twins: so different, yet so much alike. And as mentioned at the beginning, this advertisement and this (hi)story were selected both to give a concrete illustration of the semiotic approach and to consider the problematic of identity.

Why was this advertisement of interest to us? Because its (hi)story is in itself very semiotic. That is, it tells us how a pen can be considered as an object of meaning. This way of thinking is already characteristic of semiotics as distinct from technical, sociological or historical approaches, for example.

By referring to a pen in particular, the story of the twins suggests that texts and images are not the only possible objects of meaning [*sens*]; concrete and material objects can also be meaningful [*significant*], not only because of the added value conferred on them by their producers – a question we will take up later in the case of the Opinel knife (Chapter 6) – but also because they are situated in a narrative of use or consumption (in this instance, in a relation of gift and return-gift). And it is indeed part of the semiotician's calling to dedicate himself or herself to analysing all forms of meaning [*signification*], and all of the ways in which it manifests itself. Once again, as a starting-point, semiotics works with every type of sign and all sorts of languages that make meaning [*signification*] possible, no matter whether these signs and languages happen to be verbal or non-verbal.

In a more general yet more specifically semiotic way, the story of the Waterman twins illustrates the economy and the dynamism of this process; an economy and a dynamism which are peculiar to questions of meaning [*signification*] and which are among the essential tropes of semiotics – at least in the form elaborated and developed by A.-J. Greimas and his school.[9] Here, meaning [*signification*] is approached and analysed as a production, as a progressive and unfolding articulation that corresponds to an enrichment of meaning [*sens*]. The story of the characters we called 'I' and 'you' demonstrates the ways in which meaning [*une signification*] can be constructed and understood. The meaning [*signification*] specific to the Waterman advertisement surrounds the careers of the twins, of these two men apparently so different but who, in the end, show

9. Today there are a number of books and articles on the work of this semiotic research group. Apart from two collected works which I believe to be quite representative of the group, I will only cite here a few 'pedagògic' works (this is said without any pejorative implication – to the contrary). J.-Cl. Coquet (ed.), *Sémiotique: l'Ecole de Paris* (Paris: Hachette, 1982). H. Parret and H.-G. Ruprecht (eds), 'Exigences et perspectives de la sémiotique', *Recueil d'hommages pour Algirdas Julien Greimas*, vol. 2 (Amsterdam: Benjamins, 1985). M. Arrivé and J.-C. Coquet (eds), *Sémiotique en jeu*. (Paris and Amsterdam: Hadès and Benjamins, 1987). The 'pedagogic' works are as follows. J. Courtés, *Introduction à la sémiotique narrative et discursive* (Paris: Hachette, 1976). J. Courtés, *Sémantique de l'énoncé: applications pratiques* (Paris: Hachette, 1989). A. Hénault, *Les Enjeux de la sémiotique* (Paris: Pressses Universitaires de France, 1983). A. Hénault, *Histoire de la sémiotique* (Paris: Presses Universitaires de France, 1993).

themselves to be so much alike when their respective careers are compared over the course of a lifetime.

It is also possible to see that the construction and understanding of this meaning [*signification*] were independent of any conscious intent, any particular condition or temporality. That is, neither of the two brothers actively tried to make his career cross that of his twin; and this makes possible and affirms an ethical twinship that doubles and overlaps their natural twinship. In other words, the production of that meaning [*signification*] is independent of any intention either to act or to communicate. Finally, the construction of the double life-path is as progressive as the recognition of their ethical twinship is sudden.

To give such a meaning [*signification*] to their lives, 'I' would have had to analyse the sequence of events making up the courses of their lives; he would have had to segment them, as would any semiotician when beginning to analyse a text, an image or a space. He would also have had to follow the way the differences and the similarities among the units recurred. And he would have had to imagine all that might have been, as opposed to what actually occurred. That is to say, he would have had to recognize the choices that each one made and take into account their adherence to these choices. To put this another way – and to return again to fundamental semiotic concepts – he would have had to approach their lives along both the syntagmatic axis (the axis of process) and the paradigmatic axis (the axis of system).

By working in this way 'I' discovered 'the invariance behind the variation' in their respective actions and situations.[10] He could then have found the extent to which both were alike by focusing (not on the intrinsic aspects of these actions and situations but rather) on their relationships, and by arranging these hierarchically according to whether they turned out to be more or less invariant or more or less variable.

This discovery of twinship can be considered, after the fact, as a scheme that is, after all, rather simple and abstract. And yet what a diversity of situations, places, times and objects it took to make it happen: a senior school and a uniform, blue whales and a law school, the Amazon river, a lawyer's office and a scientific mission, and then also a pen, a letter, a photograph, and so on. 'I''s undertaking thus constitutes a truly meta-semiotic operation – a giving of meaning [*sens*] to meaning [*sens*] – in so far as he had to analyse and reconstruct the signifying form that is their twinship from the original signifying material, from the courses of their two lives. Here, the idea of a meta-semiotic operation is taken from the article 'Identité' by Greimas and Courtés.[11] They define 'identification' as follows:

10. This expression is from the linguist Roman Jakobson. See his *Une vie dans le langage* (Paris: Minuit, 1984), p. 155.
11. A.-J. Greimas and J. Courtés, *Sémiotique, dictionnaire raisonné de la théorie du langage*, vol. 1 (Paris: Hachette, 1979), p. 178.

the recognition of the identity of two objects, their identification, presupposes their alterity; that is to say, a minimal semic or phenic unit that sets them apart. From this point of view, identification is a meta-linguistic operation calling upon a semic or phenic analysis: far from being a first approach to semiotic material, identification is but one operation among others in the construction of the semiotic object.

It is also after the fact, or more exactly *a posteriori*, that 'I' has tracked a course of action going from the simpler and the more abstract to the more complex and the more representational (*figuratif*); from a possible conversion of his life and his brother's into a *scheme* to what is effectively a conversion (of events, eras, the present day, letter writing, and so on) into *signs*. Semiotics itself does no more or less than this when it analyses the general economy of a discourse as a 'course', as the *parcours génératif de la signification* [generative course of meaning]. Greimas defines this quite simply, as follows:

> This course is supposed to give an account of increasingly complex structures by applying what we call conversion procedures to something that is, initially, simple. From these universals associated with the human mind, we can get to the discourse as such; and finally the goal of this course is to reach semiosis; that is to say, the unification of the signifier and the signified; that is to say, reality. For me, semiotics is a way to increase meaning [*sens*] starting from the elementary. As we complicate things, their meaning increases. Semiotics is situated between 'elementary elementaries' and the real that is its target: a task that has been going on for many generations. Only in the following sense is semiotics a scientific project: it is neither a science nor a project, nor a doctrine. ... It is an invitation for those who want to work towards an understanding of what it is to be human. ... Semiotics is a *method* for knowing, not the knowing of being itself.[12]

Does this mean there is no difference between the 'I' of the Waterman advertisement and a semiotician, except perhaps for the semiotician's jargon? The answer already lies in the above quotation from Greimas. The semiotician not only retraces the course [*parcours*] of meaning [*signification*] as we have already seen; he or she tries to provide a representation that is as clear and as systematic as possible; as 'open' as possible, so to speak. For this representation occurs as part of a scientific project. Its question is: how to go from the simple to the complex by isolating and hierarchizing a number of levels of relevance? And it is indeed this concept of relevance that constitutes, no doubt, the great difference between a discourse 'with a scientific vocation', which semiotics tends to be, and a discourse that can only be considered a kind of literary or sociological essay. Indeed it is his or her insistence on the isolation and

12. A.-J. Greimas, 'Interview with François Dosse', *Sciences humaines*, **22**, November 1992.

hierarchization of levels of relevance that enables the semiotician to meet the standard scientific criteria of coherence, completeness and simplicity.[13] And, methodologically speaking, it is this that enables the semiotician to formulate objects, to establish concepts, and to define them in a definite manner (or, better, to inter-define them). Semiotics knows that it has no capacity for strict formalization – far from it – but that is no reason for it to renounce formalization altogether; even at the cost of using what may appear to be jargon.

An opening onto the problematic of identity

Another reason for focusing on the Waterman advertisement was that it had, as it were, some value as an entrée. It seemed to be useful as a way of opening this book on aspects of identity – both identity in general and visual identity in particular – a topic that is pursued throughout the various essays in this collection.

First, as we have already seen, the Waterman advertisement introduces the idea of non-immediacy – cognitive as well as temporal – that characterizes the recognition [*reconnaissance*] of identity. This non-immediacy is due to the fact that such a recognition means establishing *relations* and not merely noticing the intrinsic qualities of the elements under consideration. Identification is indeed a meta-semiotic operation, as Greimas and Courtés have pointed out: it is the construction of a semiotic structure by transforming already existing signifying material. It is, in a way, to give meaning [*sens*] to meaning [*sens*]. Identification implies an analysis that can uncover the relationships that exist between phenomena, between events, or between actions, with all of these considered as signs and approached as such – and we will regularly return to this theme in the course of the essays that follow.

On the other hand, identification presupposes that we can recognize – consciously or not (this is not a semiotic distinction) – some minimal feature, on

13. These criteria of scientificity refer to the 'principle of empiricism' of the Danish linguist Louis Hjelmslev, one of the founders of semiotics. The three criteria are hierarchized: the need for coherence comes before completeness which precedes simplicity. Coherence which is impossible to obtain through the translation of semiotic theory into a formal language in view of its current state can nevertheless be approached as long as one strives to establish a network of concepts that are completely inter-defined. This is what Greimas and his collaborators tried to do when they prepared the two volumes of *Sémiotique, dictionnaire raisonné de la théorie du langage*. The concern for completeness is linked to a striving for an adequation of the models that one establishes to the totality of the elements contained in the corpus of materials to be analysed. Completeness is then understood in relation to a chosen level of relevance. One should note here that the objective of completeness implies that one attempts to maintain a balance between the inductive and generalizing component of analysis and the deductive, constructive and top-down component. Finally, the need for simplicity leads to simplifying and optimizing the analytical procedures by reducing the number of operations or, for example, by selecting a particular system of representation. Complying with such a need ensures, as far as possible, the economy of semiotic theory.

the plane of expression or the plane of content, and therefore recognize the necessary constitution of an initial difference. Then, subsequently, the features that constitute this initial difference will come to be seen as having been relevant only at a relatively superficial level of meaning, if only because we will, by then, have established a parallel, but more fundamental, level; a more invariant level; one which can be considered as the level where the dynamic coherence of the totality in question is located.[14] This totality is a life – or rather two lives in the case of our twin story. In other cases it might be it a work, a look or a gift, and so on.

Considering this concept of the recognition [*reconnaissance*] of identity, we might ask whether, by the same token, the production of an identity – and not just its recognition – also corresponds to a similar operation. Indeed, if we accept that recognition is a cognitive act, the subject of which is a passive receptor [*récepteur*] – or better a reader/receiver [*énonciataire*] because what is received has the character of an enunciation or statement [*énoncé*] – it seems legitimate to suggest that the construction of an identity is also a cognitive operation; and, in this case, its subject will be an active speaker/sender [*énonciateur*]. But more than this, we will attempt to show that this cognitive operation is, again, a meta-semiotic operation. The following essays will largely be given over to arguing for and illustrating this thesis. Each shows in a different way the links between the construction of identity and the enunciative activity of bricolage, the meta-semiotic nature of which has been identified by Lévi-Strauss.

But for now let us emphasize that – at least in our approach, that is to say, in a structuralist semiotic approach – identity is always differential, whether in its production or its recognition. Identity is differential on two accounts. First, this is because there can only be identity in relation to difference. Second, it is because every identity relies on the meta-semiotic operation we examined above which calls for an analysis of the signs that constitute the primary material of that identity; an analysis which examines the relationships between either the expressional units or the content units of the signs in question.

The reader will have understood from this that I am hereby confining myself to a substantialist approach to identity, inspired by the psychological and sociological disciplines. The following psycho-sociological account is, I believe, a good example of a substantialist approach:

> we will see that a social agent's identity is more than just a list of exterior and objective referents designed to answer questions about who that social agent is.

14. On these two stages of identification conceived as a meta-semiotic operation, see E. Landowski, 'Quêtes d'identité, crises d'altérité', in S. Artemel and D. Sengel (eds), *Multiculturalism and the Crisis of Difference: Proceedings of the Colloquium 'A Common European Identity in a Multicultural Continent'* (Istanbul: Bogaziçi University, CECA, 1993).

To these material referents we will need to add psychological and cultural referents – and also psycho-sociological ones – because a social agent is not a mere object without self-being or without relational being.[15]

Moreover, we must insist on the fact that our approach to identity is a generative one, for identity is defined by its mode of production; that is to say, by the process of increasing complexity which, precisely, causes it to become an 'object of meaning [*sens*]'. It is therefore not its mere genesis – technical, psychological, or other – that will be considered here.

The story of the twins was a clear enough illustration of this; identity is linked to the idea of a course of action [*parcours*]. The Waterman advertisement told of the respective social courses of two men and led to the recognition [*reconnaissance*] of a more remarkable and a more submerged course: a course that progressively traced the intersections of their double destiny. Identity is, then, to be analysed via a syntagmatic approach: that is to say, by considering oriented or 'horizontal' proceedings and chains of events, and by deriving from them isotopic elements that can either remain in parallel with one another or else end up being combined as one. Again, these are semiotic processes that become recognizable after the fact.

Identity, approached in this way, is the result of progressively connecting units or 'quantities' that are disconnected at the outset of the analysis: different locations, different universes, different characters and the rest. So it seems that identity can be constructed or recognized on the basis of such relays or on the negation of an initial discontinuity. Following the philosopher Michel Serres, it is therefore possible to find some exemplary topological images of identity in the metaphors of the bridge and the pit:

> The bridge is a path connecting two river banks; it makes a discontinuity continuous. It straddles a fracture. It stitches up a gap. The river meanders like a snake along its course [*parcours*]; it is not a space for transport. Hence, there is no longer one space, but rather two spatial variations without a common boundary. ... Communication breaks down: but, in a startling way, the bridge restores it again. The pit is a hole in space, a local breach in a particular variation. If it lies in one's path, it can hold up one's journey – the traveller falls the fall of the vector – but it can also connect variations that happen to pile up inside it: leaves, leaflets, geological formations. The bridge is a paradox: it connects that which is disconnected. The pit is an even greater paradox: it disconnects that which is connected while also connecting that which is disconnected.[16]

15. A. Mucchielli, *L'Identité* (Paris: Presses Universitaires de France, 1986), pp. 5–6.
16. M. Serres, 'Discours et parcours', in *L'Identité* (seminar directed by C. Lévi-Strauss, assisted by J.-M. Benoist) (Paris: Presses Universitaires de France, 1983), p. 28.

These images of the bridge and the pit could, perhaps, be dangerous stereotypes, obvious universals. But they are interesting because they suggest a way of thinking about the connecting principle at the heart of the syntagmatic dimension of identity. Moreover, they leave behind ideas of tension and orientation inherent in the notion of identity. Serres actually uses another example that is a perfect expression of that tension: the stories [*récits*] of great travellers such as Ulysses, Oedipus and Gilgamesh. Via these examples, the philosopher presents his hypothesis about the distinction between course [*parcours*] and discourse [*discours*]:

> Space – that discrete unity revived indefinitely or by repetition along its discursive sequence – is not a theme of the Odyssean cycle. The plurality of disconnected spaces, all of them different, is the original chaos, and this chaos is the condition for the series by which they are assembled. Ulysses's voyage, like that of Oedipus, is sheer 'par-course' [*parcours*]. And it is also discourse. This is how I will use the prefixes from now on. This is not the discourse of a par-course but, radically, the par-course of a discourse: the course [*cours*], the *cursus*, the way, the path, that which passes through the original disjunction. ... The map [*carte*] of the voyage proliferates with original spaces; the spaces are completely disseminated; they are where everyone is, here and there, now and then; everyone may be determined in these ways, so that any global wandering, any mythical adventure, is, in the end, nothing but a general connecting-up. It is as if the purpose or goal of discourse were to only connect. Or is it that the connection, the relationship, the *rapport* was itself the way by which the first discourse travelled? Muthos, first logos; transport (of delight), first relationship, first *rapport*. Connecting: the condition for transport.[17]

Lévi-Strauss was astonished when, on the occasion of this presentation, Serres proposed that 'culture is designed to disconnect and reconnect spaces'. It was an opportunity for the anthropologist to recall the conclusion to his Parsifal myth-analysis: 'that every myth tries to solve a problem of communication and that, in the end – because myth is overwhelmed by the number of possible connections to be made, by the sheer complication of the graph – every myth is a means to plug in and unplug relays or connections'.[18]

In the following essays, we shall often return to these ideas of non-discontinuity, connection [*connexion*] and connecting [*raccord*]. We will show that visual identities imply such forms of sequencing. And we will see that these forms are not necessarily linked to a story's linear unfolding but, rather, that they are founded upon general topological devices – which we can call 'collocations' – such as imbrication, transversalization and circumscription. However, to

17. *Ibid.*, pp. 34–5.
18. C. Lévi-Strauss, in *ibid.*, pp. 40–1.

answer the question of whether this is a *necessary* condition for the establishment of visual identities would require many more concrete semiotic analyses than this collection alone can offer.

Still, the story of the Waterman twins is a rather good general introduction to the problematic of identity considered as a dialectic between inertia and tension. On the one hand, there is the inertia of what has already been acquired (the weight of habits) and the effectiveness of our habitual ways of recognizing ourselves and making ourselves recognizable. On the other hand, there is the tension of a lifetime's project: the full realization of the self and the problem of having to choose certain values – choices that can unsettle one's very existence. On one side, the preservation of continuity; on the other, perseverance and consistency. On one side, that through which we are recognized; on the other, that by which we are driven.

And so identity must be considered as a dialectic between 'character' and 'truth towards others' [*parole tenue*]. This is a reference to Ricoeur's concept of narrative identity. He places narrativity [*narration*] at the core of the problematic of identity not only because 'in many stories [*récits*], the self looks to the level of the whole life for its identity', but also because, according to him, 'no story is ever ethically neutral'.[19] And, for Ricoeur, the ethical dimension is part of one of the fundamental principles of identity: 'ipseity'. We will return to this shortly. For now, let us remind ourselves that if the 'I' of the Waterman letter had been able to recognize his identity, it would have been precisely because he had considered his and his brother's 'course' at the level of their whole life; or at the least at the level of a life lived sufficiently for him to see his identity as being predicated on an ethical twinship (as opposed to a natural, genetic one).

Let us return now to the ideas of 'character' and 'truth towards others' [*parole tenue*]. Character, says Ricoeur, is the 'what of the who'.[20] It is the set of ongoing dispositions that enable us to recognize someone; it is the set of distinctive traits, habits, and acquired identifications which become definite dispositions. The character is fundamentaly linked to permanence through time, to a sedimentation 'that tends to cover and, to some extent, abolish innovation'. Truth towards others [*parole tenue*] is the polar opposite of character.

> Truth towards others (and therefore to oneself), by contrast with character, speaks of a bearing that resists any inscription in a general dimension, but rather inscribes itself exclusively in the dimension of the 'who?'. Here also, words can be a good indication. Preserving one's character (self-control) is one thing; persevering in loyalty to the word one has given [*parole donnée*] is another. Continuity of character is one thing; consistency in friendship another.[21]

19. P. Ricoeur, *Soi-même comme un autre* (Paris: Seuil, 1990), p. 139.
20. *Ibid.*, p. 147.
21. *Ibid.*, p. 148.

Truth towards others may seem to involve a logic of continuity, perhaps even more so than character. In fact nothing could be further from the truth: for it is on the side of innovation and change because it is concerned with an ethical purpose and therefore − a requirement that can sometimes lead to a breach − it can mean rejecting dispositions that seemed utterly durable.

We are reminded here of Walter Bonatti. The life of this Italian mountaineer is, for us, perhaps the best example of such a breach. During the winter of 1965, after achieving many firsts that had already led him to recognition as one of the leading figures in the history of mountaineering, Walter Bonatti set out alone to climb the northern face of the Cervin and achieved an 'absolute first': a new route up the north face, the first solo climb, the first such climb in winter. On his way down he announced that he would retire from mountaineering − which he did. He became a reporter and a writer and got involved in other adventures. In this sense, he abandoned his sameness for the sake of remaining himself.

But, to keep to our own path, let us now return to the philosophical high ground. For Ricoeur narrative identity is an interval, or rather a temporal mediation between character and truth towards others [*parole tenue*]. And these poles of differential temporal permanence represent the opposing modes of articulation of the two great principles of identity: the *idem* and the *ipse*. The *idem* is the same, as opposed to the variable and changing *ipse*. *Idem* actually refers to the notion of permanence through time itself. The *ipse*, on the other hand, is not associated with this idea: rather it is associated with the ethical foundation of the self and with its relation to the other. Hence, for Ricoeur, we should think of narrative identity as the 'specific mediation [*médiété*] between the pole of "character", where *idem* and *ipse* tend to coincide, and the pole of "preserving oneself" or "self-control" [*maintien de soi*], where "ipseity" frees itself from sameness'.[22]

Narrative identity is therefore located in the middle of a spectrum of variations running between character and truth towards others [*parole tenue*]. The schema on the following page represents the articulations between the various notions that allow Ricoeur to define his concept of narrative identity.

It might be said that this kind of philosophical thought is too far removed for our purpose, and that it is indeed an abstraction with little bearing on the concrete matter of visual identities. But I would argue that the opposite is true. This is simply because the opposition between character and truth towards others [*parole tenue*], and its mediation through the story's own temporality, was actually at the core of our Waterman story. Indeed, by placing the brothers' lives in an overall scheme, a connection was made; a connection between times and

22. *Ibid.*, p. 13.

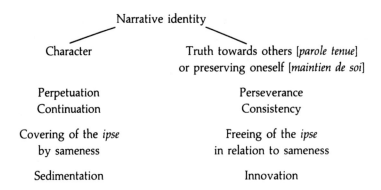

Narrative identity

Character | Truth towards others [*parole tenue*] or preserving oneself [*maintien de soi*]

Perpetuation | Perseverance
Continuation | Consistency

Covering of the *ipse* by sameness | Freeing of the *ipse* in relation to sameness

Sedimentation | Innovation

places, between professions and statuses. And it was through a particular narrative structure that a mediation could eventually be established between the initial differences or discordances and the final similarity or concordance. The *ethical* twinship of the two boys could only be factually established by the totalizing force of what Ricoeur calls the 'synthesis of the heterogeneous' affirmed by the story [*récit*] and its eventual closure.[23]

But this concept of identity in Ricoeur is not just valid in the case of the Waterman advertisement. In its way it foreshadows, via its central concepts of 'time' and the 'subject', our own visual identities' problematic, even if the latter is much more associated with the concepts of 'space' and 'work' [*oeuvre*]. We will also encounter the structuring force of closure and the idea of a 'synthesis of the heterogeneous' in the Lévi-Straussian concept of bricolage. This too offers a dynamic articulation between signs and structure: blocks 'pre-stressed' by custom and the totality of meaning [*signification*].

Finally, we will again encounter in the concept of bricolage the opposition between sedimentation and innovation in the specifically semiotic concept of *enunciative praxis*. For this can be defined as an instance of mediation between set canonical forms of discourse on the one hand and, on the other, the original meanings [*significations*] that can be produced by a speaker and that can constitute them as a unique subject.

23. *Ibid.*, p. 169.

2

IBM and Apple's logo-centrism

Like any other identity, visual identity can, in the first instance, be defined in terms of both difference and continuity. Visual identity means *difference* because it ensures the recognition and proper positioning of a commercial enterprise and because it is an expression of the company's specificity. On the other hand, visual identity means *continuity* because it testifies to the ongoing industrial, economic and social values of the company. Continuity cannot be seen here as mere repetition but rather as a kind of 'becoming' with its own logic and directional sequence. In more semiotic terms, identity can be conceived or perceived along the two axes of 'system' (paradigm) and 'process' (syntagm). This dual dimension is implicit in the demands made by companies on their design agencies and semiotic consultants. The primary goal of these service providers is to invent (or reinvent) the expressive traits and the consistency of content which, on the one hand, ensure the expression of the company's 'texture' [*aspérité*] − a paradigmatic concern, as it were − and, on the other, make it possible to recount its 'mission' [*projet de vie*] − a concern which can be considered syntagmatic.

The well-known logos of the two information-technology giants IBM and Apple are perfect illustrations of how corporate design is a matter of both difference and continuity. The purpose of this chapter is not to analyse the design parameters that give rise to these visual identities; nor is it to examine their style guides. Rather I want to examine the principles of difference and continuity, referred to above, by moving beyond the logos' moments of production and looking at them not from a technical point of view but from the point of view of their meaning. I want to show that, while the construction and affirmation of a visual identity must obviously obey institutional, commercial and technical necessities and constraints, they must also be subject to specifically semiotic laws or, if one prefers, to the general conditions for the production of meaning.

Let us therefore focus on the analysis of these two logos as *signs* − or more appropriately as *visual statements* − which are integrated into the respective

corporate discourses of these two information-technology companies. The explication of the semiotic conditions establishing the relation between signifier and signified will lead to a possible comparison between corporate design and other meaningful practices, other visual semiotics, that seem to be far removed, in both time and space, from this particular form of design.

Visual invariants of the IBM and Apple logos

Let us first consider the IBM logo, the older of the two. The first version of this logo (Figure 1) – which was solid rather than striped – was created in 1956 by the graphic artist Paul Rand using only the initials of the company name: International Business Machines. A typographer by training, Rand, who had worked initially for *Esquire* magazine and later for the Bill Bernbach advertising agency, was working at the time with the designer Charles Eames and the architect Elliot Noyes. His project was to create the kind of global visual identity that IBM chairman, Tom Watson Jr, wanted for the company.

Rand designed an original Egyptian font for the three letters. Indeed, we can notice that the 'I' and the 'M' display the characteristic rectangular 'feet' of the Egyptian font but also that these 'feet' are asymmetrical in relation to the 'legs' of the letters (Figures 2 and 3). Moreover, the 'eyes' of the 'B' are not rounded, and the width of the 'M' has been modified in order not to separate the two preceding letters which are of different widths. The fact that this logo presents itself as a single block, even though the three letters composing it have quite different visual weights and different rhythms, is not the least of its achievements.

By 1962 Rand came to draw the three letters with horizontal stripes, thereby establishing its current look (Figure 4). Here, his purpose as a graphic artist was to increase the impact of the logo and to turn it into an expression of speed and efficiency.

Figure 1

ABCDEFGHI

JKLMNOPQ!

Figure 2

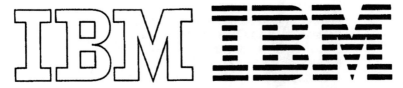

Figure 3 **Figure 4**

Even a non-exhaustive list of the various versions of the IBM logo will show that there are a number of variations which are essentially effects of changing the number of stripes and the use of either the positive or the negative form.

– The logo has thirteen stripes on corporate stationery (business cards and legal documents, for example) and eight stripes on commercial and advertising documents (such as leaflets and advertisements).

– Moreover, because of the optical factors involved in readability, there are positive and negative versions. Let us have a closer look at these two versions. The fourth band from the top of the letter 'M', on the inside corner, is treated differently: it is cut in the negative version, whereas it is only indented in the positive. Also, the relationship between light and dark stripes is different: the height of the light stripes is less than that of the dark ones in the negative version while the dark stripes are taller than the light ones in the positive version (Figures 5 and 6). The IBM logo, then, has different instantiations, thereby increasing the recognition of its 'visual invariants', to use a term coined by the painter André Lhote.[1] The consistency arises from the logo's general configuration, its chromatic consistency and its form.

1. A. Lhote, *Les Invariants plastiques* (Paris: Hermann, 1967). Here we take this expression in a sense which is different from that given by André Lhote. For the painter the visual invariants are both of a descriptive and a normative order: these are recurrent characteristics with no consideration of place or time and which constitute the essential aspect of the texture of the great works of the 'land of painting'. These recurrent traits are also, for the painter, absolute values, 'truths', that a good painter must respect. But they 'are only encountered in a pure state in some rare, austere and

The positive and negative versions require different
forms of reproduction and are not interchangeable.

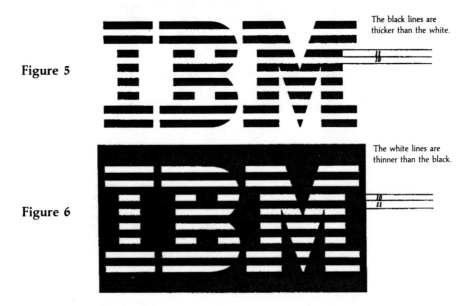

Figure 5

The black lines are
thicker than the white.

Figure 6

The white lines are
thinner than the black.

An optical effect that is common in photography changes how a
line is perceived according to its treatment: as black on a white
ground or, vice versa, as white on a black ground. To balance
this perception, it is necessary to reduce slightly the width of the
white lines. This is what is done with this particular logo.

– The alignment of the three letters constitutes a rather complex ternary
configuration: a kind of triptych – even though, once again, Rand was sure to
avoid visually separating the three letters.

– The stripes create a repetition of the a-b-a-b type that is made of thick,
horizontal, distinct, monochromatic lines. Notice that the IBM logo is
fundamentally conceived as monochromatic while the corporate colour is bright
blue and that the association between IBM and this colour is so strong that the
company itself is known as 'Big Blue'.

– As far as form is concerned: this derives from Rand's Egyptian font and
from the significant boldness of the body of the three letters. Here, form is
characterized by strength and angularity.

cont.
Spartan works; in this case, they are blindingly obvious'. As far as I am concerned, visual invariants
only reveal the descriptive approach. They are differential and recognized traits; and they are so
because of their variables of realization, because they are prone to being traits relevant to the form
of expression of a visual identity.

So much for the 'visual invariants' of the IBM logo. Let us now turn to the Apple logo (Figure 7). Designed in 1977 by Rob Janov, the artistic director of the McKenna agency, the logo was adopted by the company and often strongly defended within the company by Steve Jobs himself.[2] The idea of a multicolour logo was a bold one. The cost was considered prohibitive, especially for a design for everyday use on letterhead. But this logo, and the quality of finish that it implied (a quality that Steve Jobs wanted precisely to convey), eventually replaced the company's first logo. That is, in 1975, Ron Wayne, Jobs' former colleague at Atari, had already designed a logo for Apple (Figure 8). In a style reminiscent of a 'Dungeons and Dragons' card, it showed Newton under his apple tree.

Figure 7

2. See the remarkable work – very precise and very well documented – by Jeffrey S. Young on the 'underlying aspects' of the information revolution in Apple's early years: *Steve Jobs, un destin fulgurant* (Paris: Micro Application, 1989).

Figure 8

It is interesting to focus on some of the more striking differences between these two Apple logos. First of all, the bitten apple as drawn by Janov seems to search for some form of credibility; the presumptuous comparison with one of the greatest scientific minds of all times, and the reference to painting and book illustrations, having been dropped. Moreover, even without yet mapping the contents of the new logo, we notice that it is significantly simpler than the Newtonian vignette (a seventeenth-century man, in the countryside, reading a book, under a tree with an apple on one of its branches). The rainbow apple, minus bite, has the advantage of being much easier to read.

Finally and most importantly, the apple drops the narrative character of the Newtonian vignette. The first Apple logo shows the episode which, legend has it, led to the English physicist and astronomer's stroke of genius. It is a pictogram, in the anthropologist André Leroi-Gourhan's sense of the term. The

picture suggests a 'before', a 'during' and an 'after'.[3] By contrast, the bitten apple appears to be a mythogram: it does not imply a linear narrative, even if — as we will see — it is composed of fragments from our cultural history which are themselves narratively derived. This apple assembles and articulates two symbols each with its own narrative origin: a tale of disobedience, and a tale of renewal. These narrative origins somehow neutralize and fixate each other by virtue of their co-presence [*cohabitation*] and interweaving. On several occasions in this book, we will come across this same process of de-temporalizing (or effacement of time) through the compounding and collocation of signs (in particular in Chapters 4 and 5). But let us return to the visual invariants of the current Apple logo.

This logo is quite astonishing because its own visual characteristics appear to be the result of deductive reasoning based on those of the IBM logo. That is, the characteristics seem to come from a systematic inversion of those of the IBM logo.

– The shape of the apple gives the logo a relatively simple appearance. Even the 'leaf' is inscribed within its overall shape; it is not a truly autonomous visual entity. So, unlike the IBM logo's triptych form, the Apple logo is not strictly a diptych.

– The shapes of the fruit and its leaf are made up exclusively of curves. The curves dominate and, where there is a break in the contour, it is never truly an angle, much less a right angle.

– The outline of the apple surrounds a particular form of chromatic sequence: it is non-repeating and is made of joined polychromatic stripes. (We will remember that the IBM logo is made of separate monochromatic bands.) Furthermore, the non-repeating chromatic pattern is structured as a reversal: it is an a-b-b-a sequence; vertically, the cold colours open and close the sequence. The question of the *figurative* dimension of the logos is dealt with below (see pp. 54–8), but we can already note that the chiasmic organisation of the rainbow in

3. This is how Leroi-Gourhan defines the pictogram in contrast to the mythogram in *Les Racines du monde* (Paris: Belfond, 1982), p. 64: 'What characterizes the pictogram in its relationship to writing is its linearity as is the case in the sequential alignment of the phases of an action. ... We can even extend this to an action where the gesture evokes the passage of time, as one sees it in Lascaux: the man overturned by the bison is a pictogram, that is to say, an image which has a past, a present and a future. ... The mythogram, by contrast, does not present the successive states of an action but the non-linearly structured characters who are the protagonists of a mythological event.' In Australian Aboriginal painting, for instance, many texts are simple mythograms where one presents a character and, next to this character, a spear, a bird or another character; these specimens aligned next to each other or fused together in a general motif are mythological. They rely solely on an oral tradition.' Regarding the existence of mythograms in contemporary visual discourses, see my analyses of a poster for Urgo and the publicity for the Presses Universitaires de France in J.-M. Floch, *Petites mythologies de l'oeil et de l'esprit* (Paris and Amsterdam: Hadès and Benjamins, 1985); and *Sémiotique, marketing et communication* (Paris, Presses Universitaires de France, 1990).

the Apple logo is quite remarkable. It is a disorderly version of the colours of the rainbow. Traditionally, the rainbow is represented by a sequence of polychromatic bands going from warm to cold colours, or vice versa. Indeed this is how company logos, such as Steelcase Strafor's or NBC's, and regional council logos, Lorraine's for example, use the rainbow symbol (Figures 9 and 10).

– In the Apple logo the warm colours are privileged, at the centre of the configuration. And there are more warm colours than cold – violet, red, orange and yellow, as against blue and green. And, above all, the warm colours are where the eye comes to rest because of the interruption in the overall form caused by the bite.

To conclude this analysis of the visual invariants of the Apple logo, it must be pointed out that they involve some problems of actualization. However, by contrast with the IBM logo, these problems have to do with production rather than perception. The contiguity of the differently coloured stripes requires greater technical precision during printing. Such precision is difficult to achieve with certain kinds of industrial process. So it is undeniable that the contiguity and polychromaticity of the Apple logo are expensive to achieve. It is as if Steve Jobs had grasped – intuitively perhaps – the importance of the visual invariants

Figure 9 Figure 10

of his logo and that he had therefore backed the idea, if not the systematic use, of that contiguity and that polychromaticity against all odds.[4]

Seen from a strategic angle, by changing its logo to the bitten apple the Apple company clearly identifies its adversary and openly admits its ambitions. By adopting a true logo which is simple and strong, and by incorporating a lined motif along with systematic reversals of the visual invariants of IBM, Apple faces 'Big Blue' with defiance. Furthermore, by affirming its identity in this way Apple also delimits the identity of its adversary by positioning both companies within a single discourse. Before turning to the 'messages' that these logos are supposed to convey (in accordance with the respective cultures of IBM and Apple), let us use the following diagram to show both the inversions and the symmetry of the visual invariants discussed above (Figure 11).

	IBM	APPLE
Structure	• complex configuration • repetition (abab) • disjoined lines	• simple configuration • non-repetition (abba) • joined lines
Colour	• monochromatic • cold	• polychromatic • warm
Forms	• substance ('bold') • straight	• outline • curved

Figure 11 Inversions and symmetry of the visual invariants of the IBM and Apple logos

The 'messages' of the two logos

So far I have tried to identify the different visual aspects of the IBM and Apple logos, using the hypothesis that these logos are signs. But in doing so the aspects of these signs as *signifiers* have not yet been established. That is, if a signifier exists only in relation to a signified, then we need to address the question of the *content* of the logos. To make this quite clear, we might say the following: to examine the visual qualities of a logo, an object or an image with

4. The work of J.-S. Young provides a number of testimonies to Steve Jobs' innate sense of design – that is, of course, if one can refer to an innate sense in relation to design! It turns out, in any event, that it was indeed Steve Jobs who both strove for coherence between the principle behind Apple's products and their sensory manifestation and strove, for instance, for the 'finished look' of their exteriors as well as the precision of their interior workings, along with the general shape and the use of plastic; not to mention that he was the originator of the name 'Apple'.

the greatest possible degree of attention does not yet imply that we have analysed the *purpose* of their expression, their signifier side – even if we were sure to work only with the invariant and differential qualities of these objects of meaning. Therefore, the visual invariants of the logos from IBM and Apple can only be considered in terms of their respective signifiers once the analysis of their messages has been completed and the connection between these invariants of expression and the semantic units underpinning the contents has been established by what is referred to as 'commutation'.[5]

We must also be quite clear about the following matter: in this study we are interested in understanding the role and value of the logos within the particular cultures of IBM and Apple. These two logos are, in the context of this approach, two signs among the set of verbal and non-verbal signs used by the companies to talk about themselves to themselves, just as much as to others. This is why the samples are treated here as an integrated set which is as important and as representative as possible of the corporate and advertising documents used by these two companies.

Within necessary limits I decided to compile a file, somewhat similar to the file an anthropologist might compile on the ritual objects he or she intends to analyse, by collating all possible information about the techniques used in the manufacture of the logos, their usage, and the myths that can account for their origins. I did not approach the content of the logos through what they may 'say' (or suggest) to whoever might happen upon them; neither did I attempt to establish a list of their connotations, absolute or *sub specie aeternitatis*; nor did I attempt to collect, qualitatively or quantitatively, the resulting meaning of these logos for a population or a target audience (a narrow or broad sample). But the collection of samples of corporate and advertising discourses from the two companies does include, as for most instances of discourse, aspects of the companies' 'philosophies', accounts (which are rewritings) of their social and cultural origins, as well as presentations of their results and their projects. The logos are systematically associated with these elements; elements which contextualize them and so give them their meaning and their value. And, finally, there are discursive practices which express the values conveyed by the logo, each representing a number of 'internal' interpretations.

5. Commutation is a notion central to semiotics. It is indeed 'the explanation of the cohesion – or the co-presupposition – between the plane of expression and the plane of content (of a language) according to which a change in content must correspond to a change in expression and vice versa'. See A.-J. Greimas and J. Courtés, *Sémiotique, dictionnaire raisonné de la théorie du langage*, vol. 1 (Paris: Hachette, 1979), p. 48. Methodologically, commutation is the procedure of recognition of the discrete units of one or the other plane of the language being studied.

It is normal practice in the case of, for example, the blueprints for a newly launched logo or the styleguide for a visual identity to have a preliminary text setting out the basic corporate values. From such documents, both internal and external, published by IBM itself about its logo, we can discover that the company stands by its 'leading edge technology', its 'competency' and the 'high quality of service' it delivers to its customers. These are also the values underpinning the commercial and promotional profile, always signed, as it is, with the blue logo. Similar documents from Apple, on the other hand, indicate that the bitten apple is the embodiment of all things 'alternative'; in opposition to IBM, Apple has always presented itself as the different way of thinking about information technology, as well as about 'creativity', 'conviviality' and 'freedom'. Here 'conviviality' defines the relationship of the user to his or her computer, and individual 'freedom' tells the little Promethean story of Apple's victory on behalf of everyone [*au profit de tous*].

An initial comparative analysis of the messages conveyed by the two logos enables us to identify their narrative dimension. In effect this is a question of progress and upheaval, of performance and competence, and of values – quality of service for IBM, freedom and conviviality for Apple. Also, roles are allocated, so that the history of information technology comes to include its positive heroes and those happy to benefit from their prowess.

On closer inspection, we notice that both the IBM and the Apple accounts rely on the articulation of two distinct narrative programmes: a conceptual programme and a programme of commercial transaction. In the first programme both IBM and Apple are subjects of discontinuity in the history of information technology: for IBM, one or more 'leading edge advance(s)'; for Apple, an 'alternative'. The performance of each of these is associated with a corresponding competency: IBM directly refers to 'competency' – in the common use of the term – while Apple refers to 'creativity'. The second narrative programme, on the other hand, brings in another subject to which a further role is allocated: the client-user. This programme can be analysed as communicating the object of value constructed by the previous programme; the value of 'service' in the first instance, and values of 'freedom' and 'conviviality' in the second.

1984 and *1984*

We will return to the obvious differences that already exist between the IBM and Apple stories (see p. 52) but, for the moment, one can only be struck by the narrative similarities in the two logos' messages. Both give accounts of:

- the production of added value;
- a contribution to the history of information technology;

- commercial transaction; and
- client benefit.

Both give accounts of the origin and acquisition of the cognitive wealth represented by computers and information technology. One might argue that this is a rather banal corporate discourse. In fact the study of many logos in various sectors has convinced me that this is not the case. For not all logos develop narrative programmes of such complexity and not all logos define the company by emphasizing the discontinuity that their activities have caused in their sector. Put another way, not all logos glorify a progressive or revolutionary spirit. Some in fact glorify permanence and historical fixity.

This similarity is particularly puzzling because, as we have already noticed, the visual invariants of the two logos involve inverted symmetry. Going from IBM to Apple culture, we find ourselves in the presence of an inversion of the *differential* visual traits of the logos but, conversely, we recognize that their narrative contents are *identical*.

This becomes even more remarkable if we turn to descriptions of Apple culture and to analyses of the company's 'total communication'. Indeed, in order to test the connection between the visual invariants of the Apple logo and its 'message', and in order to establish these as signifier and signified respectively, we might consider the expressive traits that correspond, in the Apple discourse, to a painful story of perpetuity in a universe where humanity is exposed to the *absence* of freedom and conviviality. In other words, we could ask: how does Apple represent such a world, a world that would be an instance of those very values which Apple itself opposes? To be even more precise, what general configuration, what colours, what forms convey Apple's anti-world?

We can answer this question by collecting together as many documents as possible about Apple and by examining, amongst other things, the visual material and the films which are most representative of its communication. There is indeed a quite famous film in the short history of Apple, involving the 1984 launch of the Macintosh, then the jewel in Apple's crown. To this day this product remains the incarnation of the Apple spirit and stands for its contribution to the history of information technology.[6]

In its opening sequences the film shows rows of people, heads shaven, marching despondently through tunnels that join big grey buildings. Each one of these people looks straight ahead, with an empty gaze. All end up sitting on parallel benches in some kind of hall or nave, eyes now riveted to a giant screen (Figures 12 and 13). On the screen, with its blue cathode stripes, we see the malevolent face of some sort of supreme Leader. One is, of course, reminded of

6. The Apple film *1984* was conceived by the American agency Chiat Day and directed by Ridley Scott.

Big Brother and George Orwell's *1984*. The Leader is in the middle of a long speech. The audience listens, without any semblance of reaction. But then an athletic young woman, pursued by faceless guards, comes running up, armed with a sledge-hammer. She is blonde and shapely; she wears red shorts and a tee shirt showing a colour drawing of the Mac (Figure 14). She manages to throw her hammer at the screen so that it implodes. The formidable impact of the implosion reaches the people in the audience who, mouths agape, fade into the grey surroundings. And, in the frames preceding the appearance of the Apple logo, we read: 'On January 24th, Apple Computer will introduce Macintosh. And you'll see why 1984 won't be like *1984*.'

Figure 12

Figure 13

Figure 14

Now it is possible to see how the visual invariants of the IBM logo are included in the Orwellian universe of the film:

- The rather complex configuration that characterizes the IBM logo is present in the exterior aspects of the totalitarian city.
- The lines of people with shaved heads and uniform clothes, the repetitive accentuated steps, the serried rows in the large video hall, are all so many repetitions of the same type of disjointed unity.
- Finally the viewer is also confronted by the same monochromatic coldness and the same dominant straight lines: tunnels, buildings, the walls of the hall, the alignments, and so on.

By contrast, the young woman forms a unique shape [*silhouette*]. Her body and her curves are clearly emphasized in a number of shots. Moreover, her shorts are bright red and the coloured lines of the Macintosh drawing are clearly visible. We recognize therefore, in the very shape of the young woman herself, the visual invariants of the Apple logo.

A strange semiotic phenomenon

If we now consider the totality of the relationships and the system of transformation inscribed both in the Apple logo and the *1984* film, and in the IBM logo, we notice a strange semiotic phenomenon. Indeed, when the message is maintained — as with the double narrative programme developed by both the IBM and the Apple logos — the *visual invariants* defining the configurations, the shapes, and the colours are reversed. And, conversely, when the visual invariants are maintained — as is the case when one considers first the IBM logo and then the totalitarian universe described in the Apple film — it is the *contents* of the message that are reversed.

It is possible to see how this play of relationships and transformations causes a semi-symbolic system to develop in Apple's visual discourse.[7] One can indeed

7. Semi-symbolic systems are signifying systems characterized by a correlation between categories concerning the plane of expression and the plane of content. In our culture the classical example of semi-symbolism is that of the correlation between the category 'verticality vs. horizontality' of head movements (a category of expression of gestural language) and the category 'affirmation vs. negation' (a category of the plane of content).

Expression:	verticality vs. horizontality
Content:	affirmation vs. negation

For an introduction to the problematics put in place by this type of signifying system, see 'Semi-symbolique' in A.-J. Greimas and J. Courtés, *Sémiotique, dictionnaire raisonné de la théorie du langage*, vol. 2 (Paris: Hachette, 1986), pp. 203–6.

establish a correlation between, on the one hand, certain of the discourse's visual categories and, on the other hand, certain semiotic categories that organize its underlying contents:

complex configuration	vs.	simple configuration
cold monochrome	vs.	warm polychrome
straight shapes	vs.	curved shapes
repetition of identical units	vs.	a non-repeated shape

servitude	vs.	freedom
perpetuity	vs.	before/after

But this is not the most interesting point. For there may be something more interesting coming to light in this analysis of these information technology logos. This is the same 'remarkable phenomenon' observed by Lévi-Strauss when trying to describe masks from two native American communities from the North-west Coast!

In *La voie des masques*, he stresses the 'almost physical link' he developed with the art of North-west America during the time he worked there, and the many questions he had about the style and shape of certain masks. The book starts with an affirmation of the general heuristic value of the structuralist approach:

> I could not answer any of these questions until I could understand that masks, like myths, cannot be interpreted in and of themselves, as if they were separate objects. Envisaged from a semantic point of view, a myth only gathers meaning once it is placed within the group of its transformations. Similarly, one type of mask, considered only from a visual point of view, replicates other types: it transforms their shape and their colours in establishing its own individuality. For that individuality to stand in opposition to that of another mask, it is necessary and sufficient for the same relationship [*rapport*] to exist between the message the first mask is intended to transmit or denote and the message that the other mask is supposed to convey.[8]

Lévi-Strauss first sets out to recognize the visual invariants of the so-called *swaihwé* mask which, throughout the cultural area under study, was considered to bring good fortune and to assist in the acquisition of wealth. It is a mask adorned with feathers and is predominantly white. It is also characterized by bulging eyes and a wide-open mouth from which an enormous tongue protrudes (Figure 15). After a long and detailed analysis of the myths of the origins of the *swaihwé* mask, he shows that, from a semantic point of view, it has a double affinity: with fish on the one hand, and copper on the other. We will return to this double affinity later (see p. 52).

8. C. Lévi-Strauss, *La voie des masques* (Paris: Plon, 1979).

Figure 15 **Figure 16**

But, further on, in order to understand the *raison d'être* for these traits, and so as to establish them as a system, Lévi-Strauss comes to recognize the same mask among the Kwakiutl, neighbours of the Salish. They have a mask with the same visual invariants, the same name (*xwéxwé* or *kwékwé*), and the same affinities with fish and copper. He then goes on to demonstrate an incompatibility between these *xwéxwé* masks and the wealth of which copper is both an exemplary material and a symbol.

But Lévi-Strauss does not close the book once he realizes that the same mask can fulfil opposing functions depending on the tribe: Salish as opposed to Kwakiutl. He moves on to a proposition — again a very structuralist one — stating that forms, colours and other aspects of the mask cannot be dissociated from those of *other* masks to which it is placed in opposition: 'because [it is] selected to characterize a type of mask which exists, in part, in order to contradict the first one. In this proposition, only a comparison between the two types will make it possible to define a semantic field in which the respective functions of each type will complete each other.'[9]

The anthropologist arrives at the other mask by deduction:

- it must be black or use dark colours;
- its adornments, also of animal origin, must no longer be feathers but fur;
- the eyes must be the opposite of bulging: the sockets must be empty;
- finally, the mouth must hold the tongue back.

9. *Ibid.*, p. 59.

And this mask does indeed exist among the Kwakiutl: it is the mask of Dzonokwa, a fierce giant who holds great wealth which she spontaneously offers to those she protects (Figure 16). The mask of Dzonokwa therefore has the same semantic function as the *swaihwé* mask: it signifies generosity and the source of wealth. By contrast it is the perfect visual opposite. And, in Kwakiutl culture, it stands in opposition to the *xwéxwé* mask which, as we have seen, has the same form as the *swaihwé* mask of the Salish, while having an opposite semantic function.

With this realization Lévi-Strauss establishes the canonical formula for the relationship between correlation and opposition among the two types of mask and the semantic functions assigned by the two ethnic groups: 'When, from one group to the other, the visual form is maintained, the semantic function is reversed, whereas when the semantic function is maintained, the visual form is reversed.'[10] This 'remarkable phenomenon' is illustrated in the following diagram where the plain lines correspond to the visual form and the dotted lines to the message content (Figure 17).

What else have we seen from this comparative analysis of the IBM and Apple logos and from the analysis of the film for the Macintosh launch? We've seen the same phenomenon: from the IBM logo to the Apple logo, the visual characteristics are reversed while the narrative content is maintained. By contrast the Orwellian world of Apple's *1984* film uses the visual characteristics of the IBM logo but does so in order to reverse the semantic value: that is, the film references perpetuity, servitude and loneliness. We can therefore use Lévi-Strauss's graph to visualize the relationship between correlation and opposition that we have discovered here (Figure 18).

| XWEWXE | SWAIHWE | DZONOKWA |
| Kwakiutl | Salish | Kwakiutl |

Figure 17

10. *Ibid.*, p. 88.

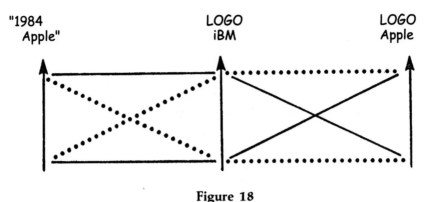

Figure 18

The strange dichotomy between classic themes and motifs in the Middle Ages

It might be thought that the similarity between our two logos and Lévi-Strauss's native American masks is purely coincidental. Then it would be a mere curiosity encountered by chance in the course of one's readings or one's work, something we might collect if we had nothing better to do, somewhat like the nobility and the upper middle classes in the seventeenth and eighteenth centuries who started the trend of 'Salons de curiosités'.

But this is not the case. As we will see later in the case of Chanel's 'total look' (Chapter 4), not only can we find other examples of this same semiotic phenomenon, but well-known researchers apart from Lévi-Strauss, working on materials from other times and cultures, have also observed and analysed the same kinds of correlation and transformation. For instance, in the introduction to his *Essais d'iconologie*, the art historian Panofsky addresses issues raised by Renaissance iconography and iconology precisely as a 'second coming of classical antiquity'.[11] He reminds us that the Middle Ages were by no means oblivious to the beauty of classical art and took great interest in the intellectual and poetic values of classical literature. Panofsky stresses that 'it is significant that at the height of the medieval period, in the thirteenth and fourteenth centuries, classical motifs were never used for the representation of classical themes while, correspondingly, classical themes were never expressed by classical motifs'.[12] Later, Panofsky comes to a conclusion about this phenomenon that is quite similar to ours and Lévi-Strauss's, even though he focuses exclusively on pictorial contents. So the reader might accept that the figurative

11. E. Panofsky, *Essais d'iconologie* (Paris: Gallimard, 1967), p. 32.
12. *Ibid.*, p. 33.

dimension of Panofsky's motifs and the abstract dimension of his themes are in the same relationship of solidarity to each other as are the levels of expression and the contents of a natural language generally.[13]

Panofsky turns initially to the sort of reason that comes naturally to a medievalist: 'If we wonder about the reason for this strange separation, in a non-classical environment, between classical motifs carrying a non-classical meaning and classical themes expressed by non-classical characters, the first explanation that comes to mind has to do with the difference between image-based and textual traditions'.[14] However, this explanation does not stand up to scrutiny:

> Though important, the contrast between the two traditions (one image-based, the other textual) could not by itself account for the strange dichotomy between classical motifs and classical themes which characterizes the art of the Middle Ages. Indeed, even though there was a tradition of representationalism in certain areas of classical imagery, no sooner had the Middle Ages defined a style of its own than the classical tradition of representation was deliberately rejected in favour of a radically non-classical one.[15]

Moreover, Panofsky concludes that 'the separation between classical themes and motifs happens not only because of an absence of a representationalist tradition but in spite of such a tradition'.[16] And he finally suggests that such a separation is linked to the actual identity of medieval culture and to the realization of that identity. This idea is already present in Panofsky's earlier reference to the apogee of the medieval period, to the strange dichotomy '*characterizing* the art of the Middle Ages', to the 'style that was its *own*'. This idea is developed more effectively in the final pages of the book, and precisely in terms of semiotic systems:

> Clearly, an era that neither could nor would accept that classical motifs and themes were co-located within the same structure, did everything it could to avoid furthering such an association. Once the Middle Ages had established *its own ideal* civilization and discovered *its own methods* for artistic expression, it could no longer appreciate or even understand any phenomenon lacking a common denominator with the contemporary world.[17]

13. I have explained this on several occasions. See in particular (a) an analysis of Jünger's novel, *Sur les falaises de marbre*, 'Des couleurs du monde au discours poétique: analyse de la dimension chromatique des *Falaises de marbre* de E. Jünger', *Documents*, 6(1), 1969 and (b) an analysis of such diverse images as a comic strip by B. Rabier and pharmaceutical visual advertisements: in Floch, *Petites mythologies*, pp. 79–80, and *Sémiotique*, pp. 83–118.

14. Panofsky, *op. cit.*, p. 34.

15. *Ibid.*, p. 39.

16. *Ibid.*, pp. 40–1.

17. *Ibid.*, p. 42; emphasis added.

If we have emphasized, in quoting Panofsky's reflections, terms such as 'own ideal' and 'own methods of expression', this is again so as to show that the 'strange dichotomy' he analyses does indeed raise the question of identity, and that reversing or maintaining the signifier or the signified, in moving from one system to another, is among the truly semiotic modes of production of visual identity. It is 'semiotic' in so far as the mode of production directly concerns the relationship of solidarity between the two levels constitutive of signs and of language generally.

Wealth from mines and wealth of mind

Let's return to our logos and Lévi-Strauss's masks. What we can gain from reading *La Voie des masques* goes beyond the mere discovery of a parallel between two logos belonging to information-technology companies and two masks belonging to native American tribes. Indeed the parallelism can be extended if we now return to the little 'myths of the origin' of wealth to be found in the logos' narratives. For isn't information technology an expression of wealth in our society just as copper is for Lévi-Strauss's communities?

Lévi-Strauss's analysis of the origin myths associated with the *swaihwé* and Dzonokwa masks shows that although the narrative structure of their messages confirms our understanding that their semantic functions are identical, nevertheless the definitions of wealth differ significantly between the Salish and the Kwakiutl. For the Salish, copper is of aquatic origin since it is associated with fish; and it is of vertical origin since it is fished or dredged from deep waters. Moreover, it has to do with pieces of native copper. It is the reverse for the Kwakiutl: copper is of terrestrial and horizontal origin, since the Dzonokwa who own it live in the middle of the forest and it concerns ornate copper plates. In these opposite qualities of the copper searched for by the Salish and the Kwakiutl respectively we can see in operation the great axiological disjunction between nature and culture.

This is also how the IBM and Apple cultures define the cognitive wealth of information technology. These definitions are also based on two opposite axiological values, on two different 'philosophies' of knowledge that have been in conflict since well before our technological era. The IBM logo started as an abbreviation and it remains so even when the three letters are crossed by a set of either eight or thirteen lines. This logo reminds us of the numeric mode of representation since it plays on presence and absence, colour and non-colour; but it also reminds us of verbal language and its linear avatar: writing. The fundamentally verbal and linear dimension of the logo is paradoxically the origin of one of the most beautiful IBM images. In 1981, in a poster that worked like a

rebus of the company's philosophy, Paul Rand actually played on the English phonetics of IBM. In order to express the importance of innovation and work to the company, Rand drew from left to right on a single horizontal line: an eye, a bee, and the M with eight bands of the I-B-M logo (Figure 19).

By contrast the Apple logo belongs to the pictorial order and the non-linear assembly of signs: it combines two visual symbols — a bitten apple and a rainbow, and we will return to this later — where one circumscribes the other to give the logo a 'radiating', non-linear presence. Added to this, here the verbal is opposed to the non-verbal and the analogue to the numeric.

From these two epistemic attitudes, in these inversely privileged types of language and discourse, we may recognize two major axes of knowledge sustained throughout the history of Western thinking: the phonocentric (which, from Aristotle to IBM, advocates reason and indirect knowledge of the reality of

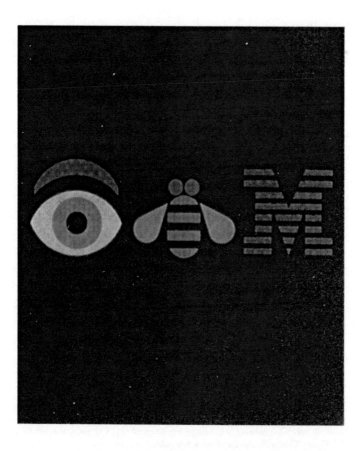

Figure 19

the world through the mediation of verbal language) and the optocentric (which, from Plotinus to Apple, aligns itself with intuition and direct knowledge). The semanticist François Rastier noted, at a conference of the *Association internationale de sémiologie de l'image*, that the American centres for research in cognitive semantics are themselves avatars of these two major traditions.[18] He also notes that the eastern American centres value rationalist thought whereas the western centres value empiricism. If this is correct, then it is rather interesting to remember that IBM has its 'origin' on the east coast and Apple in the west; and so it would be no small semiotic satisfaction to perform such transversal operations on the history of western cultures and the geography of American companies.

'Figuration is never innocent' (Greimas)

Let us now return to the bitten apple and the rainbow of the Apple logo and to the lettering chosen by Rand for the IBM logo. To some extent, this analysis of their figurative dimension was postponed (pp. 39–40). This was because it was not necessary, at that point, to study these logos in terms of their immediate lexicalization. That is, I have always argued for (and, I hope, illustrated on several occasions) the theory that visual works can be revealed as objects of meaning without transposing them into text, 'turning them into speech', as we used to say.[19] So, if we can now legitimately turn to the analysis of the figurative dimension of the two logos this is because the analysis of their visual dimension has already allowed us to define them as signs.

In a piece dealing with the most remarkable instances of visual identity to emerge in recent years, Jean-Louis Gassée, then chairman of the Apple Products Division, said about the meaning of the Apple logo: 'Our logo is a great mystery: it is a symbol of pleasure and knowledge, partially eaten away and displaying the colours of the rainbow, but not in the proper order. We couldn't wish for a more fitting logo: pleasure, knowledge, hope and anarchy.'[20] It is obvious, here, that the figurative reading is a cultural event or, to put it another way, that the perception of readily recognizable images (in a logo in this instance) is always achieved via a personal grid for reading the world, a grid acquired from childhood onwards and specific to one's culture. Therefore, in

18. François Rastier made this remark during the discussion following his address 'Image et langage: peinture parlante et poésie' at the Second Congress of the Association internationale de sémiotique de l'image, Bilbao, December 1992. The proceedings of this Congress are yet to appear.
19. See J.-M. Floch, 'Quelques positions pour une sémiotique visuelle' and 'A propos de *Rhétorique de l'image* de R. Barthes', *Bulletin* (ILF-CRNS), no. 4/5, 1978. Also Floch, *Petites mythologies*.
20. J.-L. Gassée, quoted in *Graphis Corporate Identity*, vol. 1 (Zurich: Graphis, 1989).

noting that the Apple rainbow is not 'in the proper order', Gassée is referring to a coded representation of the physical phenomenon, a representation according to which the chromatic sequence 'normally' starts with the cold end of the spectrum and ends with the warm end, or vice versa – but never appears as it does in the chromatic chiasmus revealed above in our analysis of the visual invariants of the Apple logo.

By recognizing a bitten apple and a rainbow in the company logo, Gassée offers a reading which is expectable for anyone from a Judaeo–Christian cultural background, one who will easily identify these as two of the most famous biblical images. The bitten apple references the story of Adam and Eve, the Tree of Knowledge, the cunning of the first wife and the disobedience of God's creatures. The rainbow references the story of the Flood and the moment when Noah comes to the end of his trials. We must conclude, then, that this is an instance of the absence of innocence in figuration [*figurativité*] unearthed by Greimas: in either the production or the reception of meaning, the figurative dimension is where secondary meanings, or 'connotations', are actualized.

This is also why the partly eaten apple is understood – by the same people or by those using different grids for reading or selecting signifying elements – as a reference to New York City, commonly known as the 'Big Apple'; and, in this way, as alluding to the east coast. The bitten apple could then be interpreted as a suggestion of what Apple has in store for IBM. Finally, with its figuration, and the evocation of reading grids that always accompanies a figuration, the apple can be interpreted by those who have an even wider knowledge of American history as a privileged image of the 1960s: a reminder of the songs of Bob Dylan and the Beatles, or an allusion to Steve Jobs' vegetarian diet and the orchards of the spiritual communities he used to frequent at the time Apple was created.[21]

Let us now address the issue of the distorted colour spectrum. This prism is one of the recurrent visual motifs of the psychedelic graphic discourse, also part of the 1960s. It is linked to the infatuation of that era with Eastern philosophies and the search for the 'field of consciousness' that they were supposed to reveal.

We can also see that the distorted rainbow of the Apple logo has lost its bow! It is as if the figurative bricolage of the logo had kept the chromatic component of the biblical motif at the expense of its formal component: the colour materials of the story have been reused, but not its geometric configuration. By working this way with the prism, the logo comes to include the symbol of rebirth, renewal and the opening of new possibilities, while the symbol of the new alliance, the bow or arc, has been overlooked. Should we see in this yet another proof of an intention to oppose IBM? What is undeniable is that Apple's

21. See Young, *op. cit.*, p. 91.

opposition to the 'Big Blue' logo would be even more obvious if it only retained the rainbow prism in order to process it into horizontal bands. Against the sequencing effect achieved by the restrictive binary system (colour/no colour/ colour/no colour ...) of the IBM logo, Apple opposes the palette effect of its logo, and thereby the idea of choice between possible alternatives.

But any secondary meaning that can be attributed to the Apple logo (by virtue of its use of chromatic reordering) is of little importance. What is essential for us here is to show that the figuration of a logo provides it with a certain cultural 'substance' [*épaisseur*] for a certain target audience and increases the efficacy of its denotative message.

One can also find that same function pervading the figurative dimension of the IBM logo. It may, of course, seem paradoxical to talk about figuration in regard to a logo such as this. But if, on the one hand, we admit that figuration results from the recognition of 'units' of expression of the 'natural world'[22] within the sphere of language content and that, on the other hand, the 'natural world' is a macrosemiotic event including, among other things, the typographical semiotic, we can consider the Egyptian characters and the block of blue bands as together constituting the figurative dimension of the IBM logo.

Where does the Egyptian font come from? What world does it evoke? The style is associated with the typography of the world of commerce, of posters, of shopfronts, of drugstores; it is the typography of business triumphs. It was designed especially to ensure maximum impact when used in advertisements or public announcements. This typeface stems from the early nineteenth century; and its common use in the USA at the time of the birth of the nation may explain why Americans believe it is legitimately their own (Figure 20). This is not the case for other major western typefaces.

Let us now consider the bands of the logo. As already mentioned, the pattern of parallel horizontal stripes gives the logo a significant strength of impact; but it also has its own cultural suggestivity. In the context of American culture, it is indeed reminiscent of the place for signatures on legal documents and, therefore, of the idea of honouring a commitment (Figure 21). We find, therefore, in the secondary meanings generated by the typographic figuration of the IBM logo the combined thematic elements of progress, efficiency and honouring commitment: thematic elements already marked by the corporate 'message'

22. What I mean here by 'natural world' is the collection of sensory qualities through which the world offers itself to man, but to man as a social being integrated from birth into a specific culture. This is why we speak of 'natural languages' to indicate the pre-existence of these in relation to the individual. One must therefore consider the 'natural world' as a syncretic statement which brings into play a number of particular semioses. At a more theoretical level the 'natural world' must be understood as a semiotic interpretation of the notions of 'referent' or 'extra-linguistic context' which used to appear in linguistic theory in the strict sense.

Figure 20

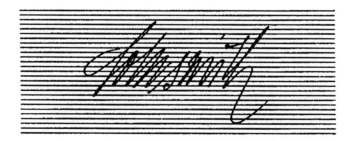

Figure 21

with which the logo is associated. Recall that IBM, when it comes to client service, refers to 'its high quality of service' whereas Apple refers to conviviality and freedom – or in other Apple terminology, to 'democracy'. The difference is significant: both talk about values, but where Apple proposes basic values (existential or utopian values, as I've shown elsewhere[23]) and thus aims to identify with the target audience of its message and its action, IBM proposes use values (practical values) and maintains a certain distance between itself and the target audience, sustaining the distinction between their respective programmes and their hierarchy. The IBM ethic is that of service provider – not that of accomplice or fellow traveller.

So the IBM logo, with its Egyptian font and its striped surface, glorifies the values of efficiency and commitment; it speaks of the dynamism and strength of corporate America. But what does Apple speak of with its bitten apple and its psychedelic rainbow if not disobedience to established order and a totally different America: the America of the sixties, of non-conformism and doing one's own thing, of the quest for spirituality and a desire to live in a community without being subjected to the world of money?

We find these same secondary meanings associated with the small effect of the Apple logo and the contrastingly monumental effect of the IBM logo. In the American culture of the 1960s and 1970s, smallness would have been associated with individuality and freedom. The history of the Apple philosophy thus joins that of the famous Volkswagen Beetle which, in the hands of the Bill Bernach advertising agency, became for US audiences the symbol of shrewdness, cunning, anti-conformist humour and individual freedom. 'Think small' was the title of one of Volkswagen's campaigns (Figure 22). Steve Jobs even recognized that Apple owed, so to speak, a spiritual debt to Volkswagen: 'Steve Wozniak and I invented Apple essentially because we wanted a personal computer. Not only could we not afford the computers then available on the market, but these computers were of no use to us. We needed a Volkswagen. Volkswagens are definitely not as fast or as comfortable as other vehicles, but they enable their owners to go where they want to go, when they want to go, and with whom they want to go. Owners of Volkswagens are in complete control of their vehicle.'[24]

23. Floch, *Sémiotique*. See, in particular, my chapter on advertising and the Citroën campaign. I will return to this axiology of consumption in my analysis of the discourse of furniture manufacturers and the discourse of the Habitat range (see Chapter 5).
24. Steve Jobs, 'Computers and people, July–August 1981', in Young, *op. cit.*, p. 14.

Figure 22

A history of stripes

In all this, the respective figurations of the Apple and IBM logos again put them face to face; they multiply the opposing discourses of their visual dimensions. It may even be possible to find in the pattern of stripes, as used in the logos, this 'curious phenomenon': the 'strange dichotomy' between semiotic inversion and consistency which is at the core of this chapter. Again, we encounter the actuality of this phenomenon, in the content as such, between the abstract and figurative levels – an actuality that the historian Panofsky, as we recall, uncovered in medieval iconography. Let me explain this further.

In a recent work entitled *L'Étoffe du diable*,[25] Michel Pastoureau, a historian of Western symbolism, is interested in stripes and sets out to follow their avatars from the Middle Ages to our own times. On several occasions, Pastoureau returns to the visual characteristics that cause stripes to form a rather special formal and chromatic pattern. First there is the impact, the effect of perpetual motion, which makes the striped surface stand out in its context: 'In any picture, the first element to be seen is the striped one'. And we recall that this is exactly why Paul Rand chose to run a series of horizontal stripes across the three letters of the IBM logo. As Pastoureau says: the stripes 'make waves' and, 'as opposed to plain motifs, stripes side-step, accentuate, mark'.[26] I couldn't better express this direct impact – this psychological impact, perhaps – of stripes in a logo.

Second, stripes – true heraldic stripes, which are indeed those used in the IBM logo – cause foreground and background to fuse into a single space. It is this characteristic that appears to trigger the various historical transformations of the semantics of stripes and causes them to be associated with the diabolical and with transgression:

> A striped surface always seems to cheat because it prevents the eye from distinguishing the foreground image and the background on which it is placed. Reading by depth [*en épaisseur*] – the usual way to read images in medieval times – starting with the background and moving towards the plane closest to the spectator's eye, becomes impossible. The 'leafed' structure [*la structure 'en feuilleté'*] to which medieval perception was so sensitive and so accustomed, is gone. The eye no longer knows where to start reading, where to find the picture's background. It is in this way that the striped surface comes across as perverse, almost diabolical.[27]

Pastoureau therefore follows the semiotic avatars of stripes from the clothes of the traitor in the Scriptures, of the impious and the young women destined for

25. M. Pastoureau, *L'Étoffe du diable* (Paris: Seuil, 1991).
26. *Ibid.*, p. 146.
27. *Ibid.*, p. 52.

prostitution, to those we see at the end of the eighteenth century, 'when everything changes after 1775'. This is where we join American history: 'In one decade, that of the American revolution, stripes, which had been rare and exotic only one generation earlier, start invading the world of clothing, textile, emblems and decor.'[28] From that point on and owing to a certain Americo-philia (especially among the French) stripes have always held an American connotation and so become a symbol of freedom. But what is of interest in this instance is that the origin of the American revolutionary stripes actually seems to be found in our 'curious phenomenon', in the 'strange dichotomy' at the core of this chapter on the Apple and IBM logos. The stripes are kept as signifier, but the meaning is reversed. Indeed, Pastoureau observes that

> it may well be that the American revolutionaries chose a striped cloth, symbol of slavery (around 1770, the striped uniform is already the dress of prisoners in the penal colonies of Pennsylvania and Maryland), to express the idea of the slave breaking his shackles and, thereby, *reversed* the code of the stripes. Once a sign of deprivation of liberty, it becomes, with the American revolution, a sign of freedom gained.[29]

Are the stripes of the IBM logo a distant inheritance from the stripes of the American revolution? If so, we might also find, in the counter-use made by Apple, a form of historical irony: in two centuries of American culture, stripes change from being a symbol of slavery to being a symbol of freedom and back again to being a symbol of slavery – at least within the Apple counter-culture. The Apple logo, with its horizontal stripes and its brightly coloured reordering, would then be to the IBM logo what (for the audience at Woodstock in 1969) the 'Stars and Stripes' played by Jimi Hendrix was to the official national anthem.

Whatever else it was, the purpose of this chapter has not been to address the difficult issue of the role of figuration in the effectivity of visual identity. From my own point of view, it has only been to draw attention to that remarkable semiotic phenomenon described some time ago by Lévi-Strauss in his analysis of the Salish and Kwakiutl masks and by Panofsky in his studies of medieval imagery; a phenomenon which we too observed in the completely different environment of graphic design. Beyond the mere effect of surprise and curiosity, I have tried to raise the question of visual identity (and I deliberately avoid the term 'style' even though Lévi-Strauss does use it) and primarily the question of the semiotic parameters of its production. In relation to this, I might now say that a logo cannot exist by itself, that it cannot be analysed or interpreted outside the semantic universe that provides it with its value and its meaning, and

28. *Ibid.*, p. 75.
29. *Ibid.*, p. 159. Emphasis added by J.-M. Floch.

that an identity always implies a system of transformations which set the rules for a given semantic universe – and this is a system in which the negation on which identity (and, conversely, alterity) is founded uses the principle of commutation between signifier and signified. Logos could then, perhaps, be like masks. Lévi-Strauss's words would then also apply to the systems of visual identity in modern societies: 'A mask is not primarily what it represents but what it transforms – that is to say, what it chooses not to represent. Like the myth, the mask denies as much as it affirms. It is made not only of what it says or believes it says, but also of what it excludes.'[30]

30. C. Lévi-Strauss, *La Voie*, p. 144.

3

Michel Bras: telling how tastes talk

Eve, or more precisely Eve light italic, is a remarkable typographic font by virtue of its delicately drawn slopes and its slenderness (Figure 1). Designer Yan Pennor's selected this font for Michel Bras' name and for the town and country made famous by his cooking: 'Laguiole, France'. Michel Bras is one of today's greatest French chefs. Born in 1946, he first learned his trade from his mother who transformed the area that extends from 'Lou Mazuc' to Laguiole into a privileged place for regional gastronomy. He later developed his skills under the famous Alain Chapel. After taking over the family restaurant in 1978, Bras had his home, just a restaurant and a few rooms, built near Laguiole. Here the main body of the building is reminiscent of the 'burons', the shepherds' huts of the Aubrac.

The use of Eve light italic alone is not sufficient to guarantee the visual identity that Pennor's designed for Michel Bras. In this case, the font becomes subservient to the logo, which is the more obvious vehicle for this identity. Indeed, the Eve font threatens the visual dominance of the logo on none of the several items carrying the Michel Bras insignia, including the stationery, the menu covers and the liqueur labels (Figure 2). Furthermore, the embossed recycled paper used as the main background separates the logo and frames it. (To appreciate this fine embossing fully, it is necessary actually to touch the paper lightly with one's fingertip.) As a matter of fact, the textural effect and the effect of the drawing (the tactile value and the visual value) alternate in the *mise en abîme* of the general process of this visual identity:

- the luminous drawing of the alpine fennel (*la cistre*);
- the texture of the black embossed background;
- the curves of the Eve light italic font;
- the texture of the background paper.

In the logo itself, the tip of an upside-down alpine fennel leaf stands out against a black background. The leaf comes across as a series of tiny dots of light, evoking the luminous shapes of the negativeless photographs made by

Figure 1

Man Ray in the 1920s which he called 'rayographs'. The shape is not a cut-out: there is no line surrounding it and no outline defining its perimeter. The general impression is of an 'acheiro-poetic' image, as orthodox theologians would say of icons, pictures 'not made by human hand'. So by contrast with the lines of the Eve font, the alpine fennel looks like a stand-alone imprint or cast. It shows no visible signs of its creation, no concern for beautiful drawing, no easy exploitation of prints from old botany books. The shape appears to be as close as it can be to its object; the creation as close as it can be to its subject.

The delicacy of alpine fennel

Alpine fennel [*la cistre*] is an umbelliferous plant (Figure 3) — and in French one should not confuse it with its two masculine homonyms: 'le cistre' (cittern or cither) and 'le sistre' (sistrum). The sistrum is a small percussion instrument or rattle with a handle and a curved frame crossed by several movable sound-

Fraîcheur de

COING

L I Q U E U R

MICHEL BRAS
Laguiole·France

INGREDIENTS : COING, ALCOOL, SUCRE DE CANNE.

PRODUIT DE FRANCE • EMB. 12.186

18%

75cl

Figure 2

producing rods. The cittern – whose name derives from the Greek *kithara* via the Italian *citara* – is also a musical instrument. It is comparable to the mandolin and the lute and was in vogue during the sixteenth and seventeenth centuries. Botanists call the cistre *Meum athamanticum*, but its common name is 'fenouil des Alpes', or 'alpine fennel'. As the etymological origin of its family name (*ombelliferae*) indicates, the alpine fennel is a plant whose top stalks, or pedicels, grow in the shape of an umbrella. These stalks grow from a common base and then diverge to display their flowers on a single plane, on one circular or ellipsoidal surface. This means that the flower heads of alpine fennel have a quite unique design that could well make it the very symbol of rupture in semantic continuity generally or, to be more specific, of rupture in the unfolding of a particular text or image. Alpine fennel could then be the symbol of anything discrete or discreet, in either the scientific or the aesthetic senses of these terms. Nevertheless, the drawing of the alpine fennel in the Bras logo requires both close attention and a certain sensitivity; a requirement it shares, as we noted earlier, with the pattern of the Eve font and the logo's fine embossing or light relief.

Meum athamanticum

Figure 3

In terms of design, the font and the logo's light relief come together to create an impression of something delicate. Let us examine this more global meaning-effect produced by Michel Bras' visual identity. A semantic analysis of this delicacy soon opens up a concept of fineness or 'tenuity' that is evoked when we actually touch the logo's contoured surface. It also opens up a concept of discontinuity suggested by the characteristic design of the umbelliferous plant: the word 'delicate' being used to qualify either something that is 'sensitive to the slightest outside influence', or someone who 'appreciates the slightest nuances'. This extreme sensitivity explains the design's connotations of being both refined and elaborate – in either the positive or pejorative senses of these terms. Going somewhat further, it would be possible to regroup these different dictionary definitions into two broad groupings:

- one centred on the concept of fragility ('delicate' evokes fragile and thin); and
- one centred on the concept of astuteness ('delicate' in the sense of deep, ingenious, or sharp as in the French *délié* – another word deriving from the Latin *delicatus*).

It is as if the delicate nature of both the Eve font and the alpine fennel could be interpreted in two apparently contradictory ways: 'delicate' can be synonymous

with weakness, but it can also be understood in terms of strength. And it could perhaps mean a paradoxical combination of both. We will return to this later, but for now we should note the sheer narrative fecundity of the delicate. It shares this fecundity with other fundamental sensory qualities such as light, depth or hardness, for instance.[1] These are all qualities that can be transformed into actual, if simple, stories whose structures are, nevertheless, ultimately quite complex.

Given all of this, delicateness has a special narrative status: in fact, a narrative duality. For we often use 'delicate' to mean fragile, and this suggests the presence of antagonistic forces and introduces conditions of danger and resistance by enlisting a narrative based on doubly physical and polemical relations. This then leads to certain subjects of the narrative having uncertain or diminished capabilities. But against this we also often use 'delicate' to mean subtle, and this suggests narratives of malignity or effective intelligence. These are narratives which may be based on relations that can either be polemical or not, but which are always of a cognitive nature.

Moreover, a subject showing malignity or effective intelligence is clearly competent, perhaps even more competent than other subjects. For this subject has the capacity to both grasp and produce the discontinuities mentioned earlier. It must be noted here that 'delicate' no longer refers to the statement [*énoncé*] but to the stating [*énonciation*] or, more accurately, to the competence of the enunciator – or else the enunciatee, depending on whether we take 'subtle' to mean skilful or insightful. Also, any subject that we qualify as 'subtle' – whether animal, human or vegetal – is endowed with definite know-how: it presents itself as being competent and 'penetrating'. This is the paradox of delicateness. Not only does 'delicate' signify both weakness and strength but also, when synonymous with force, it tells of an intelligence which is so embodied that any action associated with it must refer directly to somatic and tactile vocabularies.

It seems therefore that 'delicate' at least qualifies, even if it doesn't restore, the relationship between the subject and the world in accordance with a particular mode of sensibility. Eve and alpine fennel are then the symbols of this relationship in so far as Bras' visual identity calls, as we have seen, upon a sensitive intelligence and an attention to the world that is conducive not only to perceiving but also to appreciating and feeling the subtle nuances of the most ordinary things.

'Delicacy' implies, again as we have seen, establishing a relationship. But we need to be more precise about this: to establish a relationship is to bring something into one's presence. Anything I perceive as delicate is right there, in

1. On the narrative fecundity of clarity, see J.-M. Floch, *Sémiotique, marketing et communication* (Paris: Presses Universitaires de France, 1990), pp. 49–81.

front of me, and calls upon my actual presence in the world and in being. And if, as Merleau-Ponty states, 'perception of something leads me to being', then delicacy refers in the final analysis to a recovered or cultivated opening up.[2] Michel Bras speaks of 'rediscovering the original taste' of the herbs, plants and other products he uses. He would therefore subscribe to the following reflection of Merleau-Ponty in which he represents phenomenological thinking rather well: 'It is true that the lamp has a back, that the cube has another side. But, this expression – "it is true" – does not correspond to what is given to me in perception. Perception does not offer me such truths as geometry does; rather it gives me a presence'.[3] Being delicate (along with the other fundamental sensory qualities referred to above) could be considered a phenomenological quality in so far as it refers to the relationship of the subject to the world in terms of presence, and also because it is above and beyond sensory specification: it is located outside the division of the world into distinct senses. It lies in the 'cradle of the sensory', to use Merleau-Ponty's apt phrase.[4]

But delicateness does not refer to just any kind of bringing to presence. It is a dynamic bringing to presence and one that is strangely symmetrical in its dynamic – it is an encounter. Indeed, 'delicate', understood as subtle, covers two movements and two tensions. On the one hand there is the movement and the tension of the visual world (or the auditory or olfactory worlds – the distinction is of little importance here) which penetrates the subject, or will be able to do so at a later point. And on the other hand there is the movement and the tension of an open subject which sees, smells or hears in a sustained manner. The delicate can then be characterized by the state of tension specific to the conjunction-to-come of subject and object, a conjunction which Greimas describes as being 'the only way leading to aesthesis'.[5] Actually, the touch of aroma – if we allow ourselves to define in this way the action of the alpine fennel which we are about to analyse – cancels the distance 'that, in spatial terms, is equivalent to anticipation in the temporal dimension'.[6] Cuisine conceived in this manner is very similar to poetic language where, again according to Greimas, 'super-imposed on the prosody of ordinary natural languages one finds a secondary rhythm made up of anticipations of accentuations, followed by other anticipations, and ending in anticipations of anticipations'.[7] Alpine fennel, fragile and powerful as it is, plays its decisive role in the 'anticipation of the

2. M. Merleau-Ponty, *Le Primat de la perception et ses conséquences philosophiques* (Grenoble: Cynara, 1989), p. 70.
3. *Ibid.*, p. 45.
4. *Ibid.*, p. 68.
5. A.-J. Greimas, *De l'imperfection* (Périgueux: Fanlac, 1987), p. 92.
6. *Ibid.*, p. 92.
7. *Ibid.*, p. 93.

unanticipated' which constitutes one of the fundamental dimensions of gastronomic experience.

As the 'daughter' of subtlety and anticipation, delicacy could itself be the foundation of aesthetics, as the prehistorian and anthropologist André Leroi-Gourhan would lead us to believe. He holds that aesthetics is grounded in the evaluation of nuances:

> One can deal with technology and language, and with social memory without any need for value judgements. These are facts characterized by presence or absence, evolving coherent groups to provide humanity with a level of effectiveness that increases on the whole. In this, the social overrules the individual, and evolution recognizes no other judgement than that of collective yield. Aesthetics has a completely different resonance. With aesthetics, society only rules to the extent that it must allow individuals to feel they personally exist within the group. It is founded on the evaluation of nuances [*le jugement des nuances*]. Aesthetics is designed to guide choices towards a conformity as strict as that of technology. But it is of a different order in so far as it is grounded in the opposition between different values for which the subject already holds the solution, thereby enabling his or her own social integration. The use of an axe does not imply judgement. It is either the tool of choice or it gives way to the chainsaw. But the aesthetic aura surrounding the efficient shape and movement of the axe is part of each individual judging what is good and what is beautiful – not in absolute terms but in the secure environment of the aesthetics of his or her group and in the imaginary freedom of his or her choice.[8]

The métis of alpine fennel

The Aubrac is a plateau with its horizon, its rocks, its herbs. It is also an agricultural and industrial region. But with a lower-case 'a', 'aubrac' is the name of a breed of cattle that almost became extinct; and the name 'Laguiole' refers not only to a cheese but also to a well-known knife whose production, at least in part, is once again taking place in Laguiole today. The 'country' of Michel Bras has, as all countries have, both a natural and a cultural dimension.

By choosing to represent a sprig of alpine fennel in the logo, its designer Pennor's establishes a link between the chef's art and the land, the natural dimension of the Aubrac. The whole logo actually refers to the mineral and the vegetal rather than to the animal or the human which could just as easily have been part of the design. But an imagery associated with this latter would have evoked breeding and agricultural production, the most obvious cultural

8. A. Leroi-Gourhan, *Le Geste et la parole: la mémoire et les rythmes* (Paris: Albin Michel, 1964–5), p. 94.

dimension of the Aubrac. The design as a whole or the logo image could well have been inspired by a semi-cultural motif such as the shepherd tracks, the pathways typical of the region – and these are already cultural transformations of natural space.[9] But this is not what is shown. For it is the alpine fennel that Pennor's selects as his image to signify the arts and knowledge of Michel Bras. This alpine fennel is a wild plant known for its fragility, one that requires altitude and is resistant to neither pollution nor fertilizers. It is in this sense outside the cultural. The logo speaks of the physical nature of the Aubrac, a region that is still intact and one that many would like to protect from human intervention and activity.

This discourse is fundamentally axiological. It is a discourse about the values at play in an account of the development of a particular cuisine – or, more precisely, it is a discourse about nature versus culture. It is not then a discourse about, for instance, the transformations and the course of action that establish the narrative syntax of cooking. Neither is it a discourse about the table, or the arts of the table. To get a better understanding of this we might compare the Bras logo with that of Alain Ducasse, another renowned French chef.[10] The comparison between the two logos is even more striking because the Ducasse logo was also designed by Pennor's and it testifies to the same visual intelligence, the same economy of means (Figure 4). The monogram displays the initials of the chef: the 'D' is clearly present, of course, but so is the 'A', although in a more subtle way. What is interesting in this monogram – the form of which contrasts with the typography of the name – is that it suggests elegance, perfection in presentation and the results of a great chef's work. Again, the monogram evokes the look of the dishes and of the restaurant more than the origin of the ingredients and how they are prepared. The discourse of the Ducasse logo is no longer about natural preservation, as is the case with Bras, but is instead about communicating an object of value. We can refer here to an essay by Greimas on the art of the table and the synaesthetic nature of luxury.[11] What we are saying is that Ducasse's visual identity speaks to his craft and his condition; being personally responsible for offering his prestigious restaurant's guests the pleasures of the gastronomic arts.

Let us now return to the Bras logo. Cuisine, in this case, is presented as a paradox between art and knowledge (therefore culture) which attempts to convey the most natural state of the sensory world of the Aubrac and also the

9. Shepherd tracks [*les drailles*] are tracks used by people and flocks going to pasture.
10. Alain Ducasse is one of the youngest and greatest of French chefs. He is chef at the Louis XV, the restaurant of the Hôtel de Paris in Monte Carlo.
11. For a semio-narrative and distinctly syntactic approach to cuisine, see the analysis of *soup au pistou* by A.-J. Greimas in *Du sens, II: essais sémiotiques* (Paris: Seuil, 1983), pp. 157–169.

Figure 4

'true nature' of all the elements which make up the dishes inspired by that region. With the chef of Laguiole, a cake flavoured with licorice may also taste of raw sugar, and the asparagus may be fried uncooked. As for the choice of the alpine fennel as such, it too corresponds to a natural world that has been rediscovered and protected for all its sensory richness.

Hence, as strange as it may seem, Michel Bras – at least as he is represented by his visual identity – is not a 'restaurateur', in the French etymological sense of that word (literally, one who restores). He does not restore his guests' well-being. In a way his 'restaurant' reneges on that etymological origin: he no longer wants any connection with the common ancestor of the hotel and the hospital. He is the locus of an aesthetic experiment involving the redeployment of the natural world's sensory qualities. Only in this sense can one talk about *'restauration'* (literally, catering). Dinner at Michel Bras is not the story of a feeble and famished subject but an encounter between two subjects: a sensuous person and a natural world that makes him aware of fragility and subtlety. Moreover, the story told by the Michel Bras logo is not only about the phenomenological experiences of host and client but also about a chef who respects his chosen produce and the soil from which it comes.

But the alpine fennel is more than just a symbol for fragile earth and phenomenological experience. It is also a plant which is actually, technically, used by the chef of Laguiole. Here too, as with the analysis of the IBM and Apple logos, we can place the visual discourse of the Bras logo within the wider discourse of its enunciator, in this instance the discourse of the chef of Laguiole himself. And because of the enunciator's particular craft, we can establish a link between his logo and his culinary discourse, assuming such a use of culinary discourse is relevant. Indeed we can understand culinary discourse in this case as made up of, on the one hand, Michel Bras' cuisine and, on the other, the gastronomic pleasures it offers – with these elements approached, respectively, as the productional and consumptional aspects of a

signifying whole. We must be aware of the novelty of such a semiotic undertaking and of its risks. For not only are there no instances of in-depth semiotic research in this area – at least as far as I know – but the only analysis even referring to this topic, Greimas's study of pistou, focuses on the particular discourse of the recipe; and this is far from being on the same level as culinary discourse as it is defined above.[12] A recipe is a verbal metadiscourse accounting for a cooking practice in a way that is programmatic and educational. The recipe by itself, then, is not a semiotic object. This difficulty aside, it is still true that semiotics can benefit, in this new application, from a number of anthropological and historical studies, to mention only two disciplinary areas. And this is how I shall proceed in what follows.

The alpine fennel is part of one of the most representative dishes of Bras' cuisine: 'Loup au petit-lait et à la cistre, baselle et quenelle de pain à la sauge' (bass with whey and alpine fennel, white Malabar nightshade and quenelle of sage bread).[13] The fennel plays a decisive role in the story of the appreciation of the dish. Writing about Bras' recipes and dishes, gastronomy reviewer Christian Millau states that 'the combined tastes are not blended but are freed one after the other like the stages of a rocket' – an apt image to suggest the narrativity of pleasure. When Millau writes about Bras' bass-with-whey, he states that the alpine fennel 'throws a touch of aniseed onto the bass fillet'.[14]

Let us consider this observation more closely, if only because it establishes the dish as an object of meaning and turns it into a possible object of semiotic analysis. It is an account of the effect of a particular taste sensation produced when the bass-with-whey is actually eaten. Furthermore, the gastronomical note confirms the fundamentally narrative dimension of eating, as already suggested by Millau's first statement referring to the complex tastes which, in Bras' cuisine, separate like the stages of a rocket. Therefore, 'real' dishes, those that are actually eaten and enjoyed – as opposed to those that exist merely virtually, as recipes – can be approached as actual accounts: the diverse components of the dish are endowed with roles and competencies; they are revealed as acting and acted-upon subjects.

In this instance the alpine fennel in Bras' recipe for bass-with-whey turns out to be the subject of a sudden action, similar to that of an experienced hunter, whether animal or human. It seems that the fennel acts against all expectation. What is indeed striking is that a herb with such a delicate appearance, with such soft green limbs, is capable of such powerful and wilful action, so sudden and so

12. *Ibid.*
13. The recipe can be found in M. Bras, A. Boudier and C. Millau, *Le Livre de Michel Bras* (Rodez: Rouergue, 1991), p. 286.
14. *Ibid.*, p. 11.

efficacious. It is an action whose effect on the senses of smell and taste is actually described in relation to another sense: feeling. As indicated above, in those dictionaries which refer to the plethora of gastronomical observations, aromatic herbs are characterized by a pleasant and 'pungent' smell.

The subtlety and swiftness of the alpine fennel make it a kind of minor vegetal hero, or perhaps a minor gastronomic hero. These two qualities relate the alpine fennel to those sly heroes close to the hearts of anthropologists and mythologists: the tricksters who use cunning and machination to finally square the odds with those in power. The alpine fennel shows itself imbued with *métis*, a kind of intelligence and thought which, for the ancient Greeks, implied 'a complex but highly coherent set of mental attitudes, of intellectual behaviour combining intuition, shrewdness, anticipation, mental agility, feint, resourcefulness, vigilance, a sense of opportunity, a variety of skills and experience coming from years of practice. It applies to events which are fleeting, shifting, disconcerting and ambiguous, which do not lend themselves to accurate measurement, precise calculation or rigorous reasoning'.[15] It is, in short, the strength of the weak. Greek scholars Marcel Détienne and Jean-Pierre Vernant add that 'the *métis* acts in disguise. To dupe its victim, it takes on an appearance that hides its true being rather than revealing it. In it, appearance and reality are split and confront each other as two opposite forms, creating an effect of illusion'.[16] Moreover, the human or the animal blessed with *métis* is 'always ready to pounce; acts in a flash'.[17]

Here again we come across this curious notion of delicacy, that intelligence and strength of the weak, as analysed above in our account of the meaning-effect of the drawing of the alpine fennel in Pennor's' logo. Now that we have examined the meaning-effect generated by the alpine fennel when actually eating the bass-with-whey, the visual identity created by Pennor's is revealed as a possible metadiscourse about Bras' cuisine. A drawing can 'talk' about a taste. So, in a way, Bras' visual identity exemplifies a possible translation of a cuisine's gastronomical qualities into a sense other than those of taste or touch. It forces a recognition that cuisine has the capacity to come to the surface at the symbolic level. Our examination of the design and light(n)ing qualities of the alpine fennel and our study of the meaning-effect generated by this herb when eating the bass dish suggest that the great anthropologist and prehistorian Leroi-Gourhan may have too hastily lighted upon the inability of cuisine 'to surface at a symbolic level' as he puts it.

15. M. Détienne and J.-P. Vernant, *Les Ruses de l'intelligence: la métis des Grecs* (Paris: Flammarion, 1974), pp. 9–10.
16. *Ibid.*, p. 29.
17. *Ibid.*, p. 22.

In *Le Geste et la parole*, Leroi-Gourhan argues that:

> The combination of thyme, salt and nutmeg cannot be translated into movements or even into words. Contrary to other art forms, cuisine escapes the possibility of the figurative; it does not surface at the symbolic level. In theory everything can be symbolized, but in gastronomy this can only be achieved prosthetically: the layout of a meal can be symbolic of a world on the move, but it refers to the rhythm of serving and the meaning of the dishes outside their gastronomical character. The smell of thyme can be a symbol for the open country at dawn, but this is only what remains of that smell in a space–time reference. A dish can be a design, entering the field of visual references, but its presentation is not representational of its taste. Anything in gastronomy that is other than the visual development of food recognition is no longer gastronomical. In theory, it is taste, smell and texture that establish the true foundation of that languageless aesthetic.[18]

I have already offered some evidence for thinking that cuisine can indeed be a meaningful practice and that gastronomy can be other than a mere 'languageless aesthetic'. Leaving to one side the specific combination of thyme, salt and nutmeg, we can go on to examine the role of the alpine fennel in the bass-with-whey and its meaning in the art of Michel Bras. And here I would contend that one has to admit that Pennor's' design represents a visual translation of the discourse developed by the chef of Laguiole through the gastronomic quality of his dishes. Cuisine is a language indeed, not just a gratuitous play of smells, tastes and textures. Moreover, cuisine can, like any other language, become the object of a metadiscourse about either its production (cuisine) or its consumption (gastronomy).

But, one may ask, did Michel Bras really intend to create a mythology when he used alpine fennel in his bass-with-whey? Did this chef, who although an avid reader is largely self-taught, ever read the Greek classics? Did he ever have the opportunity to read the works of Détienne and Vernant? Oddly enough, these questions are irrelevant in the present context. We are not concerned with what Michel Bras wished to achieve or what he thought at the time. In a semiotic analysis – or at least in the structuralist approach illustrated in the present work – we are only concerned with analysing the meaning generated by the alpine fennel when eating bass-with-whey; and this in order to demonstrate that we must do so by approaching the dish as a *story* and the alpine fennel as one of its *characters*. To use a favourite statement of Greimas's: outside the text (eating bass-with-whey), there is no salvation! This is how we will be able to approach cuisine: not just as a knowledge and an aesthetics, but also as a true language –

18. A. Leroi-Gourhan, *op. cit.*, p. 113.

and it is how we will be able to study dishes as discourses about the world, comparable to other discourses in other languages. Such a semiotic approach to cuisine aims to integrate cuisine into the overall set of signifying practices and to establish it as a legitimate object of analysis for all those who are concerned with the elaboration of a general semiotics contributing to the development of a cultural anthropology. The alpine fennel is then something that does more than just 'talk' about its taste of aniseed and mint; it 'says' cunning and ingenuity, the sudden reversal of a situation and the immediate efficacy of the sign.

A short mythology of herbs and spices

Let us go a bit further and follow the scent of a possible mythological dimension of the alpine fennel and Bras' bass-with-whey. In order to do this we will stay with our chosen level of relevance: the sensory and material qualities of the various components of the dish and also how the creation of meaning is correlated with these qualities in the eating of the dish. It is indeed at this level that a dish can be established semiotically as a perceptible and intelligible whole.

It has already been pointed out on a number of occasions that alpine fennel is of interest to Bras because of its axiological meaning: it is found on the high ground of the Aubrac; it is a metonym for wild and fragile nature; but it is just as much of interest to him for its aromatic strength. In his book, Bras introduces the plants he uses to compose his dishes. Next to the drawing of the alpine fennel, he writes: 'A mint-anise taste so mysterious that this umbelliferous plant allows me to escape to the rural lifestyle of the pastures'.[19] For Bras, alpine fennel is a wild plant which does not like fertilizer or pollution and is found on high ground. And it has the ability to transport him back there: so there is always this idea of an immediate effect. Finally, alpine fennel is associated with the 'aestival times' of heat and sunshine. Giving the recipe for bass-with-whey, he indicates: 'If you talk about alpine fennel to an old cheesemaker, he will tell you that the cheese of Laguiole, made during the summer, owes much of its aromatic qualities to this plant'.

Alpine fennel is therefore associated with:

- heat and dryness on the one hand; and
- the distant and the wild on the other.

Moreover, it comes from the highlands (which is why it is called *alpine* fennel); it is a herb in the cuisine of the chef of Laguiole; and it is included in the

19. Bras et al., *op. cit.*, pp. 190–7.

bass-with-whey in which we also find white Malabar nightshade and a quenelle of sage bread. White Malabar nightshade, or *Basella alba*, is a member of the family *chenopodiaceae*, whose scientific name originates from the East Indies. It is a kind of wild spinach used by Bras as a substitute for common spinach during the summer months. As for the quenelle of sage bread, it is made with burnt bread, an ingredient often found in Bras' cuisine.[20] To prepare the quenelle, the burnt bread is first crumbled and soaked in onions that are cooked through but not browned; the combination is then left to stew with two or three sage leaves. If the texture is too dry, the chef advises the addition of some vegetable stock or, better, some stock from a roast. After heating in a double boiler, the quenelle is shaped with two dessert spoons. Note, however, that we are not about to leave the chosen level of relevance adopted so far: the sensory qualities of bass-with-whey. All I want to do is to help the reader understand the nature of the various components of the dish. Three points in particular should be kept in mind:

- the quenelle is made of burnt bread;
- the burnt bread is associated with the sense of smell in Bras' aesthetic scheme;
- ultimately, the quenelle refers back to dryness and heat.

Observing both the various qualities of the alpine fennel and its use by Bras, it is difficult not to think of the imagery evoked by herbs and fennel in Greek mythology; even more so because we have already come across this ancient culture when making a connection between the immediate effectiveness of the alpine fennel and the power of the *métis* in ancient Greece. Here again we can call on assistance from the works of Marcel Détienne. Indeed, this classical scholar has written a book on the mythology of herbs and spices in ancient Greece, *Les Jardins d'Adonis* – a work with an extensive preface by Jean-Pierre Vernant.[21]

The book focuses on the myth of Adonis, the child of the herbs, the son of Myrrh.

Endowed with a power of seduction which no one can resist, the aromatic child – although still at an age when young girls and boys devoted to chaste Artemis know only innocent games – enjoys the pleasures of love. But when it is time to enter adolescence – which marks the moment when any young man should integrate with social life as warrior and future husband – his love life is suddenly interrupted. He falls at the very time of that trial which would normally allow him

20. In his recipe for bass with whey, Bras observes: 'You will often find "burnt" bread in my recipes. The idea came to me from the aroma that emanated from a soup my mother used to make. The "globs" of bread were taken from well-done, almost burnt, loaves' (Bras *et al.*, *op. cit.*, p. 286).
21. M. Détienne, *Les Jardins d'Adonis* (Paris: Gallimard, 1972).

access to full virility. The son of myrrh finds himself in a lettuce where he is killed or deposed. His sexual hyper-power, confined to the time of life when love relations are normally ignored, vanishes as soon as he reaches the age of union. It ends where marriage starts, presenting the reverse image of the latter.[22]

Détienne shows that, 'born from an exceptional conjunction of earth and solar fire, aromatic herbs are a gift from the wild which humans take possession of by processes designed to mediate the near and the far and to link the high with the low. ... Aromatic herbs, products of nature and therefore beyond the realm of cultivated plants, are only consumed as condiments and spices. Only a very small amount of these substances is required to flavour large portions of food, solid or liquid'.[23] Among the various traits that characterize aromatic herbs in the myths and rites analysed by Détienne, we can thus already recognize a number of those we have identified in relation to Bras' cuisine:

- the reference to high ground and the wild;
- the mediation between near and far;
- great efficacy; and
- the correlation with heat and dryness.

There are also other points of correspondence between these aromatic herbs and the alpine fennel: the aromatic herbs are associated with perfumes with which they share their mysterious effectiveness, and we know from other research that they can be used as part of hunting techniques.[24] And we recall that Michel Bras values alpine fennel for its aromatic qualities, as did the old cheesemakers of Laguiole, and that the critic Millau refers to the 'touch of aniseed' that the alpine fennel 'throws' on to the fillet of bass – this was, after all, the starting point for our mythological investigation.

But the comparison between these aromatic herbs and the alpine fennel goes well beyond their own characteristics and their substantive definitions. Indeed, the alpine fennel is shown to be an aromatic herb as soon as we examine it in the context of its relationship to the other ingredients for the bass-with-whey, and as soon as we take into consideration the research by Détienne on the position Greek mythology gives to aromatic herbs in contrast to lettuce and cereals.

The classical scholar indicates that the aromatic herbs find meaning and value in a representation of substances grounded in two 'sets of complementary notions' – which we (although it comes down to the same thing) would call semantic categories:

22. *Ibid.*, introduction by J.-P. Vernant, p. xvi.
23. *Ibid.*, p. 71.
24. *Ibid.*, p. 165.

cold	vs.	hot
humid	vs.	dry
principle of corruption	vs.	principle of incorruptibility
putrid smells	vs.	aromatic smells
distance from the solar fire	vs.	closeness to the solar fire

This is how aromatic herbs are opposed to lettuce, a plant that is cold and humid in nature, in which Adonis, as we recall, meets his untimely end. Détienne reminds us that 'Lettuce is corpse food in two ways that are combined in the myth of Adonis. On the one hand, it is a plant that is cold and humid in nature, and is therefore on the side of what is destined to die and putrefy. On the other, it ends the sexual power of men.'[25] And, later in *Les Jardins d'Adonis*, Détienne quotes a certain Lycon, author of a work on the Pythagorean way of life, who indicates that the name 'eunuch' was given to a lettuce with long, large leaves but no stem: 'because it predisposes to serous secretions and diminishes the drive towards love's pleasures'.[26]

We will come back later to these aphrodisiac and anti-aphrodisiac qualities attributed respectively to aromatic herbs and lettuce. Let us for now, though, pursue the description and examination of the play of relations in which the aromatic herbs are inscribed. The opposition between aromatic herbs and lettuce along the lines of the categories of dry and humid, on the one hand, and hot and cold, on the other hand, is understood in Greek mythology (as analysed by Détienne) as the opposition between two extreme positions, between two forms of imbalance. This axis of imbalance is itself opposed to the axis of balance found in cereals, barley and wheat; indeed, cereals represent a good mediation between dry and humid. This axis of balance belongs to the goddess Demeter and is thereby opposed to Adonis. This is how we can visualize these axes and their oppositions (Figure 5).

Is it now possible to see the relationship between the alpine fennel and the other ingredients in Bras' dish: whey, white Malabar nightshade and quenelle of sage bread? First, we will note the two pairs established by the name given to the dish, 'Bass with whey and alpine fennel, white Malabar nightshade and sage bread', and even more so by the actual associations of the four ingredients:

– first pair: alpine fennel and whey;
– second pair: white Malabar nightshade and quenelle.

What is whey? It is the serum-like residue left over when milk curdles. Whey is a cold and humid liquid. It is produced by ancient techniques and is used in health cures. Bras indicates in his work that 'at the turn of the century, Laguiole

25. *Ibid.,* p. 132.
26. *Ibid.,* p. 233.

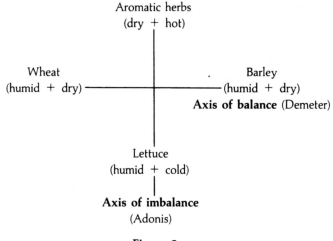

Figure 5

was renowned for its whey health cures'. We must bear in mind that whey has a serous or serum-like quality: it is characterized by cold and humidity and is associated with culture by virtue of its manufacture and use. Suffice to say then that whey is in opposition to alpine fennel which is, as we have seen, associated with dryness and heat and is, furthermore, a wild plant with a strong aroma.

As far as the quenelle of sage bread is concerned, it is made of burnt bread – something associated in Bras' memory with the sense of smell. The quenelle signals heat and dryness – Bras indicating that the texture of burnt bread, onions, groundnut oil and sage can be so dry as to warrant adding 'some vegetable stock or, better, some stock from a roast'. Moreover, the mixture is heated in a double boiler prior to shaping the quenelle with two dessert spoons. The use of a double boiler to prepare an aromatic substance is reminiscent of the techniques of the Greek perfume makers. 'To manufacture oil-based perfumes, the unguent boiler … uses a container half immersed in hot water, thereby avoiding direct contact with the flames of the cooking fire.'[27] Détienne goes on to analyse the reasons for such a technique: 'Because aromas are produced by the most lively of concoctions, inside and out, it is not advisable to expose them directly to the power of the cooking fire any more than it is advisable to expose them to the power of the solar fire: in this instance, mediation must be by water.'[28]

Let us now turn to the white Malabar nightshade which makes up a pair with the quenelle. White Malabar nightshade is a wild spinach, a cold and humid plant. And it is the 'withered' leaves, Bras tells us, that are served in the bass-with-whey

27. *Ibid.*, p. 117.
28. *Ibid.*, p. 118.

after they have been strained to remove the 'plant liquid' exuded during cooking. It is therefore a residue, like whey, and it is soft-textured. Another characteristic of this white Malabar nightshade can be found by comparing its preparation with that of the quenelle with which it constitutes a pair. The white Malabar nightshade is revealed as requiring minimal human intervention: from that point of view, it can be compared to the alpine fennel in its relationship to whey.

We recognize in this play of relationships between the four ingredients – whey, alpine fennel, white Malabar nightshade and quenelle, all of which accompany the bass – the subdivision of the set of semantic categories establishing the opposition between aromatic herbs and lettuce in the myth of Adonis. Alpine fennel and sage bread are respectively to whey and white Malabar nightshade what aromatic herbs are to lettuce in the myth of Adonis.

Alpine fennel	Sage bread	Aromatic herbs
Whey	White Malabar nightshade	Lettuce
'Bass with whey and alpine fennel …'		*Myth of Adonis*

Here we witness a crossing of terms. Alpine fennel and whey – the first pair of ingredients – are opposed along the axis of the wild and the manufactured. The term 'wild' is represented by the aromatic alpine fennel and the term 'manufactured' by the whey. On the other hand, in the second pair and still along the same axis of wild versus manufactured, it is the aromatic sage bread which is manufactured and is the equivalent of the lettuce (or the white Malabar nightshade) that is wild.

And what about the bass in all of this? Cooked in the oven, 'slow and precise' as Bras likes to emphasize, the bass fillets will be 'tender'. The flesh of the bass must be smooth and supple, neither soft nor hard: it must embody the balance between the dry and humid, by a cooking process that brings it to a median position between raw and burnt. The fillet of bass is thus on the axis of equilibrium, as are the ancient Greeks' wheat and barley. Détienne reminds us that during the Thargelian and the Pyanopsian feasts, Greek feasts that could be placed in opposition to the Adonian feasts, the Athenians used to cook a mixture of various grains on a slow fire 'because that way of cooking, at equal distance between the raw and the burnt, achieves in cooking a balance between the dry and the humid which is achieved in nature by the harmonious co-operation between moderate heat and regular rains, thereby creating the most favourable conditions for the slow maturing of the fruits of the earth'.[29]

We can therefore establish another diagram – similar to that used to visualize the play of relationships between lettuce, aromatic herbs and cereals in ancient

29. *Ibid.*, p. 210.

Greece — to place the relationships between alpine fennel, whey, white Malabar nightshade, quenelle and, finally, the bass itself (Figure 6):

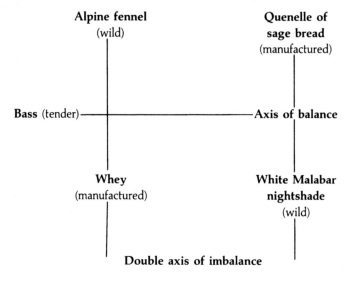

Figure 6

To end our exploration of the mythological dimension of Bras' bass-with-whey and, consequently, that of the alpine fennel in his logo, we must address the matter of the fennel itself more directly. It seems to me that it constitutes a link between the bass-with-whey and the cultural and cultic practices of ancient Greece.

Détienne points out that the small gardens established for the Adonian festivals included wheat, barley, lettuce and fennel, and he explains that fennel had all the necessary characteristics to stand for the aromatic herbs in the cultivated space of these gardens.

> Greek fennel is an aromatic plant and a condiment used as a common seasoning. It is an aromatic because its smell and taste are very similar to those of anise. And it is a condiment, because the Greeks probably did not know fennel in its garden variety, sweet fennel, the vegetable we all know today. But, for the ancient botanists, this scented condiment also had qualities clearly opposing it to lettuce. Not only does fennel provide warmth and a drying effect, it is also an excellent tonic for the genital organs and provokes an abundance of sperm.[30]

Again we encounter the aphrodisiac qualities of aromatic herbs referred to earlier.

When we consider that bass-with-fennel is a Provençal dish, and therefore part of Mediterranean culture, and that alpine fennel, considered to be a type of wild

30. *Ibid.*, pp. 201–2.

fennel, is used as such by Bras, it seems to me that we can view Bras' bass-with-whey-and-alpine-fennel as a gastronomic avatar (originating in the mountains), of an ancient mythology of aromatic herbs. The composition of the 'bass-with-whey and-alpine-fennel, white Malabar nightshade and quenelle of sage bread' that Bras makes, by playing on the contrasts between its ingredients and the doubling of its pairs, could even be considered as completely representative of the 'sensory logic' which gives (or restores) meaning and taste to Mediterranean cultural objects.

Could the myth of Adonis survive by these means in the mountains of the Aubrac? This is far too serious a matter to be left in the hands of mere semioticians.

Cuisine and bricolage

We have tried to demonstrate that it could be interesting to approach cuisine as a signifying practice and to think of dishes as narratives. Let us now address the *narration* implied by these narratives. We noted that alpine fennel is a plant growing in the highlands of Laguiole. It is one of the plants that Michel Bras 'meets' as he wanders around the pastures. And, for him, the plant is associated with the pastures, and with his wandering, to such an extent that he attributes the mysterious power that enables him to escape to these pastures to its taste of mint and aniseed. Alpine fennel is therefore closely linked to another account which is both wider and more complex than that of the bass-with-whey: it is linked to Michel Bras' actual art, to the account of the production of the meaningful objects found in the dishes that he makes and offers for gastronomic pleasure. In this account, alpine fennel is essentially linked, for the chef himself, to what happens before his work in the kitchen starts, to wandering the highlands and to the plants that he simply encounters or else chooses to collect and preserve.

The chef recalls that: 'Not a week goes by without me bringing back in my bag a herb, a flower ... These are identified, decoded, smelled, chewed ... to be tested.' Elsewhere he adds: 'Borage has all the maritime flavour of oysters but does not react well to cooking. I make borage extract with a centrifuge. One has to find the best way to use any given plant; for this one it is the taste that is important, for that one the texture. The white Malabar nightshade, for instance, is attractive because of the way it feels to the touch. It is crunchy, succulent, and gives an impression of vitality.'[31] (And Michel Bras admits that for years he has been trying to prepare the 'cousoude'.)

31. *L'Événement du Jeudi*, 28 May – 3 June, 1992, p. 131. According to Bras the 'impression of vitality' given by the white Malabar nightshade seems to contradict what I noted above about its proximity to lettuce (which is associated with death in the myth of Adonis). I don't think we should see this as a contradiction: Bras is referring, in fact, to *raw* Malabar nightshade, taken as such and not the Malabar nightshade *prepared* for the bass with whey – where the leaves (we will recall) are 'withered', as per Bras' own instructions.

Bras works in this way from a sensory logic. His is a 'concrete science' – the analysis of the bass-with-whey seems to have shown that much. The expression 'concrete science' is taken from the anthropologist Lévi-Strauss who, in *La Pensée sauvage*, argues that 'there are two distinct modes of scientific thought which are not functions of unequal stages of development of the human mind but rather of two strategic levels from which nature can be addressed: one more or less adjusted to the level of perception and imagination and the other more removed, as if the necessary associations which are the objects of all science – neolithic or modern – could be reached from two different paths: one close to the intuition of the senses, the other more remote'.[32]

Indeed, the manner in which Michel Bras uses the plants he discovers while wandering the pastures illustrates a kind of activity that, according to Lévi-Strauss again, remains today part of a science which is 'primary rather than primitive'. This activity is bricolage, the activity which, according to the anthropologist, is at the very heart of mythic thought. 'The nature of mythic thought is that it expresses itself with a repertoire whose composition is heteroclitic but which, of course, remains limited nevertheless. But it [mythic thought] must use this repertoire, no matter what the task at hand, because it has no alternative. It then comes across as an intellectual bricolage, which explains the rapport observed between the two'.[33]

Alpine fennel is one of the elements used by the bricoleur-chef Michel Bras. It is one of the signs that makes up the means at hand with which he makes do. The elements collected and used by a bricoleur are always 'preconstrained' or 'prestressed' [*précontraint*]; and this might seem to exclude plants, which are natural ingredients. But this is unlikely to be the case in the context of either Bras' culinary practice in general or, in particular, his use of alpine fennel. Even though alpine fennel is a wild plant, it already has, within the culture of the Aubrac, a value and a history which make it into a sign; it is one of those prestressed blocks that are the basic material of bricolage thinking. I believe that the above mythological analysis shows this cultural and prestressed nature of alpine fennel to a sufficient degree for our purposes.

But the culinary practice of Bras can also be compared to bricolage from yet another standpoint, that of 'tensivity' in the production process. The tension that hangs over Bras' wandering in the highlands or his returning from market and creating the menu is reminiscent of the excitement typical of the bricoleur as described by Lévi-Strauss:

32. C. Lévi-Strauss, *La Pensée sauvage* (Paris: Plon, 1962), p. 24.
33. *Ibid.*, p. 26. In an interview given recently to the daily *Le Figaro*, Lévi-Strauss explains that bricolage seems to him to be essential to the functioning of human thought. 'I build all my interpretation of myth, all my treatment of mythology on this fundamental notion of bricolage.' See C. Lévi-Strauss, interview with Pierre Bois, *Le Figaro*, 26 July 1993.

Let us observe him at work: excited by his project, his first practical step is nevertheless retrospective: he must return to a pre-existing set of tools and materials. ... To understand what each of the heteroclitic objects that make up his treasure might 'signify', he must question them and thereby define the set to be established, the set that will ultimately differ from the instrumental set only by the internal organization of its parts. That piece of oak can be a wedge used to secure a pine board or it can be a plinth stressing the quality of grain and polish in the old timber. In one instance it will be an extension, in the other it will be matter.[34]

Further considering the tension that is characteristic of the composition of the menus, Pennor's has selected a specific font for their text: Centaur, a member of the Elzévir font family with obvious similarities to Eve. This enables Michel Bras, himself an information technology buff, to set and print his menus himself (and as late as possible) from template layouts prepared by the designer. Here we have the computer at the service of 'wild thought'.

We have already mentioned bricolage when addressing the IBM and Apple logos. There we referred to 'figurative bricolage' so as to describe the mode of production implied by the inclusion of a rainbow in a bitten apple or of stripes in an Egyptian font. And now, too, we have come across the notion of bricolage but, in this case, in the analysis of the production of a personal work, a culinary work.

We will conclude this essay with another form of bricolage, this time a visual form, by establishing a parallel between the processes of the chef, Bras, and those of the designer, Pennor's. Indeed, just as Bras cooks on the basis of his 'finds', heavily charged as they are with meaning, Yan Pennor's creates visual identities for brands or companies from, among other things, typographical forms discovered during his travels and encounters and which he keeps, as he himself says, 'at hand'.

This is true for the Eve font used for Bras' identity. 'In its oldest version, Eve's design dates back to 1922. It was conceived by Rudolph Koch for Kungspor and called Locarno. Renamed Rivoli and attributed to William Sniffin we find it next in 1928 at American Typefounders. I bought it in New York in conventional phototitrage, so it was only useable in its wide-bodied version, but called it Eve light'.[35] Eve has indeed the same value as alpine fennel. It is an element loaded with history and is culturally and technically 'prestressed', as Lévi-Strauss intends this term. The possibilities offered to any designer who uses Eve are limited by the particular history of that font, just as the possibilities offered to a chef by alpine fennel are limited by the manner in which it acquires its meaning and its value in the pastoral life of the Aubrac and Mediterranean cultures.

34. *Ibid.*, p. 28.
35. Personal notes by Yan Pennor's – unpublished.

4

Chanel changing: the total look

Earlier, in analysing the Waterman advertisement, we examined the brand's logo and showed how the story of the twins (re)semanticized it in a quite different way. Following from that, we focused on the curious semiotic phenomenon that links the Apple and IBM logos and we found the same phenomenon existing in other cultures and other times. In the last chapter, we analysed the 'mythological weight', as it were, of the figure of the alpine fennel in Michel Bras' logo. The reader might infer from these first three essays that I conflate visual identity with the logo as such or, at least, that I reduce my investigations of the semiotic production of visual identities to micro-signs. This is far from being the case and I will, in the final three essays, try to analyse signs of an altogether different order but without trying to account for all the various types that visual identities can be manifested as. Indeed, it is not my intention to generate a typology of the different signs of such identity: heraldry, logos, emblems, costumes, uniforms, and so forth. The semiotic approach which I am trying to illustrate in these essays is by no means concerned with the typology of signs. Rather, it is concerned with the conditions of meaning production. So visual identity is approached *vis-à-vis* this particular mode of production.

From here on, then, we will address objects other than logos and in the present chapter we will first attempt to analyse a form of visual identity that long pre-existed its logo: the *look* – with this as defined by the *Petit Robert*: 'the purposefully elaborated physical appearance of a person (style of dress, hairstyle, etc.)'. But it won't be just any look that we look at; rather a very specific one, and one that is well known throughout the world: Chanel's 'total look'. As its name implies, the total look organizes the whole of the feminine figure or 'silhouette' as conceived by Coco Chanel. This should be considered as a meaningful whole. And one more thing is certain: we must not limit ourselves to the famous Chanel tailored suit but try to explain the general structure of Chanel's own 'silhouette'. That is, we should address it completely – from head to toe, as it were.

Another preliminary remark: in the chapter on Michel Bras, the point of the

analysis was not the bass-with-whey recipe as such, but rather the dish itself, seen as a culinary discourse. So, in similar fashion, I will now look at the Chanel look as a discourse about fashion. I will not look at such metadiscourses as the vocabularies of fashion journalism or the lexical system of the fashion professionals. Such matters have already been addressed by other semioticians – Barthes and Greimas *inter alia*.[1]

The 'elements for an immediate identification of Chanel'

In the first issue of the Chanel catalogue, published in 1993, Karl Lagerfeld says that he 'tried to put into a few pictures the exceptional professional destiny' of Coco Chanel.[2] In just five plates, Lagerfeld drew up the major stages of her career, from Gabrielle Chanel's beginnings as a milliner to the early 1960s and 'Coco's triumph'. The first of these plates is entitled 'Elements for an immediate identification of Chanel' (Figure 1). The caption reads: 'Chanel's spiritual heritage'. In the drawing we see a shoe with a black pointed toe, a padded bag with a gold chain, the famous little black dress, a multicoloured broach shaped as a cross, the 'Chanel suit' jacket, a catogan (bow), a camellia and, finally, the golden button embossed with the double-C. These distinct elements are drawn alongside each other rather than being placed in a linear way on the same model's body – for with that arrangement, it would have been impossible to see both the little black dress and the suit jacket.

In another of the five plates entitled 'Coco's Triumph' (Figure 2), Lagerfeld now draws several sketches of young women and, to the right of the sketch showing the braided suit, he writes as follows: 'The bag, the jewellery, the shoe, the camellia, the buttons, the chains, it's all there!' In fact, in this sketch we can see both the suit and all the accessories that go to make up the totality of the recurrent elements of the Chanel look from the 1950s and 1960s – elements which I also discovered while working through my personal collection of Chanel documents and analysing the Chanel label's forms of communication.[3] These are, of course, signs of identification in so far as each of them alone could, by

1. I obviously refer here to R. Barthes, *Système de la mode* (Paris: Seuil, 1967); but also to a thesis by Greimas, still unpublished: 'La mode en 1830, essai de description du vocabulaire vestimentaire d'après les journaux de mode de l'époque', 1949.
2. This catalogue is conceived and published by Publications Assouline. It is sent out 'for personal information' to Chanel's clients.
3. My personal documentation has been collated over fifteen years of reflecting on Chanel's work. These reflections have been regularly revised in the light of several different studies carried for (or about) the Chanel label. This documentation includes photographs of models created by Coco Chanel as well as of those created by Karl Lagerfeld and published in well-known international fashion magazines and in several books and articles about Coco Chanel, her work and personality.

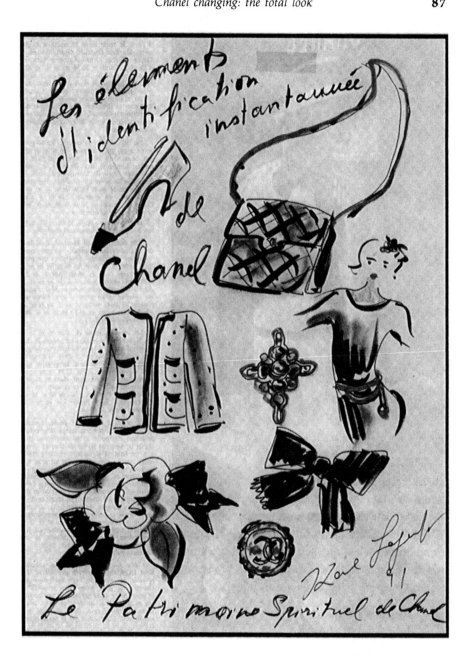

Figure 1

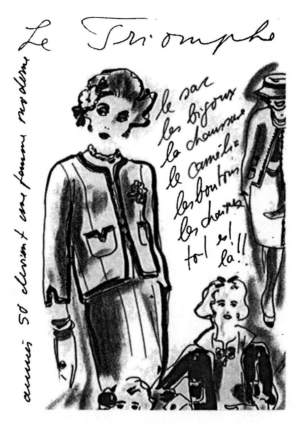

Figure 2

metonymy, easily lead to a recognition of the Chanel look. But also, and foremost, they are *signs*; that is, they are syntagmatic units of the sketch as a whole which can, in turn, now be seen as what linguists call a 'fixed syntagm'.

From a strictly historical point of view, it is also possible to arrive at a more comprehensive list of the garments and accessories invented by Chanel, some of which she created herself, others of which she found and brought into the world of fashion from outside. These include:

- the sailor's blouse (1913);
- the jersey (1916);
- cardigans and knitted suits (1918);
- trousers (1920, the year in which she also introduced short hair);
- the little black dress (1924);
- the blazer with gold buttons and the sailor's hat (1926);
- tweed (1928);
- costume jewellery (1930);

- the braid-edged tweed suit and the gold-chain belt (1956);
- the black-toed flat shoe and the quilted bag with gold chains (1957);
- the catogan (bow) (1958).

In the first instance we could analyse Lagerfeld's 'elements for an immediate identification' and integrate them into the Western dress code system (dress, coat, hat, suit, and so forth); or, more precisely and significantly, we could integrate them into the 'fashion system' of the early twentieth century. First we can identify the elements of such a system, some of which Chanel adopted and some of which she neglected. Second we can analyse the referential worlds of the elements that Chanel discovered and raised to the level of being 'creations'. In both of these areas we can notice both a rejection of the most characteristic signs of women's fashion at the time – a fashion associated with the designer Paul Poiret – and a recurrence of images borrowed from the worlds of sport and work, and from the masculine dress system. Rejecting the traditional signs and calling on these new images constitutes the figurative semiotic dimension of the total look. I will now analyse this figurative dimension and then go on to look at Chanel's visual semiotic. Finally, I will show how that visual semiotic repeats the figurative dimension of the look and reorganizes its various elements so as to open up another discourse, a strictly ethical discourse.

From the women's fashion of the day, Chanel principally rejected all that failed to correspond with the actual functions of clothing: walking, carrying, working, and so forth.[4] That is, clothing had to be useful; it must be practical and comfortable.

> She said that she was working towards a new society. 'Until that point, I had dressed useless and lazy women supported by their chambermaids. But now I had a new client base made up of active women. An active woman needs to be at ease in the way she dresses. She must be allowed to roll her sleeves up.'[5]

Chanel refused to make a pocket so small that a hand wouldn't fit in it. She did away with buttons that were only there for decorative purposes – 'Never use a button without a buttonhole!' With great care she ensured that a skirt could wrap so as to allow for free leg movement; and she believed that 'armholes can never be wide enough'. To allow this freedom of bodily movement, Chanel shortened her skirts; she used crêpe because it was supple; she invented the shoulder bag; she always made sure that 'there is enough movement in the back, at least 10 cm – one must be able to bend down, play golf or put one's shoes on;

4. As strange as it may seem at first sight, Chanel reminds us here of Le Corbusier: the architect of La Chaux-de-Fonds thought of a house as a 'machine for living'. Chanel and Le Corbusier not only both searched for functionality and exalted modernity, but there are also, I believe, many other common points of connection between their work, in their aesthetics as well as in their ethics.
5. C. Delay, *Chanel solitaire* (Paris: Gallimard, 1983), p. 117.

one must therefore take a client's measurements with her arms crossed.' Thus she denounced in Poiret's designs dresses that were tight around the ankles and so stopped women from moving freely. The contrast between Chanel's designs and those of Poiret was particularly striking for their contemporaries, as is shown by the Cocteau drawing entitled 'Poiret leaves – Chanel arrives' (Figure 3).

Later, we will turn to a second reason for Chanel rejecting Poiret's figure or 'silhouette': his use of Turkish motifs and flounces and, at the root of all this, his flamboyant baroque. For the moment, however, we should note that, as a representational semiotic, the Chanel look offers us a narrative about the acquisition of individual freedom. On analysis, the modernness of this appears as a recurrent theme: 'I invented the sports dress for myself alone; not because other women were involved in sport but because I was. I didn't go out because I wanted to be involved with fashion; I was involved with fashion because I was going out – because I was the first to live *this* century's life.' We know that Chanel was proud to have created the 'dress-code expression of [her] century'.

Figure 3 Jean Cocteau, 'Poiret s'eloigne – Chanel arrive'
© SPADEM, 1995

However, Chanel does more than just decommission the Poiret style so as to conquer the freedom and autonomy of a modern gestural style. Her own figure or silhouette does not exist simply in the service of movement. It is also made up of specific elements and materials which, in the 1920s and 1930s, only found their meaning and value by reference to two worlds that were then considered the opposite of the world of women or, more accurately, of the world of women's fashion: namely, the worlds of work and men's clothing. It is therefore, once again, via our 'strange semiotic phenomenon' (cf. Chapter 2 on the Apple and IBM logos) that the second component of Chanel's figurative semiotic was established – the signifiers of work and masculinity were retained so as to be very clearly and very precisely correlated with opposite signifieds: wealth and femininity. So, the jersey, sailor's blouse and striped waistcoat on the one hand, and the beret, trousers, tie and short hair on the other were respective representations of the world of work and the world of man. At the time no one missed the point and, of course, Poiret least of all. He scorned the 'luxurious wretchedness' of Coco Chanel and her 'little malnourished telegraphists'. So one can also understand why her contemporaries were often shocked by what was, at its best, her androgynous appearance.

This game of inversion between the signifier and the signified of sexual identity (as socially defined) is reminiscent of Jacques Prévert's mischievous adage: 'Un garçon manqué est une fille réussie' – 'a tomboy is a well-made girl', or more literally 'a mis-made boy is a well-made girl'.[6] More to the point, the game of inversion is a strategy by which Chanel was able to establish a definition of feminine identity that would be unique to her. And there is an even further precision to the semiotic conditions that enabled Chanel to bring that identity about – the very conditions which are of interest to us here. It is not the semiotician's role to identify the historical, psychological or any other 'reasons' there may have been for Chanel being the subject of these conditions. The essential point here is that we face the other component of the Chanel look's figurative semiotic. Let me explain. We have already noted that certain of the motifs and dress features that make up the representational dimension of the look spoke of freedom and modernness, and we have just shown how other features and other motifs spoke of the elaboration and definition of femininity according to Chanel. We can therefore assume that the figurative semiotic of the Chanel look ensured:

6. This is true. If a girl who dresses like a boy, speaks like a boy and plays like a boy is not always a boy (since she still 'lacks' masculinity as exemplified by the literal meaning of the expression *garçon manqué*), then one has to conclude that she is even more feminine than the other girls. She is truly a 'well-made girl'. Who has never fallen for the charm of a woman dressed in a man's shirt?

- on the one hand, a discourse defining a certain femininity that arises from a paradox and which thereby established the subject of the Chanel 'myth';
- on the other hand, a discourse about freedom specific to the 'century of steel'. One should narratively interpret that freedom as the value-object pursued by woman as defined in the first discourse. The various recognizable representations of the look referred therefore to a subject: woman, and her quest: modern freedom.

We should note that it is this figurative (or representational) semiotic of the Chanel look which became the main theme for the various Chanel biographers and that, even today, this is still what interests journalists. In making this observation, I am by no means questioning the relevance of such texts and approaches. I merely wish to indicate that, in this chapter, I will try to put forward a different aspect of that look: an aspect constituting its visual semiotic.

The total look's specifically visual dimension

Chanel's total look is not only composed of the signs that identify it, it is also — one could say in a very concrete manner — a silhouette, a perceptible shape deployed in space and subject to the gaze. The choice of materials, the quality of light, the way elements and accessories are brought together, the privileging of certain colours over others, or the outline of the female body itself: all of these elements that cause any 'look' to be truly and fundamentally a visual identity are so many choices that proceed, in short, from a certain 'vision' of how a woman should dress.

From this point of view Chanel's total look can be analysed as a visual process. This is a process in which the semiotic nature, the capacity to signify, is not restricted to verbal segmentation. By saying this, I realize perfectly well that I am proposing a 'strong double hypothesis' — as Greimas would say. Let me explain more precisely. The *first* side of the hypothesis would be: if we speak of a visual 'process', one theoretical consequence is that we must postulate a 'system': a system which has that process as one possible realization. Thereby we imply precisely the semiotics that is generally referred to today as visual semiotics. The *second* side of the hypothesis would be that visual semiotics is distinct from figurative semiotics. The latter relies on calling forth a visual statement's signifier (coloured surfaces, lines, and so on) by using a culturally relative 'reading grid'. It is actualized by breaking up visual objects according to a form of lexicalization, so that representations of the world are recognized and named. This is how Greimas, in elaborating his figurative semiotics, referred to the role of the reading grid:

The reading grid is semiotic in nature and brings forth the [visual] signifier. By taking charge of packets of visual traits of variable density which it establishes as representational 'formings' [*formants*], it transforms the visual representations of sign-objects and provides them with a signified. On closer analysis, the semiotic event shows that its primary constitutive operation is the selection of a number of visual traits and their globalization whose simultaneous uptake transforms the packet of homogeneous traits in such a 'forming' [*formant*]. This is a unit of the signifier that is recognizable as the partial representation of an object in the natural world when it is framed by the grid of the signifier.[7]

But within the scope of a *visual* semiotics, an object of visual meaning can also be approached as an *account* that can be subject to analysis – so the visual semiotics used here does not subscribe to the cult of the unutterable. But its analysis cannot be reduced solely to a lexicalization (whether this be thought of as an ordinary *or* a professional lexicalization). There is no meaning but that which is named. It is by starting from concrete analysis and empirical research (which I have carried out, on my own or collaboratively, now for over twenty years) that I make this observation and this is why I have come to reject the theoretical 'take-over' that was once attempted by Roland Barthes when he tried to reverse the relationship between semiology and linguistics. According to that reversal linguistics came to include semiology because there was no meaning but that which is named. By contrast I believe that defending and exemplifying the original Saussurean hierarchy in which semiology includes linguistics – a position taken by both Hjelmslev and Greimas – is actually one of visual semiotics' tasks. In other words, we should not accept the idea that an immediate and necessary lexicalization is incorrect when trying to establish a signifying whole; so that we *should* be able to recognize a verbal meaning in it.

But let us return to Coco Chanel's own figure or silhouette. The phrase 'total look' emphasizes that it comes across as a closed unit and as a whole which is both perceptible and intelligible. A striking aspect of this silhouette, when compared to those designed by Poiret or Dior – that is, those corresponding to the two great affirmative periods of the Chanel look, the 1920s and the 1950s – is that it allows a clear perception of its various parts. This silhouette proposes a precise combination of different units (parts of the body or parts of the dress), and these units can be valued separately. But at the same time, the Chanel 'silhouette' also leaves a general impression of clarity, of immediate readability, as well as an impression of steadiness [*aplomb*] – in both meanings of the French

7. A.-J. Greimas, 'Sémiotique figurative et sémiotique plastique', *Actes sémiotiques: Documents*, **60**(4), 1984. I have bracketed the word 'visual' which I have substituted for the word 'planar' [*planaire*] used by Greimas. This term was justified in a text written as a preface to a collection of visual semiotic analyses of photographs, paintings and architectural drawings.

word *aplomb*: physical stability and psychological assurance. So let us first examine the perceptible dimension of the total look.

1. The first characteristic is that the look produces a closure of the general shape. This results from what is clearly an 'attack' by the silhouette upon the black toes of the shoes. Ground and silhouette become dissociated, uncoupled. Indeed, if the colour beige has the advantage of lengthening the leg, the actual shape of the shoe does not attempt a smooth transition from ground to leg – as is shown by the astonishing shoes developed by the great Italian footwear designer Salvatore Ferragamo (Figures 4 and 5). Moreover, the black tip offers the obvious practical advantage of keeping one's shoes impeccable while, aesthetically, it is there so as to affirm the look's closed structure, its 'tectonic' shape, its wholeness. This closure effect is just as perceptible at the other end of the silhouette where we only have to look at the way the head is treated. Here we find the same longing for closure in the definite and short hairstyle, in the catogan (hairbow), or in the elaborately structured sailor's hat. This is utterly distinct from the ornamental plumes so dear to Poiret. The neck is clearly visible in the Chanel design and this contributes to an affirmation of the silhouette's clear segmentation as well as attracting attention to her emphasis on a certain 'way of holding one's head'.

2. A further characteristic element is the privileging of the line. This could, of course, be due to the tailored suit's famous braiding. In other examples it can be achieved by the design of a collar, by the presence of a belt, by the precision of a fold, or by the choice of a print. The line is also a question of weight. There is always a certain 'hang' to the Chanel look – and one which by no means detracts from the comfort and practicality of her dresses. We know that Chanel deliberately weighed her suits down with gold chains. On the other hand, we can note that this privileging of the line not only reinforces the overall segmentation of the silhouette but also that it ensures its own delineation and location in space. Because it functions as an outline, the overall line puts the

Figure 4 Figure 5

silhouette in a precise depth of field in relation to the observer and in relation to its environment generally.

3. For all this, there are also solid areas to the Chanel look. These are generally effects of the jewellery: bracelets, necklaces, brooches, pendants, and so forth. But they never overwhelm the silhouette's linearity in general or the specific linearity of any given part of the look. So, when Coco Chanel was still a milliner, her hats were distinctive by virtue of their delineation in space, and the clear delineation of her wide rims was even more noticeable because they lacked the excessive amounts of ornamentation which were otherwise the norm at the time. Moreover, these solid areas are always very simply placed: they are subject to a general principle of enclosure that governs the various parts of the look and this, in turn, allows for what we can think of as enclaves, spaces where the solid areas can 'express themselves'. The freedom of these solid areas, one which is consubstantial to them, is always a conditional freedom.

4. Finally, the Coco Chanel look includes its own light, which is captured and elaborated by colour and substance. So it is possible to talk about a Chanel chromaticism: beige (Chanel was nicknamed 'the queen of beige'), navy blue, white, red and black of course (with the famous 'little black dress', the number 5, the catogan (bow), the crêpe de Chine, and so on). Denouncing the 'palette' common to dresses worn by 1920s opera-goers, Chanel is reputed to have said: 'I'll bloody well fit them in black.'[8] But, on the other hand, there is also the sparkle of diamonds, the indecisive grey of pearls, the depths of gold and the glistening of gemstones. But we should note that these colours are always associated with the localized and solid areas of accessories. Light is also a function of materials and how they are worked. Jersey, tweed and crêpe – Coco Chanel's favourite materials – share a mastery of light: they avoid light's whims, its furtive sliding, or its overflowing with respect to form and contour. They prevent light from taking over the various parts of the look, from transforming it into one continuous movement. And as for those materials which tend toward glistening and moiré: these are used as contrasts so as to accentuate the design's intrinsic purity and clarity. The beauty of the dresses and suits made from these materials remains an articulated beauty.

The classical and baroque visions

Our analysis of the specifically visual dimension of the Chanel silhouette and the total look that it created leads us to recognize the peculiar realization of a 'coherent

8. Delay, *op. cit.*, p. 92.

perspective' which belongs to classical vision.[9] This realization is peculiar in that it accepts a baroque component so as to establish itself better by contrast. This said, we must further clarify the definitions of these classical and baroque visions. Without this, not only would our explanation appear arbitrary or even unduly pre-empted, but we would not be able to pursue the analysis of the Chanel look any further – and particularly the analysis of its ethical content. Indeed, the examination of this ethical dimension requires a semiotic interpretation of the two visions. So, I must now make the following three statements:

1. First, I must stress that the classical and the baroque are not defined here as periods in the history of Western art (roughly the sixteenth and seventeenth centuries) but as 'visions' or 'coherent' perspectives – and I will define these terms below.

2. Then I must specify that, in order to define these visions, I will refer to the work of the art historian and theorist Heinrich Wölfflin. I will therefore review the five categories that, according to Wölfflin, cause the classical and the baroque to be seen as opposite visions.

3. Finally, I must justify my view that such visions represent actual instances of the semiotic. Otherwise anything I might say below about the 'classicism' of Chanel would be of no semiotic importance. And, of course, my approach must always be semiotic – for it is this approach to visual identity that gives this book its purpose. Practically this means that I must demonstrate how the classical and baroque visions can be considered as actual semioses, each furnished with a plane of expression and a plane of content.[10] I will then examine and discuss a recent reading of the work of Wölfflin so as to reaffirm the coherence and viability of my own reading. What then are the five categories that allow Wölfflin to interdefine the classical and the baroque?

1. Linear versus pictorial

The classical vision involves, first of all, the primacy of the line: shapes and their various parts are created by contours (Figures 6 and 7). One could say that this is a view that sets out to segregate, to build hierarchies, to articulate in a visible way what it had isolated on an initial reflex action. 'Everything is drawn, line by

9. I use here Abraham Zemsz's expression to signify the visual systems underlying the semiotic processes of images, drawings and paintings. A. Zemsz, 'Les optiques cohérentes', *Actes sémiotiques: Documents*, **68**(7), 1985.

10. H. Wölfflin, *Principes fondamentaux de l'histoire de l'art* (Brionne: Monfort, 1984). This is without doubt the most important work that Wölfflin wrote on the classical and baroque visions. I have previously included Wölfflin's definitions and my interpretations of them as semiotic forms in two of my previous works: *Les Formes de l'empreinte* (Périgueux: Fanlac, 1986); and *Sémiotique, marketing et communication* (Paris: Presses Universitaires de France, 1990).

line, in a regular and distinctive way; every line appears conscious of its own beauty, but also of the fact that it must be in harmony with its companions.' Shapes established in this way become almost palpable, tactile and permanent; the world is shown to be controllable. The baroque vision, on the other hand, privileges solid areas and their associations (Figures 8 and 9). 'The mortal enemy of the pictorial effect is the isolation of the form.' Hence, this vision prefers objects to be linked and to merge, thereby giving the effect of an object in motion, of a moving apparition. The classical vision, on the contrary, sets out to establish stable structures, a measurable reality.

2. Planes and depths

The classical mind prefers a space organized into distinct planes, parallel to each other and frontal in relation to a fixed observer. This attention to different planes is connected with the focus on lines – every line is dependent upon a plane. On the other hand, the baroque mind prefers depth; it calls upon a plurality of points of view and avoids placing shapes side by side on a single plane; so it is no longer possible to analyse space as constructed through a number of neatly segregated slices. The directions suggested by powerful obliques, or the close proximity of points of view which can make two shapes of quite unequal size coexist in the same field of vision: these force the 'observer to absorb the whole depth of field, the whole space, in one single take, as a unique reality'.

3. Closed form and open form

A representation is said to be closed when, by means that are of a more or less tectonic nature, the picture appears limited by itself, reduced to a complete meaning; conversely, there will be open form when the work overflows in many directions, when it suffers no limitation, even though an intimate unity remains within it and ensures its closed character from an aesthetic point of view'.[11] If we take painting as an example, we will notice that the straight lines and the corners of the frame meet with a visual resonance in the general composition of the painting and that a baroque painting will always represent 'a performance in progress, where the gaze takes pleasure in partaking of it for a moment'.

11. Wölfflin, *op. cit.*, p. 139.

Figure 6
Huber, *Golgotha*

Figure 7
Benedetto de Majano,
bust of Pietro Mellini

Figure 8 Van de Velde, *House among the Trees*

Figure 9 Bernini, bust of
Cardinal Borghese

4. Plurality and unity

A totality established by the classical mind is represented as a plurality of elements which, while remaining distinct, must be in harmony. For example, a beautiful silhouette will be 'a harmony of organized parts which discovers its own fulfilment in itself'. It will therefore be clearly composed of relatively independent parts, each with its own interest. Against this concern for decomposition and localization that is characteristic of the classical mind, the baroque mind opposes a desire to absorb within a single form. And this principle of unification and intensification causes the various parts to lose their autonomy, to lose their rights to individual existence. Everything assists in the move towards propagation and, ultimately, towards fusion. This, however, does not mean that the baroque is synonymous with accumulation or abundance – for there is also a 'light' baroque which can be described as 'floating'. Compared with the classical, one could say that the baroque is not material: its values are visual, not tactile.

5. Light and dark

Finally, the classical and baroque visions are opposed by virtue of their concepts of light. According to the classical vision, light must work on behalf of a complete manifestation and instantaneous readability of forms. 'Each touch of light acts so as to draw the detail of the shape, to organize and place it within the totality.' While the classical mind will therefore play with light so as to render a material and 'definitive' reality, the baroque mind will privilege chromatic value and desaturation so as to render a reality that is subject to the vagaries of light. Hence clarity of form always appears to wrest itself from darkness. As Wölfflin points out, baroque light appears to enjoy a 'privilege of irrationality'. Here we meet again the typically baroque idea of a loss of cognitive mastery by a subject faced with a world taken as an event.

In this summary of Wölfflin's five categories, the reader will no doubt have noticed the recurrence of certain notions such as distinctness, permanence and isolation on one side; association, instantaneousness and indivisibility on the other. My intention here was to bring out the idea that these categories are actually five facets of a single coherent point of view. For instance, the focus on line over volume goes hand in hand with a representation of space in distinct planes and with a relative autonomy given to parts. Similarly, the contour of shapes arises from the same logic as that of their full manifestation (via light being put in the service of readability). Wölfflin himself stressed the reciprocity that unites all five categories. In the conclusion to his *Fundamental Principles*, he refers in the following terms to the passage from classical vision to baroque vision:

Considered in its fullest extent, the transformation in presentation depends on five pairs of categories. [12] Perhaps one could establish other categories – but as far as I am concerned, I can't easily see what these might be – and it could be that those outlined here are not so closely related as not to be re-used in other combinations. Nevertheless they reciprocally condition each other to a certain extent and even if one does not use the word 'category' in a restrictive sense, one can accept that they indicate five different points of view of a single thing. [13]

Some years ago, in *Les Formes de l'empreinte*, I tried to schematize these 'visions' in so far as they concern semiotics. [14] I noticed, in presenting Wölfflin's five categories, a double recurrence of terms and expressions: (a) certain terms and expressions have to do with the deployment or unfolding relevant to the classical and baroque approaches to perception and therefore to the plane of expression of their respective semiotics; (b) others have to do with the meaning-effects produced by the different approaches to form, light and space: these are therefore relevant to the plane of content. I arrived, then, at the following schema which shows the analysis of this double recurrence:

	Classical 'vision'		Baroque 'vision'
Expression	Non-continuity		Non-discontinuity
		vs.	
Content	Non-discontinuity		Non-continuity

This schema calls for some important clarifications which may be of interest – although perhaps only to semioticians concerned with theoretical arguments and knowledgeable about the most recent research on the relationship between semiotics and aesthetics. It is therefore quite possible for the reader to skip the following few pages and go straight to the further analysis of the Chanel look.

1. First clarification concerning my schema

It is now necessary to explain and justify each of the terms selected to refer to one or other level of each of the two visions:

– 'Non-continuity' (classical plane of expression). According to the classical view, the approach to the perceptible is fundamentally associated with decomposition, separation and delineation. This is why Wölfflin refers to

12. It is obvious that Wölfflin did not mean the term 'category' in the semiotic sense, as I do. I call a 'category' what he calls 'double categories'. This does not change anything of the relevance of his reflection, nor of the legitimate integration of it into semiotic research. As I have said elsewhere and some time ago, Wölfflin must be considered as one of the great precursors to visual semiotics in the structuralist spirit.
13. Wölfflin, *op. cit.*, p. 260.
14. Floche, *Les Formes.*

the classical as an 'isolating style'. And it is also why I have always preferred to refer to 'non-continuity' rather than 'discontinuity', the prefixes *se-* and *de-* always indicating, I believe, a negation. At this point, I would even prefer to refer to 'non-continuation' – and on the other side of things, to 'non-discontinuation'. This would emphasize the generative and dynamic aspects of these ways of treating the perceptible.

– 'Non-discontinuity' (classical plane of content). On the other hand, the meaning-effects produced by this negation of continuity are all subject, we might say, to the regime of the non-discontinued. Perenniality, stability, 'peaceful adjustment', as well as the controllable character afforded by the world, as seen by the classical mind, constitute just so many interpretations or thematizations of the negation of a discontinuity. And these interpretations are temporal, 'thymic', ethical, and so on. We will return to these diverse interpretations when we analyse the plane of content of Chanel's classical vision.

– 'Non-discontinuity' (baroque plane of expression). Against the classical, the baroque, as part of its expression, searches, exploits or provokes non-discontinuations of the perceptible world. It privileges extension and transgression (in the spatial meaning of the term) and creates visual motifs such as interlacing.

– 'Non-continuity' (baroque plane of content). Finally, the meaning-effects produced by the baroque derive from the regime of non-continuity. Wölfflin says that the baroque view had 'the knack of reducing the instant to the narrowest of points'. Such an observation by the art historian is a good indication that the search for non-continuity takes the whole space-time complex (as opposed to mere temporality) as its target. And we will see that the baroque subject's presence in the world, its passions and its cognitive competence all derive from this semantics of non-continuation.

2. Second clarification

The schema I am proposing for the classical and the baroque visions has the advantage of affirming or recalling that these forms of aesthetics are semioses, real semioses with a plane of expression and a plane of content. In other words, to be slightly more theoretical, this means that they are defined by the non-conformity of their planes: these are not symbolic systems in the Hjelmslevian sense of the word.

3. Third clarification

This third clarification refers to another semiotic reading of Wölfflin's works. My

schema of the classical and baroque views, roughly sketched as it may be, at least has the advantage of limiting the reduction of the classical and the baroque discourses to a single dimension: that of affect and passion. Or at least it avoids the excessive privilege often given to these. Passions, in that some may be classical and others baroque, must remain, I believe, presuppositions in relation to the already presupposed category of non-continuation versus non-discontinuation; and the same must hold for – though not at the same level – presence in the world and cognitive competence.

Therefore I do not totally agree with the reading of Wölfflin's work by semiotician and poeticist Claude Zilberberg in his book *Présence de Wölfflin*[15] – no matter how cogent this reading may be and no matter how much help it may offer to someone who has an actual and long-standing interest in the prosodic aspect of the classical and baroque views. For instance, we must recognize the focus and the authority with which Zilberberg stresses 'the part played by tempo in the identification of the consistency of styles'.

Zilberberg indeed believes that he does not 'move away' from Wölfflin in his readings of *Renaissance and Baroque* and the *Fundamental Principles* 'because, in the latter, the destiny of forms belonged to the plane of expression of a semiosis and the "matter" (Hjelmslev) of the plane of content of that semiosis was "human sensibility" or "the spiritual and sensorial contents of historical periods" '.[16] It is true that, with this statement, the poeticist does not depart from the art historian. However, I believe he does so when he privileges 'the affective, passionate dimension of the analysis of forms' – a privilege that supposedly corresponds to 'a specifically semiotic perspective'![17] Does affect then become 'the cognitive key' to understanding styles and do styles becomes 'a formal and affective' complex? This is what Wölfflin would have argued. Consequently, the opposition between classical and baroque could be schematized as follows:

Form:	Classical	Baroque
Affect:	Ease	Unease

For Zilberberg, 'the discontinuities of form in the play of forms are isomorphic with the affective discontinuities. From this standpoint alone [one must] accept the hypothesis according to which the classical style chooses distance while the baroque style chooses presence ...'.[18]

Looking more closely at these observations on the classical and the baroque, I believe there is no real need to abandon the schema I proposed in 1986 in *Les*

15. C. Zilberberg, 'Présence de Wölfflin', *Nouveaux Actes sémiotiques*, 23–4 (Limoges: Pulim, 1992). I deeply regret that Zilberberg was obviously not aware of my own schematization of the classic and baroque visions – though I must admit that it only appeared in a small book on photography.
16. *Ibid.*, p. 14.
17. *Ibid.*, p. 1.
18. *Ibid.*, p. 25.

Formes de l'empreinte, and this for a number of reasons.[19] (a) They seem to account for the meaning-effects produced by the two views – as described by Wölfflin – in a more exhaustive and economical manner than Zilberberg's, while also sharing his concern for non-contradiction. In other words my schema appears to correspond to the principle of empiricism formulated by Hjelmslev and adopted by many semioticians.[20] (b) My schema is also more economical than simply privileging the passional dimension and working from the idea that this dimension must be constitutive. It is by no means obvious to me that affects should be 'the key to the cognitive'. The opposite could even be argued if we try to realize the fundamentally cognitive dimension of aesthetic works and try to show, for instance, that classical tranquillity is nothing more than a secondary meaning-effect, of a 'thymic' kind, produced by the idea that the world, when constructed according to the classical vision, is presented as controllable. Lévi-Strauss has repeatedly argued in favour of this fundamentally cognitive dimension of artefacts – certainly of works of art – and with a legitimacy provided by long and patient descriptions of these works. And my own descriptive experience, although much more modest, has led me to agree with the anthropologist's conclusions. (c) The analysis of Chanel's work also leaves me convinced of the sound viability of the schema that I developed from a reading of Wölfflin's texts, from an examination of the actual works that he mentions and from the study of contemporary paintings and photographs. Indeed, the schematization accounts for:

– the passional discourse of the two visions;
– as well as their respective ethics; and
– their way of conceiving presence in the world and depth of field.

For I do not believe either, contrary to Zilberberg, that the classical and the baroque are opposed according to distance and presence on the semantic axis of depth (Figure 10):

Figure 10

As far as I am concerned, the classical and the baroque are opposed by virtue of two different ways of addressing the problematics of presence in the world

19. Floche, *op. cit.*, p. 108.
20. I must stress that this principle of empiricism as defined by Hjelmslev remains for present-day semioticians the criterion of scientificity for their theories. Recall that this is mentioned in footnote 13 of Chapter 1 (p.26).

and of depth. I will merely mention here that it would be dangerous to confuse the *phenomenological* problematic of depth (as ; ociated with such philosophers as Merleau-Ponty and Deleuze) with the *aesthetic* notion of depth (associated with Wölfflin). Wölfflin's depth refers to the baroque manner of perceiving and dealing with presence in the world – for which phenomenological depth is the 'first dimension', the constitutive dimension. There is, therefore, sufficient space for another approach to the same presence/depth relation: namely its opposite, that of the classical vision.

The schema I have proposed for these two visions can account for these two approaches respectively. If we accept, on the one hand, that depth is a perceptible form taken up by presence in the world and if we accept, on the other hand, that this presence is a subject of the phenomenological discourse inherent in every aesthetic, then it is possible to identify the respective semiotic relationships of the two views (expression and content) within the depth of representation of the works. Beyond subject matter and any situations actually depicted in such works, the classical will deal with the depth of being-in-the-world according to a logic of non-continuation – while the baroque will do so according to a logic of non-discontinuation.

And were we to do this with pictures? This is the least one could ask of someone who claims to be a semiotician of the visual. To build a picture, I shall present some small 'proxemic' scenarios; an approach which I believe is perfectly appropriate under the circumstances. Presence to the world is, according to the classical principle of non-continuation, a step back taken by the subject in relation to a world which is still within arm's reach. Baroque presence is the opposite and works according to the principle of non-discontinuation: it is the coming forth towards the subject of a world which is still within its vision.[21]

4. Finally, I offer a fourth clarification of my schema

This schema enables us to predict that co-realization within a single statement will illustrate a semi-symbolic system, one which is characterized by the coupling of a category of expression with a category of content. This semi-symbolic system –

21. This is how the baroque scenario for phenomenological depth generates its 'immediacy of proximity of point of view' which Wölfflin considers (and rightly so) to be specific to that vision. We should now finish this reflection on phenomenological depth and aesthetic depths. But let me just indicate here that I intend to return to this at length in a forthcoming work, provisionally entitled *Essais de sémiotique esthétique*. This work will, amongst other things, be an 'argument for and illustration of' this distinction between phenomenological depth and aesthetic depths; using concrete analyses of contemporary pictorial works (Cézanne, Giacometti, Barré, Benrath, and so on) and very old pictorial works such as the Russian icons of the fifteenth century. I must point out here that I have already briefly introduced this distinction in my address to the Bilbao Colloquium (1990) on the 'Visible': 'Is the abstract–figurative opposition important enough to mean that we should adopt such serious and deep methodological options in visual semiotics?' (due to appear in the Italian journal *Versus*).

which could be assimilated to a complex prosody – will display the remarkable particularity of exploiting a single category for both its expression and its content: continuity versus discontinuity, and achieving this by an inversion of terms. This semi-symbolic system that I mention is, of course, Chanel's total look. So let us now return to the actual analysis of this look and its discourse.

Coco Chanel's classical vision

We have already examined the perceptible dimension of Chanel's silhouette. There we identified a certain number of formal, topological and chromatic characteristics of it by comparison with those created by Poiret and Dior. And these characteristics indeed corresponded to those of a classical artwork. We could even name a few that would correspond to the realization of one or other of Wölfflin's categories – even if it is more appropriate to think in terms of a global characterization and a global 'vision'.

- The braiding of the tailored suit (the jacket, its pockets, and so on) or, for instance, the silhouette made by the little black dress: these illustrate the 'linearity' typical of the classical vision.[22]
- The different treatments of the front and back of the suit, the side-by-side aspect of the braided pockets, or the precise spatial location of the contact between the silhouette and its ground: these can be understood in terms of a need to distinguish clearly a certain number of spatial planes and to stress the frontal aspect of the look.
- The closure effect of the silhouette – achieved as much by the black toe of the flat shoe as by the short hair, the catogan (hairbow), or the sailor's hat: this establishes what Wölfflin calls a 'closed form'.
- The contours, the insistence on isolating shapes and the precise placing of a few actual solid areas (bracelets, necklaces, brooches, etc.): these correspond to the principle of 'plurality' which is opposed to that of unity found in the baroque.
- Finally, the privileging of colours such as beige, black and navy blue, and the recurrent choice of materials such as jersey or tweed: these can be seen as means of creating an 'absolute brightness', not just the 'relative' brightness of the baroque.

22. In his *Chanel solitaire*, Claude Delay reports some of Chanel's ideas, testifying to her love of 'line' and a certain historical consciousness of a return to a classical vision: 'A closure before 1914! I didn't expect, when going to the races, to witness the death of the nineteenth century, the end of an era. A magnificent era but a decadent one, the last glimpses of a baroque style when ornament had destroyed line, where excess had choked the body's architecture, as tropical-forest parasites would choke a tree.'

This said, however, there are, nevertheless, baroque elements in the Chanel silhouette. These are, primarily, the accessories (bracelets, necklaces, brooches, and so on) and the chain on the quilted bag.[23] Solid areas, glistenings, fusions, interlacing, flashes or ephemeral glimmers: the great visual effects of the baroque are recognizable here. But, let us note once again that these are quite precisely circumscribed. They do not in any way undermine the classical ordering of the overall silhouette. Everything points to these baroque visual elements being there simply to magnify – as a contrast or counterpoint – the fundamentally classical vision of the Chanel look. And because it is via accessories that the counterpoint is established, it appears that we must agree with Barthes' thesis about 'trinkets' as opposed to jewels.

> The most modest of trinkets remains the essential element of any attire because it represents its desire for order, for composition; that is, for what could be said to be intelligence. ... The trinket reigns over the clothing not because it is absolutely precious but because it provides a decisive element in making it signify. It is the meaning of a style that from now on is precious, and that meaning is not a function of each element but a function of their relationship. In this relationship, it is the detached term (a pocket, a flower, a scarf, a trinket) that ultimately holds the power of signification: a truth that is not only analytical but also poetic.[24]

Although the focus of attention of Chanel's total look draws upon a classical vision, this look nevertheless remains, semiotically, a complex term which conjugates, without conflating them, classical vision and baroque vision. We should note that the 'signs for an immediate identification of Chanel' as drawn by Karl Lagerfeld indeed constitute signs that are both necessary and sufficient for the expression and perception of that complex term. The Chanel total look is therefore one of those 'small mythologies of the eye and the mind' that I have always valued.[25]

23. The baroque counterpoint can be realized according to the semiotic phenomenon of recursivity. (A phrase such as 'the colour of the leaves of the trees of the garden of the neighbours' is a linguistic illustration of this.) Indeed, this syntagmatic unit can be found as such inside a similar hierarchy – that of the total look – at various levels of derivation. One can find the baroque in the embroidery of the 1920s or the braid of the 1950s, for example, which are on the inside of the clothing (or parts of the clothing), and this is a classical vision if one considers the Chanel outline in its totality. This is to say that I consider it possible for recursivity to be thought of no longer as the sole property of natural languages.
24. R. Barthes, 'Des joyaux aux bijoux', *Jardin des modes*, April 1961.
25. I allude here to one of my works, *Petites Mythologies de l'oeil et de l'esprit* where I define semi-symbolism and illustrate its realization in a diversity of visual semioses: photographs, drawing, architecture, painting, comic strips and advertising posters.

Coco Chanel and Robinson Crusoe

Coco Chanel is classical.[26] But, as we saw, she nevertheless remains concerned with a need to find means to ensure that the baroque counterpoint remains essential to the affirmation of her vision. And she will do this 'with any means at hand'. She will use the embroidery to be found on those dresses-with-braces from the Russian folk tradition, motifs from Byzantine goldsmiths, Florentine and Egyptian finery, the precious jewellery of the Paris of the 1920s which brought colours and gemstones back into vogue.

But Chanel is not only being a bricoleuse when she makes sure some contrapuntal baroque element is retained in her look. She is also doing this when she assembles the totality of the look. That is, she also, and most importantly, uses bricolage to make up the overall classicism of her silhouette. And she did this even during her early days as milliner when making hats from out of those she bought from the Bon Marché department store. As always, and I will return to this in greater detail in the next chapter on Habitat, such a bricolage presupposes a transformation of elements that have been collected and subsequently 'summoned', as it were. Bricolage is not a mere transportation of a unit from one semiotic system into another. For example, Chanel used Scottish tweeds to make light subservient to form, but she also managed to convince the manufacturers to limit the washing of the wool so the tweeds would retain a certain softness. In this instance Chanel is interested in the appearance and the visual effect of the tweed and this is why she uses it – for its visual qualities and not for its qualities of thickness; not for its tactile materiality.

'Chanel constructed her own fashion according to her own needs in the same fashion that Crusoe built his island shack.' Is this a 'diagnosis' made by Paul Morand, as Claude Delay has proposed, or is it an observation by Chanel herself about her own creative process?[27] This debate is not important; the reflection is simply correct. With the bricolage aspect of the Chanel silhouette, we rejoin the figurative dimension of the total look. But this time we do so in a different way, approaching it from another angle: from the angle of the specifically visual

26. I am certainly not the first semiotician to say this. Roland Barthes already stated it in 1973 in an article for the magazine *Marie-Claire*: 'If today you were to open a history of French literature you would be sure to find in it the name of a new classical author: Coco Chanel. Chanel does not write with paper and ink (except for fun) but with material, form and colour. This does not prevent us from thinking of her as someone with the authority and the panache of a writer of the *grand siècle*: as elegant as Racine, as Jansenist as Pascal (whom she quotes), as philosophical as La Rochefoucauld (whom she imitates by also giving her best to the public), as sensitive as Madame de Sévigné and finally as insubordinate as that great woman with whom she shares a surname and a function (see her recent declarations of war on the fashion designers). Chanel, it is said, keeps fashion just at the limit of barbarism and fills it with all the values of the classical order: reason, the natural, permanence and the desire to please – no, to astonish.'

27. Curiously, Claude Delay notes this, first in relation to the diagnosis of the writer, Morand (*op. cit.*, p. 58) and, second, in the context of a reflection by Chanel herself (see *ibid.*, p. 117).

qualities of the bricolaged parts. I tried to show earlier how Chanel's use (in the 1920s) of certain signs borrowed from the worlds of sport, work and men's fashion reflected her non-acceptance of Poiret's silhouette and of the image of the woman it implied. In this she supported a certain ideological discourse concerning liberation and modernity. Chanel made Poiret unfashionable. She herself never hid her intentions: 'I wonder why I started in this industry and why I was seen in this context as a revolutionary. It was not to create something that pleased me but to ensure that what I didn't like would become unfashionable. I used my talent as an explosive. I have a strong critical mind and a strong critical eye. I have, as Jules Renard said, a self-assured distaste.'[28]

So Chanel's 1920s silhouette is a 'fact of fashion' but it is not yet, or at least does not yet appear to be, a 'fact of style'. Let me explain this distinction that I want both to introduce and to propose here: the distinction between 'fact of fashion' and 'fact of style'. Here I must try to outline an initial semiotic approach to this question.[29] The Chanel silhouette of the 1920s is a fact of fashion because her contemporaries saw in it elements borrowed from the worlds of sport, work and men; so thereby they grasped the silhouette's signifier via a cultural reading grid – one that was routinely applied by a certain class of French society from the early part of the century onwards. The Chanel silhouette thus gets its meaning and value, positive or negative, from the recognition of these borrowings and the difference between it and Poiret's. Similarly, but now in the 1950s, the Chanel silhouette will derive meaning and value from a comparison with Dior's and Schiaparelli's. It is, therefore, its figurative dimension, or its figurative reading, that establishes it as a 'fact of fashion'.

However, even in the 1920s, the same Chanel silhouette is a 'fact of style' in that it offers a classical vision and does so by contrast with the overall classical configuration on the one hand and the baroque counterpoint on the other. It is, therefore, a fact of style through its visual dimension which also provides it with the principle of its sensory invariance. This visual dimension states that the 'silhouette' is a sensorial totality by another use of its bricolaged elements. She subjects it to a certain tempo – as Zilberberg would have it – and causes it to draw upon a second discourse – one with an essentially ethical nature, as I hope to demonstrate below.

Two observations can be made regarding the notion of 'fact of style':

- I think it's fair to interpret the opposition between fact of fashion and fact of style on the basis of the opposition between character and 'preserving oneself' or 'self-control' [*maintien de soi*] proposed by Ricoeur – an opposition

28. P. Morand, *L'Allure de Chanel* (Paris: Hermann, 1976), p. 143.
29. There are already many other approaches to this distinction between fashion and style. I refer to the critical synthesis proposed by Gilles Marion in his recent work *Mode et marché* (Paris: Liaisons, 1992), pp. 95–105.

used earlier in the chapter on the Waterman advertisement (Chapter 1). 'Fact of fashion' would correspond to the pole of identity formed by character; so it would be associated with time – even though, paradoxically, fashion is usually thought of as short-lived. On the other hand, 'fact of style', by virtue of its productional logic, corresponds to the pole of ethics and the 'life project'. One would then have the following correlations:

Fact of fashion	Fact of style
Figurative dimension	Visual dimension
Character-identity	'Preserving oneself'-identity

– But, on further reflection, perhaps we should also include in the definition of 'fact of style' something of the pole of character. Perhaps we should see the fact of style as a fixed or static rhythmic syntagm. The fact of style could then be defined as the production of a self-preservational-identity that would have been taken over – or 'recovered', to borrow an image from Ricoeur – by the logic of a character-identity. Such a position would account both for the style's inscription in time and for its appearance in the guise of replaceable unities. The 'total look' would then be a syntagmatic unity that displays and encapsulates a rhythmic structure which, in turn, works as a secondary modelling system.

An ethics of control

Earlier, I proposed a view of depth (in its phenomenological sense) as the primary 'sensorial form' covering the presence of the world to the subject and vice versa: the presence of the subject to the world. We have also seen that the classical vision subjects sensorial forms to the principle of non-continuity. Without returning to this topic as such, we must nevertheless note the following: depth can also be the sensorial form that the presence of self to the world of *others* takes – for the world is not only a world of things – and we should therefore expect that the classical subjects its relationship to others to this principle of non-continuity. I think this is how we can interpret Chanel keeping her distance from others (or putting a certain distance between herself and others) – particularly where close relatives were concerned. Even though many more questions can be raised when addressing the issue of the relationship between aesthetics and ethics, two such can be raised here in that they directly concern our purpose:

– Is it legitimate to see in the non-continuity of depth between self and other a classical 'form of life' – considered as a 'tempo' (as Zilberberg's

problematic would have it) – which would somehow precede its realization in an aesthetics?

– Or can we think of aesthetics as primary, as a presupposed semiotic generating a proxemic system and therefore one which presupposes a relational 'lifestyle'? This would allow us to show the three moments in the generation of a 'form of life' as follows:

> Relational lifestyle
> Proxemic system
> Aesthetics (as a semiotic form)

But these two questions depend on considerations that would take us beyond the scope of this chapter. Let us rather address just one central aspect of them: the content of Chanel's classical aesthetic. Recall that, in our schematization of classical and baroque aesthetics, the classical effects of meaning relied on the principle of non-discontinuity, where beings and things are evaluated and valued according to a kind of control or preservation. By contrast, the baroque evaluates and values them according to a non-preservational mode – that of non-continuity. Now this preservation or control which acts as the foundation of all classical discourse can be 'converted' into narrative structures whose contractual relationships and established trust will generate states of mind such as quietness and tranquillity – here, Wölfflin refers to the 'peaceful' character of the classical world.[30] Further, going beyond this first 'conversion', classical control can be transformed into a value; just as love, which is in itself another form of account, can be transformed into a value. That is, one can search for love or fear it. Therefore, if control is seen as a value and if it becomes the underlying value of a 'life project', then it must be admitted that any such quest, 'on the scale of a lifetime', is part of an ethic, in Ricoeur's sense of the term.

Finally, to complete the extended definition that I want to apply to Chanel's ethics, two more points need clarification:

– on the one hand, 'control' can refer to the relationship of oneself to oneself, so that it comes to mean 'to control oneself';
– on the other hand, a subject can develop an enabling strategy for perceiving his or her quest for such conscious control: he or she will then be sure that the other knows that he or she has a preference for controlling him- or herself.

30. I refer to conversion deliberately because I am alluding to the generative course [*parcours*] of meaning and to the processes that ensure and regulate the passages between the various strata of that course. Each one of these passages corresponds in fact to a return to and an enrichment of meaning [*signification*], meaning from the moment at which it is produced up to the moment of its manifestation. See the entry on 'conversion' in A.-J. Greimas and J. Courtés, *Sémiotique, dictionnaire raisonné de la théorie du langage*, vol. 1 (Paris: Hachette, 1979), pp. 71–2.

I have already focused on such a detailed recognition of the generative course of the ethics of 'control' because this ethic is indeed one that corresponds to Chanel's classical aesthetics. But why is this ethic of control of greater interest to us than any other dimension of the discourse of the Chanel look? Because the silhouette established by that look was conceived by Chanel for herself, long before it became a creation for others, a fact of fashion, or a system of signs. As I have tried to show, the Chanel silhouette cannot be reduced solely to the figurative dimension and even less to its historical connotations. It was endlessly enriched, redefined, defended and illustrated. Using Ricoeur's terminology, it represents 'consistency' and 'perseverance' rather than continuation or conservation. Recognizing the silhouette's invariants and examining its ongoing enrichment: both of these convince me that this silhouette is indeed a fact of style and that it speaks of a project of life, or of an ethical intent whose basic value is one of control or preservation. In other words, it represents both a life project and a form of life.

Also, just as we left it to the historians and the sociologists to analyse in depth the figurative dimension of the Chanel look and its connotative meaning-effects, so we must now leave it to those semioticians who are interested in the passions to analyse the thymic component of Chanel's aesthetic. Once again it is my belief that this thymic component is but a secondary presupposition of the already presupposed principle of non-discontinuation in Chanel's classicism.

The ethics of control manifests itself in Chanel via the attitude of the head, the level shoulders and the straight back. Edmonde Charles-Roux, one of her biographers, said of the young Chanel: 'She holds herself upright, and she will hold herself upright all her life.' Lagerfeld too has often stressed the role played by the neck and the shoulders in the Chanel silhouette. But these elements of the body can only be used to express such control via a specific approach to the shapes, fittings and materials of clothes, along with their treatment: a specific cut or a specific 'hang' or a coiffure that reveals the neck, all of which, as it were, direct [*scénographient*] the way the head is held.

Such control was often mistaken for rigidity and this was something that Coco Chanel would not have thought of as the negation of freedom – so much so that the Chanel style could even be characterized by its complementarity between freedom and control. I want to explore further this rigidity effect because it quite usefully underlines the historical link, and a very personal one at that, between the dandyism of the nineteenth century and the ethics of control that Chanel advocated. Rigidity has often been mentioned in relation to the silhouette of the dandy. And we also know that Chanel's tastes were to a large extent shaped by her English lover Boy Capel, who was 'very serious beneath his dandyism', as Chanel herself would say. Claude Delay also recounts the following admission of Chanel's: 'Capel used to say to me: "Since you like it so

much, I will have an English tailor redo what you always wear but in a more elegant way." ... All of the Rue Cambon originated there.' And Delay adds: 'Boy Capel's assured taste trained her in a certain code, one from which rigidity is by no means absent. Nothing is overdone, superadded or over-elaborated.'[31] One day Chanel was thrilled by unintentional praise from an American: 'To have spent so much money without it showing!' To be so thrilled is to be a dandy.

Many elements of the silhouette and the dandy's way of life can actually be found in Chanel's ethics and aesthetics. 'The dandy was recognizable by his sober but impeccable attire; he counted on unobtrusive colours. ... The clothing was precise, the lines were straight,' observes Françoise Coblence in her work *Le Dandysme, obligation d'incertitude*.[32] And she reminds us that Beau Brummell's tie 'replaced the yards of lace and silk in which fashionable men of the period indolently draped themselves. Brummell introduced arch-straps to keep the trousers tight over the boots, and he pioneered the use of dressing and starch for ties, for these had to be straight but not to excess.'[33] Here we can recall Chanel's objection to Poiret's pomposity and how, accordingly, she lined her jackets with small chains to achieve a proper 'hang'. And it is striking to find in the dandy 'silhouette' the same chromatic range, the same sense of blackness, the same privilege accorded to the line.[34]

But it is even more striking to notice that the similarity in treatment between the dandy silhouette and Chanel's own – which is classical on every account and according to Wölfflin's definition – corresponds to a similarity at the level of content between dandy ethics and that of Chanel. Indeed, dandy ethics also relies on a valorization of, and a striving for, control or preservation. The principle of non-discontinuity (to which both classical semantics and Chanel's ethical dimension are subject) also rules dandyism's ethical dimension, as well as its passional or 'thymic' dimension. Non-discontinuity, when made a virtue, a strength of character, is a founding principle for dandyism as the 'heroism of modern life'. And this is a return to the Roman sense of *virtu*. We can notice that non-discontinuity is also the semiotic origin of the dandy's well-known impassiveness. This is why Françoise Coblence believes the dandy's charm 'is a charm of smooth perfection and nothing less than human perfection because it appears capable of escaping from both affect and time'.[35]

Here it is necessary to draw a parallel and prove a link between dandyism and Chanel's ethics and aesthetics. That is, we must compare their joint ways of

31. Delay, *op. cit.*, p. 56.
32. F. Coblence, *Le Dandysme, obligation d'incertitude* (Paris: Presses Universitaires de France, 1988), p. 41.
33. *Ibid.*, p. 114.
34. We will recall here the celebration of the colour black by the dandy Charles Baudelaire in *Le Peintre de la vie moderne*.
35. Coblence, *op. cit.*, p. 10.

articulating the chic with the banal, their shared love of discipline, their mutual attraction to religious habits, their conjoint taste for precepts and paradoxes — and also their common merciless dislikes.[36] In all this we would doubtless re-encounter the primary 'sensorial form', namely depth — still in the sense of the classical principle of non-continuity but now also organizing the 'inner' world. That way of being present to oneself, which correlates with control, does indeed bring Chanel together with the dandy. In this way we may also be compelled to stop thinking of classical 'peacefulness' as a state that is simple to attain, and to stop associating classicism too readily with being slack.

We have already seen something of the ethics of control in our analysis of Chanel's look — that is, by starting, as we might say, from its 'non-verbal' discourse. How then could we not be tempted to read (or re-read) Chanel's interviews, her precepts and confessions with a view to finding the same ethics in her verbal discourse? I have written about this elsewhere in my analyses of Kandinsky's *Composition IV* and Barthes' drawings.[37] I showed there that several of their personal notes could be read and valued as textual extensions of their visual discourses. This is a rather paradoxical way of considering the relationships between a speaker's verbal and non-verbal utterances. I have also collected all available documentation on what Chanel said or wrote. And this is how I came across a particular text, signed 'Gabrielle Chanel', in the June–July 1936 issue of the *Revue des sports et du monde* (then under the editorship of Paul Iribe).[38] In that article, entitled 'When fashion illustrates history' (Figure 11), Chanel outlines her reasons for both admiring and sympathizing with 'the women who lived from the reign of François I to that of Louis XIII', feelings triggered merely by looking at contemporary portraits — portraits which she describes as clear, astute and direct. And what does she say, or what does she imagine, about such women? She is astonished by their 'strength', by their

36. Let us point out here that Landowski analysed dandyism at length from a socio-semiotic point of view, inter-defining the dandy in relation to the snob, the 'chameleon' and the 'bear', starting with the dynamics of identity (centrifugal or centripetal) around a social figure that plays the role of pole-of-attraction as well as that of pole-of-repulsion. These dynamics can be defined according to the category 'disjunction vs. conjunction' projected on to the semiotic square:

'snob' style		'dandy' style
conjunction	vs.	disjunction
↑		↑
non-disjunction		non-conjunction
'chameleon' style		'bear' style

E. Landowski, 'Formes de l'altérité et styles de vie', in J. Fontanille (ed.), *Les Formes de vie* (Montreal: RSSI, 1993).

37. Floch, *Mythologies*, pp. 39–77 and 99–115.

38. Architect, advertising designer, caricaturist and magazine publisher, Paul Iribe took over direction at the *Revue Ford* which he renamed *Revue des sports et du monde*. One can find here texts by Louis Jouvet and Jean Giradoux. The text by Chanel was recently republished in J. Leymairie, *Chanel* (Geneva: Skira, 1987).

'character', by their 'desire to be present'. Then she assures us that these women, 'even though their personalities were stronger than at any other time, had become conscious of the fact that they had to perpetuate, maintain and exalt their own race for the strength it displayed in the present and the richness it represented for the future'. She repeatedly returns to their strength and dignity and concludes with the '*precise* and tangible harmony [which] already united all the major luxurious works of that same period'. It seems to me that this text of Chanel's quite clearly testifies to her classical vision. With words, expressions and, now, stories, Chanel continues to show herself as being sensitive to the 'clarity' of the drawing and to the 'precision' of the harmony which define classical expression. Chanel continues to show herself as being attached to these values which, in short, stem from control.

Figure 11

5

Epicurean Habitats

Putting furniture to good use

Some time ago, while analysing furniture manufacturers' catalogues and the furniture pages in mail order catalogues, I noticed that what was proposed there as the 'good use' of furniture implied a certain ideology. 'Good use' meant that, for every stage of life, furniture comes to be invested with specific consumption values. In other words we are supposed to purchase and enjoy our furniture differently according to whether we happen to be young or old – or more precisely, according to whether we are just starting out in life or are already well established in it. These distinct stages of life and their associated behaviours are somehow reminiscent of Epinal's pictures in which dual staircases symbolize the life cycle. For every ascending or descending step there is a corresponding couple at different ages. In this way, the viewer is informed about how life should progress and about the various stages to be encountered in one's love life and one's social life (Figure 1). We might even ask: could the mail-order catalogues actually be commercial avatars of that same popular imagery? In describing the 'good use' of furniture, I used the 'semiotic grid of consumption values', as developed during my various interventions into the areas of marketing and advertising. I first introduced this in one of my earlier works;[1] but since I also intend to use it in the first phase of this analysis of Habitat, I will summarize it briefly below.

In this chapter I want to argue for and illustrate the idea that what Habitat offers can be defined by the above-mentioned 'grid of consumption values' and

1. See J.-M. Floch, *Sémiotique, marketing et communication* (Paris: Presses Universitaires de France, 1990), pp. 119–52. I also presented an initial analysis of this 'good use' in a collection in homage to Fr J. Geninasca. See J.-M. Floch, 'Du bon usage de la table et du lit, et d'une approche possible du design', in A. La Baconnière (ed.), *Espaces du texte* (Neuchâtel: n.p., 1990), pp. 357–65.

 As far as the semiotic square is concerned I will now offer just a brief introduction. For a more detailed introduction, I refer the reader to many introductory works to semiotics and in particular

Figure 1

cont.

the critical description of the square proposed in J. Courtés, *Analyse sémiotique du discours, de l'énoncé à l'énonciation* (Paris: Hachette, 1991), pp. 152–60.

The semiotic square is a representation – both static and dynamic – of the first articulations of meaning [*sens*]. It is a topography of the relationships and the processes that constitute the minimal conditions for the production of meaning [*signification*]. Any category that articulates a semantic micro-universe (such as, for example, life vs. death, nature vs. culture, masculine vs. feminine, and so forth) can be 'projected' on to the semiotic square, and this enables us to recognize four isotopical terms: four positions of inter-defined meaning [*sens*] by three types of relationships and by two types of processes. Accordingly this is the structure we obtain:

– The two primitive terms of the category projected on the square (call them S1 and S2) are placed in a relationship of opposition (of co-presupposition): this relationship is represented horizontally.

– From any one of these two primitive terms one can derive, by a process of negation, a contradictory term; the two terms thereby defined are (sub-)contraries, each in relation to the other and they are therefore also located on the horizontal:

a. Non-S1 is the contradictory term to S1;
b. Non-S2 is the contradictory term to S2.

The relations of contradiction are presented by diagonals. These diagonals are shaped as arrows in order to visualize the course determined by the operation of negation created by the contradictories.

– The relations between non-S1 and S2 and that between non-S2 and S1 are said to be relations of complementarity. The process that corresponds to the course from one to the other of the complementarities is a process of assertion. This is the second type of process. Vertical arrows represent these complementarities and the assertions which determine the possible course from one term to the other.

that this represents a variation on the 'good use' of furniture widely disseminated in the manufacturers' and distributors' commercial literature. This is the first phase of the analysis. In the second phase I will attempt to demonstrate that Habitat's offering involves, more essentially or rather at another level, a chromatic–rhythmic structure. I will explain this concept below; but allow me for now to stress that this proposed chromatic rhythm is a *structure* and, moreover, a structure created from signs and therefore through bricolage. We will also see that it is a quite specific kind of bricolage in that its process – the collection of signs used to elaborate the structure – is a commercial one, a *'chine'*: around the world for Habitat itself and around particular Habitat shops for Habitat customers.[2] This is how the Habitat identity comes to be inscribed in the field of these investigations of visual identity.

At this point, I must also stress that the 'good use' which we are about to analyse corresponds to the more or less implicit proposal of a canonical development of the grid of consumption values. And I should also stress that, in using the term 'ideology' (as above), it is meant to have the specific meaning given to it in semiotics. That is, it refers to a syntagmatic articulation of values. Ideology should thus be regarded as an actualization of values that are merely virtual at the axiological level. To clarify this, at the risk of some imprecision, I would contend that ideology can be defined as a permanent *quest* for values.[3]

We should remember that the grid of consumption values arose from the contrariety [*contrariété*] established (in the discourse of sign users) between use

cont.

> – All this is rather abstract. So, let us return to the example given in a chapter called 'Etes-vous arpenteur ou somnambule?' in my *Sémiotique*, pp. 27–30. If one considers the category 'good vs. evil', its projection on to the square will allow us to recognize the two terms which, by negation, are contradictory to them respectively: 'not good' and 'not evil'. But although it is easy to conceive that saying 'good' implies 'not evil', and to say 'evil' implies 'not good', it is a little more difficult to recognize that one can perfectly well say 'this is not evil' [*c'est pas mal*, literally, 'that's not bad!'] without going so far as to say 'it's good'. The same thing applies to 'this is not good' and 'this is evil'. In other words, the negation of good (holding the position of not-good) will, and will only, lead to the affirmation of evil, which is to say moving up towards the position of evil.

Figure 2

2. Translators' note: Floch's specialist and multiple use of *'chine'* is detailed in a later section, 'On chine, pp. 129–35. For now it can be thought of as 'hawking' or 'hawking around', either as a buyer or a seller – for example, at a fleamarket.
3. See the entry on 'Ideology' in A.-J. Greimas and J. Courtés, *Sémiotique, dictionnaire raisonné de la théorie du langage*, vol. 1 (Paris: Hachette, 1979), pp. 179–80: 'Values, in an axiology, are virtual and originate from the semiotic articulation of the collective semantic world. ... By investing themselves in the ideological model, they actualize themselves and are taken in hand by a subject, individual or collective. This is to say that an ideology, with respect to the level of semiotic surface structures, can be defined as an actantial structure that actualizes the values that it selects within the axiological systems (of virtual order)'.

values and basic values, and that it can be considered as an interpretation of Greimas's categorical distinction between the practical and the mythical which he uses to describe the values invested in the motor car.[4] But what is the meaning of 'contrariety'? And what do we mean by 'use values' and 'basic values'?

To introduce the distinction between these two kinds of value we can simply refer to the brief example given by Greimas and Courtés in their work, *Sémiotique, dictionnaire raisonné de la théorie du langage*: 'Recognition of complex narrative processes led narrative semiotics to distinguish between use values and basic values: the banana that the monkey tries to reach is a basic value whereas the stick he gets to execute this process can only have use value.'[5] And as far as contrariety is concerned, it is defined by the same authors as 'the relationship of reciprocal presupposition that exists between two terms on the semantic axis when the presence of one presupposes that of the other and, conversely, when the absence of one also presupposes the absence of the other'.[6]

Projecting the categorical distinction between use values and basic values onto the semiotic grid enables us to identify four major types of valorization which can (more or less arbitrarily) be called: the practical, the utopian, the ludic and the critical:

- Practical valorization corresponds to use values from the moment they are first conceived, as opposed to basic values; they could also be called 'utilitarian values'.
- Utopian valorization corresponds to basic values also conceived according to the relationship of contrariety. Where the distinction between use values and basic values articulates the totality of a 'life', these values can be called 'existential values', a term which may be less ambiguous than 'utopian'. Indeed, 'utopian' is too often understood in the now-common sense of an illusory world; while in semiotics it qualifies that space where the subject– hero finds himself or herself by identifying with the basic value that is the object of his or her quest.[7]
- Ludic valorization is the negation of practical valorization. (I am not completely satisfied with the term 'ludic' either, but doesn't lexical

4. A.-J. Greimas, 'Un problème de sémiotique narrative: les objets de valeur', in *Du sens, II: essais sémiotiques* (Paris: Seuil, 1983). I will return, in a different way, to this category in the Opinel chapter (Chapter 6).
5. Greimas and Courtés, *op. cit.*, p. 415.
6. *Ibid.*, p. 69.
7. No matter what, 'utopian' is certainly preferable to 'mythical' which is sometimes used by those who refer today to the square of consumption values. Indeed, 'mythical' can be understood by the reader in the Lévi-Straussian meaning of a conciliation of opposite values. 'Mythical' would then suggest an interpretation that is too restrictive for the type of valorization I'm referring to here. All these basic values are not conciliations of opposites. To valorize culture or nature is one thing. To valorize the conciliation of nature and culture is another.

creativity sometimes have to be risked, even at the cost of perennial complaints about useless jargon?) This type of valorization corresponds to an emphasis on values of gratuity, values which can be thematized as either ludic or aesthetic.

– Finally, critical valorization represents the negation of utopian valorization. This type of valorization can be understood as a logic of 'distanciation' from basic values, or as a logic of calculation and interests. Here, cunning, elegant solutions, and good cost-benefit or quality-price ratios are emphasized. This is the position exemplified by Ulysses, he 'of the thousand ruses' – *polumachineos*, the original Homeric adjective, is a good way of expressing the logic of this critical position.

As mentioned above, I have often encountered this same grid of consumption values in my analyses of the semio-narrative components of advertising communication, and also when studying consumer discourse. Accordingly, I have found it in the discourses of supply and demand, and also in such diverse trade sectors as those pertaining to cars, golf clubs, shoes, clothing and even bras – for not all bras are designed for support or 'control' [*maintien*], as the lingerie professionals would have it.

I have also come across the same consumptional axiology in furniture discourse as used by manufacturers and mail order companies – and it can also be found in the discourse of their clients, though this is not integral to our topic in the current chapter. Chairs, tables, beds and bookcases can be promoted as functional and practical, sure and solid, modern or traditional, luxurious and refined – even as economical and artful. Underlying these qualifiers, we can recognize, *in fine*, the four major types of valorization.

– Furniture presented as functional, solid or modular is invested with the values I have called practical; it is a means to an end.

– Luxury and refinement are two particular thematizations of the negation of use-valorization or 'practical' valorization. This is not to say that furniture described in such terms is not functional. It merely means that its *value* does not lie in its functionality.

– Once we accept that furniture can establish its value beyond its sheer functionality, it is to be expected that there are those who will invest it with existential values, as we called them above.[8] Furniture can then represent, for instance, modernity or tradition. It can locate the subject–client in his or her

8. This emphasis on existential values can be illustrated by the following editorial by Joseph Grange, taken from a catalogue for Grange furniture: 'What is a piece of furniture beyond its function, its utility, its practicality? It is the expression of an era, of its values, of its sensibility, of its opening on to happiness. We must know how to read these living archives of ourselves (which we call "styles") so they can speak to today's sensibilities.'

time, or mark his or her nostalgia for another time. Furniture invested in this way can be considered, in more general terms, as a representation of the subject's identity. Manufacturers may promise, for instance, personalized 'surroundings' [*cadre de vie*]. This is how one manufacturer introduces their catalogue: 'You are most likely to find your best possible world in your own home. This is where you can create a world that really suits you, away from the problems of the outside world and the accelerated rhythm of life. [We] fully [know] this because it is [our] purpose to help create your own domestic well-being.'

– And finally, furniture presented as economical and artful is part of the field of critical valorization. It represents an 'ideal solution' or a positive quality–price ratio and speaks to the fact that you are an 'astute organizer'. As another manufacturer says: 'This is how you can arrange your available space intelligently without breaking the bank.' And there will be distributors who claim they can call on integrated designers so as to offer furniture that is 'beautiful, functional and very cheap'. The semiotic grid below illustrates the four valorizations and, therefore, the basic axiology of furniture consumer markets:

'solid' and 'modular' furniture	**practical valorization**	**utopian valorization**	'traditional' or 'modern' furniture
	\|	⨯ \|	
'economical' and 'artful' furniture	**critical valorization**	**ludic valorization**	'luxurious' and 'refined' furniture

Figure 3

Let us be clear: this is an axiology by virtue of the fact that the valorizations are approached paradigmatically, according to their 'or ... or ... ' relationships or as a system of virtualities. We have not yet begun to examine the actualization of these values; that is, in terms of their 'ideology', as referred to above. Recognizing such an axiology is of value to anyone involved in marketing. It enables us to position the various manufacturers and mail-order companies in so far as their products call upon one or another such valorizations. In particular, mail-order companies develop and offer a number of product ranges where the concept and presentation, textual as well as visual, represent different valorizations of the products. One such mail-order company, in presenting its three ranges ('City', 'Country' and 'Life-Style'), opts exclusively for ludic and utopian valorizations. Another, which also presents three ranges ('Contemporary', 'Modern' and 'Style'), tries to occupy all four positions. To elaborate: critical and practical valorizations are articulated in the discourse covering the various products of the

'Contemporary' range while the other two ranges, 'Style' and 'Modern', will be allocated respectively to the ludic and the utopian valorizations.

Systematically exploiting the topography of this sector's discourse, when implemented over a number of years, is ultimately used for the following purposes:

– to track the overall market supply;
– to make a distinction between any manufacturer's or mail-order company's evolution with respect to any of its particular ranges, or else to its products generally;
– to identify 'leading products' that are launched to 'pull' the whole range or label from one position to another.

It will also be used to develop a qualitative typology of the customer base which can be used, for example, to follow trends in quantitative demand, once such a demand actually becomes quantifiable.

But let us return to our main area of interest: the 'good use' of furniture. This means that we should address relevant issues in a syntagmatic way because, as noted earlier, 'good use' involves a quest or a journey. All of the furniture that concerns us here is presented, as it were, 'in an environment'. This is the role and direct responsibility of copywriters, graphic designers and photographers. Hence the various catalogues show décors, characters, events, and so forth. Here, a young pregnant woman tries out a pub chair with her first child sitting on her lap (Figure 4). There, unruly kids playing in their bedroom test the durability of their bunk beds – made, naturally, from non-toxic materials (Figure 5). Again, it would be hard not to be moved by another such scene where the children serve breakfast in bed to their parents. The same catalogues don't hesitate to advise on what you are supposed to do 'when you first settle down'. For example, here is the introduction to a catalogue for a range of inexpensive furniture designed with young people in mind:

> Discovering the pleasures of settling in to your own place for the first time can be fantastic. Even if you only have limited space it's still very special. This is your big step forward, your big achievement, your independence! And even if your budget won't stretch to meet all your wants, you can still compensate by being resourceful.

And we could look in a similar way at accounts and representations aimed at older demographics. However, I want to move on to the central subject of this chapter: the particular visual identity presented by Habitat – a certain 'ambience', as Baudrillard would call it.[9]

9. Baudrillard gave over the first part of his *Système des objets*, to the analysis of the furniture system and the recognition of the category 'storage vs. ambience' [*rangement vs. ambiance*]. The axiology

TOUS LES MEUBLES DE CETTE DOUBLE PAGE SONT A MONTER SOI-MEME.

Vous essayez, choisissez et emportez vous-même.

Vous visitez notre exposition de meubles à votre rythme, vous pouvez toucher, mesurer, essayer. La plupart de nos produits sont vendus en libre-service. Comme c'est vous qui vous servez, vous payez moins cher...

● **möbelfakta**

Lorsque des lits superposés ont le label Möbelfakta, c'est pour vous l'assurance qu'ils sont solides, résistants et bien finis. Ces lits répondent aussi à des exigences très strictes en matière de sécurité, ils sont très stables et le lit du haut est bien protégé par une barrière suffisamment large. Lire p. 4-5.

Figure 4 **Figure 5**

Analysing the various accounts and representations presented in the catalogues, we can notice that the four broad types of valorization are connected to the various 'stages of life'. A definite 'life project' is therefore being proposed (or imposed — the distinction matters little in this case): for no one searches for just any value (or any type of value) regardless of the time frame in which it happens to occur. There is an order, a proper order even. So, as we have already seen, when starting out in life, we're supposed to look for economical and artful furniture — or for 'critical' furniture to use our terminology. Accordingly a marketing scenario develops around the young couple's first home which is geared towards selling what is called 'start-up furniture' [*premier équipement*]. This involves very basic pieces, easily shiftable furniture that can be afforded on a low budget. At this stage of life we are supposed to 'make the

cont.

of consumption that I have referred to and the recognition of this axiology in the discourse of the range may come across as a return to the problematic of Baudrillard, except that the philosopher's approach remains paradoxically very ideologizing for an enterprise that is supposed to demythologize. See J. Baudrillard, *Système des objets* (Paris: Gallimard, 1968).

most of limited space and limited incomes'. However, whether or not the couple happens to be married, there will soon be a child on the way and then a second one, so that it then becomes necessary to move out of the studio or two-bedroom flat. At this next stage, we're supposed to buy furniture that's durable, functional and adaptable – 'practical' furniture, according to the above axiology – 'furniture that grows with your children'. Then, if everything goes according to plan – and everything in the easy, opulent world of mail-order catalogues always does go well – we finally attain the stage of 'plenty'. Here we find ourselves having to entertain, so we can now resist the temptation to act irrationally or on impulse. For the 'pleasure of staging' [*plaisir de la mise en scène*] or just to reward ourselves for our well-deserved comfort, we now look for refined materials or for furniture whose size (not to mention the size of its invoices) shows us, and our guests, that we now appreciate the joys flowing from all things cumbersome and useless: 'This couch needs a place of its own!' And still time goes on – for people don't age in the commercial world – until we become more concerned with individual quality of life. So now, whether traditional or modern, the furniture comes to represent an 'environment specially made for your needs' or 'one that is convenient': it comes to represent your personal identity. Then we either return to our roots or else we take on the modernity or postmodernity of our times.

 Life is thus presented as a series of quests for quite distinct objects of value. Moreover, this chaining of events is located on a timeline, in a sequence corresponding to stages of life. It is on account of this sequence that I showed above how furniture catalogues work as commercial and kaleidoscopic variations on the forms of popular iconography that represent stages of life sequentially (cf. Figure 1). There is, however, one difference: Epinal's images show this sequence semi-symbolically and associate the ascending stairs with happiness (games, first love, social success) and the descending stairs with unhappiness (fatigue, the infirmity of old age, death).

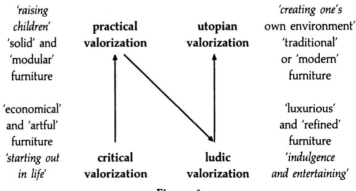

Figure 6

Using the grid of consumption values this is how we can represent the ideology of the 'proper use' of furniture according to the stages in life:

The natural and the non-essential

We have just seen how manufacturers and mail-order companies associate the four types of valorization with the four main stages of life and how they thereby propose a well-ordered journey through life – and perhaps a too well-ordered journey. The success of two major distributors, Ikea and Habitat, would tend to support this. Indeed, these two companies target the same customer base: the 'young home' [*jeune habitat*]. Nevertheless, they offer two quite distinct valorizations of the furniture designed for it. So it can be argued that Ikea and Habitat have divided up the four corners of the grid of consumption values. Each brand has taken on values directly opposed to the other; and they have done so without collusion (or at least not until the early 1990s), with Ikea promoting 'critical' and 'practical' values and Habitat promoting the 'ludic' and the 'utopian'.[10]

Ikea's philosophy reads: 'Our furniture must be attractive, follow rigorous criteria of usability and quality, and must be consistent with our low pricing policy'. The Swedish company's catalogues and shops are filled with 'economic miracles' that can be taken away in slim-line boxes to be assembled by the customer. The opening of the 1994 Ikea catalogue, celebrating fifty years in business, reminds us of the Ikea concept and its history. To illustrate this philosophy the designers chose to emphasize a particular product: a chair by the name of ... Albert (Figure 7). This is shown in the catalogue in a cut-out illustration at the bottom of the page, to the right-hand side of the following text:

> Do you know Albert? It's the chair on the right! Typically Ikea. Solid, sober, comfortable and designed for us by Lars Norinder. It costs only 159 francs and comes in either white or black. So just imagine the savings you can make on a complete lounge suite or bedroom suite from Ikea! If you're still doubtful, check out the following ...

Throughout the catalogue there are, then, constant reminders of the functionality, sturdiness, resilience and of the simplicity of use and maintenance

10. In October 1993, Habitat was taken over by the Sichting Inkga Foundation, a shareholder in its competitor Ikea. It seems, however, that the two companies will keep their respective specificities. Indeed, the directors of Habitat–France, more 'faithful' to the original spirit of Habitat than their English counterparts, have been placed by the Sichting Inkga Foundation at the helm of the Habitat group.

Et ceci explique cela. Nous développons nos propres produits, achetons en grande quantité, et proposons des meubles à monter soi-même. Là où nous faisons des économies, vous en faites aussi. Le principe est simple et s'applique aussi bien à un lampadaire halogène qu'à une cuisine complète.

Connaissez-vous ALBERT ?

C'est la chaise à droite ! Typiquement IKEA. Solide, sobre, confortable et dessinée pour nous par Lars Norinder. Elle ne coûte que 159 F (en blanc ou noir). Maintenant, imaginez un peu les économies réalisées sur un salon complet ou une chambre à coucher achetés chez IKEA ! Vous doutez encore ? Voyez la suite...

Les prix de ce catalogue sont tous garantis jusqu'au 1/8/94 Au cas où des dispositions gouverne-mentales, indépendantes de notre volonté, réhausseraient le taux de la T.V.A. nous serions cependant obligés, conformément à la législation en vigueur, d'augmenter nos prix dans les mêmes proportions.

Figure 7

of the advertised furniture. *Möbelfakta*, an Ikea-specific brand, testifies to these values which I referred to above as 'practical'.

Still, even more so than this practical valorization, promoting its underlying values is at the core of this brand's distributor's discourse. To be more precise quality–price ratios are its utterly recurrent theme: economy is the supreme value of the Ikea morality. And this is true for both the managers and the customers alike — the founder of Ikea, Ingvar Kamprad, writes in his *Furniture Salesman's Testament*: 'We should be thrifty, even to the point of meanness. We need neither big titles nor uniforms. Divide your life into ten-minute units and waste as little of them as possible on futile pursuits'.[11] The aesthetic that goes with this morality is one of 'sobriety' and 'lack of anything fancy': pale colours and the curves of the wood alone must ensure the 'warmth' of this simple and ingenious comfort.

Ikea would prefer what it offers to interest the widest possible audience; the brand works from the conviction that the simple satisfaction of 'natural desires', as the philosophers say, is a quasi-universal life model. What Habitat offers involves a totally different discourse. Indeed, the English brand, knowing as it

11. The culture of Ikea is deeply influenced by the Smolandish origin of its founder. In fact, the brand-name is made up of the initials of the first name and surname of Ingvar Kamprad and those of his first home town (Elmtaryd) and his first parish (Agunnaryd). Smoland is supposed to be the most desolate part of the south of Sweden and the Smolanders are supposed to be the paragons of ingenuity and economy.

does how to communicate to its élite clientele, promotes the fulfilment of 'natural and non-essential' desires – in this it follows the advice of the epicureans who believed pleasure to be the ultimate object. With this said, however, we should also bear in mind that the epicurean search for pleasure was part of its quest for freedom and a quality of life that excluded the desire for luxury – for this would surely end in suffering and servitude. Such philosophers hold that there are natural desires that cause us no pain if not satisfied; which is why they are non-essential. For example, it is natural, but not necessary, to want to experience a particular subtle taste, one that merely pleases the palate. Geneviève Rodis-Lewis, a specialist in ancient Greek philosophy, explicates this 'intermediary situation' – the non-essential desire. In order to satisfy such a desire:

> one must either remain within nature so that one is not enslaved by it, or else one must imagine it to be necessary, out of sheer passion and vanity. It is a natural pleasure to listen to birdsong, to smell a pleasant aroma, or to admire a harmonious shape. According to Lucretius, people from early times, their basic hungers being satisfied, would delight in music and dance [*De rerum natura*,V, ll. 1379–1407]. But the art collector or the aesthete, no longer satisfied with such simple surroundings, becomes as unhappy as the gourmet who is incapable of rediscovering the joys of frugality.[12]

Perhaps Lucretius was not such a bad pre-historian then. After all, has André Leroi-Gourhan not proposed that finding strangely shaped pebbles in prehistoric sites constituted important evidence of the presence of a human spirit in such remote times? Such pebbles were clearly collected and kept solely for the pleasure of contemplation. Having natural and non-essential desires would therefore be a basic human trait. Leroi-Gourhan certainly thought so; and so did Gaston Bachelard in a similar investigation, arguing that:

> for as far back as we can look, gastronomical value takes precedence over nutritional value and humanity finds its spirit in joy rather than pain. Overcoming superfluity leads to greater spiritual excitement than overcoming necessity. Humanity is created from desire rather than need.

'My tastes may be austere, but I don't reject pleasure.' This could well have been said by the epicureans but it actually comes from the founder of Habitat, Terence Conran, who likes to remind us that 'happiness is having a garden and a kitchen'. Indeed, for those accept it, Habitat offers a chance to become one of those collectors who know how to enjoy the pleasures of simple and beautiful things that are accidentally encountered rather than systematically and anxiously pursued. The true mentality of the Habitat brand, then, is that it offers its

12. G. Rodis-Lewis, *Epicure et son école* (Paris: Gallimard, 1976), p. 184.

product via a kind of shop where visits can be experienced as times for casual strolling and happy encounters. We will return to this later.

But for the moment, let us stay with the type of values, invested in Habitat's product range. With respect to our grid of values, Habitat's belong to two complementary types, the ludic and the utopian – and once again, each is in opposition to Ikea's values. Let's deal first with what leads to the ludic. As Conran himself has often emphasized, the Habitat concept is first and foremost that of being a shop. And, indeed, it is via the layout of the shop that the various products are put forward as simple and beautiful things on the one hand and as encountered objects on the other. And it is also via this layout that the customer is constructed as the subject of a natural and non-essential desire. In other words, if the shop makes the customer then the Habitat shop establishes its customer as an epicurean subject.[13]

The shop thereby creates a subject–object relationship; in this instance, a customer–product relationship. But, as far as this actantial relationship is concerned, we have only focused so far on the actant-subject. So let us now turn to the actant-object and how it is axiologically invested. I have already shown how the overall lighting of the shop, the journey it promises and the play between the accumulation and juxtaposition of the products supports a particular way in which these products come to be encountered. But this is not all. While their fairly obvious beauty, their shapes, colours and materials make these products into moving, curious and desirable objects, their pricing also makes them into affordable temptations. In other words, being less mercantile and more 'philosophical', these products have become possible objects of natural and non-essential desires. According to our earlier terminology, this is why they should be thought of as objects invested with specifically ludic value.

But still, Habitat products are not only simple and beautiful things; they are also cultural objects that are put forward and valorized as such. Moreover, not all are of English or Scandinavian origin. Visitors and customers can find English crocks and clocks alongside Scandinavian pine furniture, but they can also find Italian terracotta (with its obligatory allusion to the garden), Spanish lights, glassware and basketwork from the Far East, as well as a wide variety of Indian textiles – batik from Madras, linen from Bombay, dhurries from Jaipur. And this is still not to mention the kitchen utensils that demonstrate a diversity of know-

13. Terence Conran would seem to want to make us relive the emotion that was his when, coming from England, he discovered France, its everyday aesthetic, its material culture: 'I am very English. In 1964, when I opened the first Habitat shop in England, I had in mind selling France to the English. I had discovered your country after the war in 1952 and it was a revelation to me. I was extremely impressed by the beauty of simple things, the fruit and vegetable stalls, the ordinary objects: an enamelled coffee-pot, a wine carafe. And by the *joie de vivre* of the French.' (The quotations from Conran cited here come from a number of recent articles about Habitat, about Conran himself and about his new company, The Conran Shop.)

how and taste: the famous English 'chicken-bricks' [*brique de poulet*], the Chinese woks, the Moroccan 'tagines'. These cultures and their material identities derive their diversity not only from geography but also from history (at least that of the late nineteenth and twentieth centuries): at Habitat we can find Shaker woodwork, furniture by De Stijl and the Bauhaus, Streamline accessories and utensils, and so on. And in addition, such references are quite overt for anyone who knows how to identify them.

The Habitat customer is thus led to understand these brand-name products as signs, or even as 'prestressed blocks' of meaning, in Lévi-Strauss's sense of this expression. Indeed, this is how the Habitat range shows, implicitly but very clearly, that the brand targets a quite well-educated customer base.[14] As objects of natural and non-essential desire and because of their simple beauty, Habitat products set up a ludic valorization. At the same time, as objects of meaning, invested with a diversity of cultures and material identities, the same products also set up a utopian valorization: they testify to investments in basic values (identity or difference, nature or culture, and so on).

So now, to complete the comparison between the two makes, let us look at two pages from the Ikea and Habitat catalogues (Figures 8 and 9). It seems to me that these pages are perfect illustrations of their axiological values and their respective discourses.

On '*chine*'

As foreshadowed above, we must now return to the question of the relation between the Habitat range and its clients. We have already seen how this encounter qualifies the relationship between object and subject by investing the latter with a natural and non-essential desire, an epicurean taste for aesthetic emotion.[15] And we have seen that the Habitat range comprises selections and collections of meaningful objects – call them signs – originating from diverse

14. The failure of Habitat in Ulis, a suburb of Paris, on the one hand, and the success of its shops in the large French university towns, on the other, have convinced Habitat of the élitist character of its range.
15. Conran and his team have themselves felt this aesthetic emotion. It is actually rather curious to find, in the story of the 'birth' of a Habitat product, the same conjunction between chance and necessity which characterizes aesthetic emotion in Lévi-Strauss: 'How is a Habitat product born? Through both chance and necessity, of course. The necessity is obvious. One must fill the shop, fill the order book, satisfy the customer and, nevertheless, preserve the spirit. Chance, for its part, is without a doubt far more interesting. Whether it's objective, accidental, guided by feelings, coincidences or facts, it's always a short story with a number of twists to it. A chance and a necessity that cannot escape generalized but transient fascinations, and still implement permanence' (G. de Bure, *Habitat 20 ans de quotidien en France* (Paris: Michel Aveline, 1993), p. 59). See also C. Lévi-Strauss, *La Pensée sauvage* (Paris: Plon, 1962), p. 39.

Quand on s'installe pour la 1 ère fois, on a tout de suite envie de se sentir chez soi. Et quand on rêve d'un palace et qu'on a pas de quoi, on va chez IKEA! Et là, pour *5690F,* vous avez tout un ensemble de meubles fonctionnels, bien déssinés, pratiques et coordonnés. Voilà vos m² aménagés intelligemment, sans vous ruiner.

Tout le studio pour

5690ᶠ

Figure 8 The whole studio for 5690 francs

When you get your first home, you'll want to feel at home right away. If you dream of living in a palace but can't afford it, go to IKEA! You'll find everything you need there: well-designed, practical, co-ordinated furniture. For just 5690 francs. You can get your place furnished with flair, without breaking the bank.

TIONS

Plus que jamais, la maison est intime, personnelle. Constellée d'objets souvenirs, elle évoque les voyages, la poésie. Et vous invite à l'invention, appliquant finalement l'esprit d'imagination "A la carte", si cher à Habitat. On aime y retrouver de jolis meubles simples, à utiliser au maximum, ou même à détourner avec humour de leur sens premier. La maison devient douce et belle dès lors qu'elle est l'image de notre passion. Petits croquis secrets, bibelots curieux des quatre coins du monde, on n'hésite plus à s'afficher chez soi.

Figure 9

More than ever before, home is a personal and intimate place. Filled with mementos, it evokes travel and poetry. It calls you to be inventive, to ultimately apply that '*à la carte*' spirit of imagination that's so dear to us at Habitat. There, you'll be happy to discover great-looking but simple furniture. You can put it to work, or play around with its original purpose. Your home can become pleasant and good to look at if it reflects your desires. Secret drawings, curios from the four corners of the world; you'll no longer think twice about being yourself when you're home, and being proud to show it.

cultures and practices. From both of these standpoints we might conclude that visiting a Habitat outlet is akin to hawking or ragging, to what is called *chine* in French. The idea of *chine* comes from the French verb *chiner*. What is this *chiner*?

The *Petit Littré* defines it as 'to assign different colours to the threads of a warp and to locate them in such a way that a design emerges during the process of manufacture. To *chiner* cloth.' This doesn't appear to give us quite what we are looking for: namely, the specific consumer behaviour involved in looking around without looking *for* something in particular, when we open ourselves to aesthetic emotion. It is true that *chine* is difficult to describe: it is a short story in its own right, one we can barely define by accumulating verbs such as 'roaming', 'finding', 'doing business', and so forth. So we need to look for something better and turn now to the *Petit Robert* dictionary. It distinguishes between two verbs *chiner*:

Chiner 1 (from 'China', the country of origin of the process): alternating colours on the threads of a warp prior to weaving the cloth, in such a manner as to end up with a design once the weaving process is complete;

Chiner 2 (probably from an alteration of *échiner*: to do back-breaking work); this second *chiner* appears to have two accepted meanings: to look for a good deal (as a second-hand dealer or a hawker would do) and to send up or rag in an ironic or joking manner (a meaning that might originate from the idea of cheating the customer).

As it turns out I have had several personal experiences of working in marketplaces that are conducive to *chine*: the fleamarkets, such as those in Saint-Ouen and Vanves of course, but also in some of the shopping arcades of Paris and Lyons and in department stores. I also worked on seasonal commercial ventures because, while there are *places* for *chine*, there are also *times* to do it. This is how I was able to come to analyse such locations, to recognize their layouts and to observe the behaviour they provoked. All this in a similar spirit to that in which, in earlier work, I approached the spaces of the underground, the RER [Réseau Express Régional, a high-speed suburban train system in Paris] and the supermarkets.[16] I came to the conclusion that *chine* as a form of consumer behaviour has more to do, semiotically and narratively speaking, with weaving than with commercial competition. In other words hunting for bargains may well have etymological connections with hard work or the send-up; but what is more certain is that the practice is inscribed, via its semantics and its narrative logic, in the world of creativity or at least in the world of producing new signifying

16. Floch, *op. cit.*, pp. 19–47; and J.-M. Floch, 'La contribution d'une sémiologie structurale à la conception d'un hypermarché', *Recherche et applications en marketing*, **4**(2), 1989.

structures out of otherwise quite distinct elements. *Chiner* is to let oneself be open to the formal and chromatic diversity of the things you happen to come across; it is to find yourself looking at irregular objects of meaning that move or please you or become part of your interiority.

Chiner, in the primary sense of the word, is the lexicalization of an account of a form of construction: that of an object of meaning, a 'design'. And this is a composite made up from elements of quite distinct qualities: previously combined multicoloured woollen threads. *Chiner*, in the commercial sense of the word, lexicalizes an account of acquisition, gathering together irregular objects that make up a stock from which a signifying structure can be elaborated. For the private citizen this structure could be a sitting-room, an apartment or a country retreat. For Terence Conran it was a shop. Conran is a *chineur*, and the structure that makes up Habitat's very specific range of offerings was established by himself and his colleagues on the basis of a collection of signs taken from contemporary 'material culture'.

The reader will know by now that I use terms such as 'sign' and 'structure' purposefully; for I want to make them aware of the idea that *chine* is the commercial form of a programme of use [*programme d'usage*] for which bricolage is the basic model. So Conran is a *chineur* because he is first and foremost a bricoleur; and bricoleurs rely on 'assemblages of residual human works', to use another phrase from Lévi-Strauss.[17] Conran, an English francophile, set himself the initial task of selling France to the English, as he himself once put it – but in effect he ended up 'selling' a version of hedonism.

Before going on to show how the Habitat range may be considered as a structure, let us look for a moment at certain aspects of its elaboration, aspects that enable us to establish comparisons with bricolage as it appears in Lévi-Strauss's *La Pensée sauvage*. As a bricoleur, Conran and his team made an inventory of what they brought back, and 'questioned' (as Lévi-Strauss puts it) these irregular objects so as to understand the contribution each one of them might make to the Habitat range. We should recall here our earlier quotation from Lévi-Strauss (towards the end of the Michel Bras essay, Chapter 3):

> [A] piece of oak can be a wedge used to secure a pine board or it can be a plinth stressing the quality of grain and polish in the old timber. In one instance it will be an extension, in the other it will be matter. But its possibilities always remain limited by the specific history of each piece and by what remains predetermined within the piece due to the original use for which it was designed, or by modifications made to it with a view to other uses. As units that make up a myth – and whose possible combinations are limited by the fact that they are borrowed

17. C. Lévi-Strauss, *op. cit.*, p. 29.

ulée striée. Intérieur émaillé. 164224 H. 30 cm **250 F** 164208 H. 20 cm **150 F. 2. PORTIA.** *Vase en céramique*
. **3. CLASSIQUE.** *Vase en céramique, finition craquelée brillante, ivoire ou céladon. Intérieur émaillé. H. 27 cm.*
. Vase en céramique blanc brillant. Intérieur émaillé. 164119 H. 20 cm **70 F. 5. ETRUSCA.** *Vase en céramique.*
25 cm. **250 F. 6.** **"HOMMAGE A GAUDI".** *Vase en céramique avec relief, finition mate, intérieur émaillé. Inspiré*
*ve Habitat. Propriété de Escofet. Barcelona. H. 25 cm. 333336 **195 F. 7. CADRE** en plastique blanc. 319821 24 x*
95 F 320129 48 x 60 cm **125 F** 320307 50 x 70 cm **145 F** 850403 60 x 80 cm **199 F.**

Figure 10

PALIO
Chaise pliante en hêtre massif teinté aniline verni
aminoplaste. Assise : l. 45 cm. P. 34 cm.
L. 43 cm. H. 82 cm. P. 48 cm.
318639 noir 331538 acajou
318736 bleu 318833 vert
321516 jaune 321524 rouge 175 F

Figure 11

from a language in which they already have a meaning that restricts freedom of movement – any elements collected and used by the bricoleur come 'prestressed' [*précontraints*].[18]

At once both free and constrained, this use of signs can be found in Habitat's overall design. The stories of the *Hommage à Gaudi* vase (Figure 10) and the *Palio* chair (Figure 11) are important in this respect. On a trip to Barcelona the then director of Habitat–France, Yves Gambier, was astonished by the 'ceramic floral carpet' of the footpath in the Paseo de Garcia, composed as it was of thousands of turquoise tiles. He recognized the 'Gaudi touch' and decided to revive this décor in a particular piece. He finally tracked down the original craftsman who had fortunately kept moulds and samples. Two of these very heavy tiles were then shipped to Habitat headquarters. 'Naturally enough, once adapted, retaining the proportions, maintaining the design, the tile expanded in space and folded to become ... guess what? ... a vase. This is how the *Hommage à Gaudi* vase was born.'

As for the *Palio* chairs, these came 'from the emotion, the tradition and the sheer practicality' of the chairs used by the Siennese on the day of the *Palio* – a cutthroat race that brings together horsemen representing the old parishes of the town. Habitat then made these folding chairs (holding to their original colours in 'the setting sun on the racecourse') out of solid beech tinted with aniline.[19] We can find more such stories to illustrate the fact that Habitat does not simply copy existing objects but modifies and adapts them, even when this is often done as if to make them seem to emerge from their original contexts – contexts that are, often enough, professional ones – into the domestic context of the house and the apartment. Sizes are changed, motifs come and go, shapes are adapted, and so forth. In this way the Conran Design Group has adapted such items as sugar bowls from café counters, bottle-racks from English off-licences, as well as workshop lights and wallpapering tables. Most of the time, such objects are modified, mainly by the Conran Design Group: sizes are changed, motifs come and go, shapes are adapted.

A certain form of enunciative praxis, a certain style

Habitat should be considered a pioneer. Today, a large majority of home décor and women's magazines have come to promote a truly dominant aesthetic – just as we used to speak of a 'dominant ideology' – and this is an aesthetic that is

18. *Ibid.*, pp. 28–9.
19. These two accounts are reported in de Bure, *op. cit.*, p. 62.

very close to the Habitat original. We are offered a mix of styles; we are urged towards recycling and 'compaction' [*télescopages*]. In short, it is now correct to have 'wild ideas to disturb received ideas' [*idées sauvages pour déranger les idées reçues*]. Here our individual tastes should be affirmed; there should be evidence of our individual 'creativity' and 'fantasy'. And certain designers have come to represent the heroes of that dominant aesthetic. For instance, over a period of only a couple of weeks, several magazine articles appeared about such a Parisian designer and his 'very personal sense of the home' as he 'mixes colours, objects and styles with skilful audacity'. These articles are illustrated by photographs with the obvious intention of educating their readers.

The second-hand shops and the flea-markets are now much better stocked than the household goods shops, to the great disappointment of household goods manufacturers and shoppers still bent on suicidal respect for what they still believe to be the norm. Moreover, layout artists on some magazines now use single and double pages to recombine and juxtapose irregular objects that have been cut out and then reduced or enlarged. They thereby recreate a two-dimensional equivalent of the fleamarket and, in so doing, define the reader as *chineur* (Figure 12).

What is happening here is so important that we may ask whether we can discern today the emergence of a style that might be called 'bricolage style'. Some journalists on the décor magazines would then be its ideologues if not its theoreticians, albeit possibly unknowingly perhaps. For instance, Caroline Tiné from *Marie Claire Maison* writes in her October 1992 editorial:

> The crisis we are living through today is not just economic. It concerns the very depth of our lives. The superfluous is no longer a function of accumulation; it has become a 'more' that takes over our emotions. It glorifies the feelings that emerge through reference, taste for life, tenderness, charm, temper and the other values that create ambience. For example, a lampshade can be ridiculous if it looks like any other mass-produced lampshade or else beautiful if we improve on it with the means at our disposal [*sic*]. Cut paper, glitter, tiny stars ... and light itself is transformed. Vases and candlesticks can mean boredom if left lying around as knick-knacks: classical, tasteless, uniform. But you can achieve pleasure and variety by choosing instead inspired ceramics like those of the 1950s, simple china candlesticks that will set off the family silverware. You will find many ideas like these in *Marie Claire Maison* because we love life, a life that chooses individual combinations over given norms.[20]

The reader may notice that such a 'bricolage style' is highly axiologized: not only does it support non-conformism and contemporaneity; it also represents the manifestation of life itself!

20. C. Tiné, editorial, *Marie Claire Maison*, October 1992.

QUOI DE NEUF BREVES

1. Pierre Mesguich vient d'ouvrir le premier magasin consacré à la mosaïque. Décors de salle de bains ou de piscine, mobilier, objets contemporains ou anciens, on trouvera dans ce nouvel espace toutes les applications de cette technique aux possibilités multiples (Mosaïk, 46, rue de l'Université, Paris-7° Tél. : 47 03 44 06).

Presse Olivier Léger

2. Voici « Gueule d'Amour », le nouveau service en faïence de Geneviève Lethu. La grande assiette, 60 F. L'assiette à dessert, 51 F. (Geneviève Lethu, 95, rue de Rennes, Paris-6°, Tél. : 45 44 40 35).

3. Des nuits entières parfumées au cèdre avec la bougie de jardin de Miller et Bertaux pour Estéban, 200 F. (Miller et Bertaux, 27, rue du Bourg-Tibourg, Paris-4° Tél. : 42 77 25 31).

4. 5. Voici deux objets de la collection « Memory Containers » créés par Joanna Lyle et Cecilia Cassina pour Alessi. Coupe à trois pieds en acier inoxydable et porte-agrumes inspiré d'un modèle réalisé en 1952. Alessi, 1 100 F et 1 400 F. (Grands magasins et magasins spécialisés).

6. Aluminium chromé pour cette poignée de porte « Apriti » dessinée par Philippe Starck pour Kleiss. Équipement de porte complet : 1 170 F. (Darmon Décoration, 15, rue de la Chapelle, Paris-18° Tél. : 40 37 29 12).

7. Inventée en 1922, la cuisinière Aga est équipée d'un ou deux fours et fonctionne au charbon, au gaz ou à l'électricité. Existe en plusieurs coloris. Aga Rayburn, à partir de 35 000 F. (Première Cuisine, 6-8, av. du Gal-de-Gaulle, 38800 Pont-de-Claix Tél. : 76 98 46 10).

8. Parce que l'osier est léger et flexible, Michel Biehn vient d'imaginer une série de meubles qu'il fait tresser par des vanniers traditionnels. Ici, chaise, 1 750 F. (Michel Biehn, 7, av. des 4-Otages, 84800 L'Isle-sur-la-Sorgue Tél. : 90 20 89 04).

Figure 12

However, this may not be the most interesting issue for semioticians; even if it might be more appealing to sociologists or historians of culture. What attracts the semiotician's attention is the kind of enunciation to be found in bricolage when, in this way, it is elevated into becoming a style. Indeed, shapes that already exist and are more or less fixed by custom and history are here opened up to the reader's curiosity. Accordingly, these shapes can be used by readers in putting together their own décors. But, in this process of assemblage, amateur décor enthusiasts position themselves as enunciating subjects of a particular spatial and visual discourse. From this point of view, bricolage – whether stereotyped in this manner or else completely improvised – ends up being one format of the same enunciative praxis.

What then is enunciative praxis? It is not simply 'usage' itself but precisely what places it (usage) into the enunciative activity, that is, into discursive production. It is recall, bringing in cultural formats that have already been constituted in already sedimented types. We can see here a return to Ricoeur's idea of sedimentation (see the essay on Waterman, Chapter 1) and also to Lévi-Strauss's 'prestressed blocks' of meaning. Enunciative praxis is thus the subject engaging with history; it is the activity, whether fast or slow, of the enunciating subject who returns to, or generates, typical formats. (And we should note here that the enunciating subject can be individual or collective.) And, finally, another way to define enunciative praxis is to say that it attends to 'a posteriori recognizable processes which are imbued with intentionality and which supply meaning to the vagaries of usage'.[21]

We have just seen that bricolage is only one form of enunciative praxis. This must now be clarified. Let us note above all that events such as the canonical forms, archetypes or stereotypes that are among the elements of enunciative praxis represent 'facts of speech' that become 'facts of language'; or more accurately, they are 'facts of usage' integrated within the linguistic system. And calling on the terminology and imagery of semiotics, we should say that they represent a 'raising' [*relèvement*] of the syntagmatic over the paradigmatic.

Now the bricoleur-as-enunciator is not a conformist subject: the enunciative act does not consist in merely calling up these fixed (perhaps even canonical) forms. On the contrary, the bricoleur not only builds a collection of 'facts of usage' (that are not necessarily stereotypical) but also adapts and reworks them. Moreover, these signs – stored away in the belief that 'they could come in handy one day' – are used and contextualized in such a way that they are then made to serve in the elaboration of a structure, an autonomous entity of internal

21. Excerpt from a seminar presentation on the problematic of enunciative praxis by J. Fontanille and D. Bertrand in the opening proceedings of the *Séminaire intersémiotique de Paris*, 1992–3, unpublished conference address.

dependencies (to use the terminology of the Danish linguist Hjelmslev). From this point of view, the enunciative praxis exemplified by bricolage corresponds to a 'lowering' [*rabattement*] of the paradigmatic with respect to the syntagmatic – a movement which, according to Jakobson, is characteristic of the poetic.[22] Therefore bricolage, as an enunciative praxis, must be seen as an event in two movements, where the second movement presupposes the first.

– The first movement is the integration of facts of usage into the linguistic system or, more generally, into the cultural system: it is a creation of fixed types and forms, sometimes canonical (for example with styles), or an emergence of spoken and non-spoken conventions. This integration can be visualized as a 'lifting' of the syntagmatic over the paradigmatic, remembering that, in linguistics and semiotics, the conventional representation of the paradigmatic axis is a vertical line and that of the syntagmatic axis is a horizontal line.

– The second movement is the selection and use, in whole or part, of facts of usage with a view to creating a signifying structure such as a myth, a poem or a painting. This invocation and contextualization can now be seen as a 'lowering' of the paradigmatic against the syntagmatic.

In the process of defining bricolage in terms of 'drawbridge' (raising and lowering) movements, we should note here that, were bricolage actually to become established as a style, it could be interpreted as the effect of a third movement, as a new 'lifting' of the syntagmatic over the paradigmatic. All this may seem rather empty; but my purpose here is only to account in the simplest way possible for the perfectly normal layering by which cultural phenomena are constituted. We can take this opportunity to examine the notion of *style* in line with what we have just seen *via-à-vis* the enunciative praxis and *via-à-vis* bricolage.

Style is generally defined as divergence or deviation. In such an approach, style is conceived as an opening, a way of taking liberties with a norm located outside the work. This approach is essentially paradigmatic and normative: so that style can be 'elegant', 'original' or 'clumsy'. However, in an approach more concerned with the work itself, and centred more on text than context, style can instead be defined as closure. And this closure is linked to the syntagmatic dimension of the work. Moreover, this approach which takes into account the internal recurrences and consistencies of the work – as Flaubert puts it, 'Continuity establishes style' – is by no means normative. Rather, it is the approach associated with those stylisticians closest to semiotics, an approach that is intended as purely descriptive and is concerned above all with relationships internal to the work itself.

22. R. Jakobson, *Essais de linguistique générale, I* (Paris: Minuit, 1963), p. 220. For my part, I have already tried to examine the relations between bricolage, myth and poetry in *Petites Mythologies de l'oeil et de l'esprit* (Paris and Amsterdam: Hadès and Benjamins, 1985).

The concepts of enunciative praxis and bricolage could contribute, I believe, to a re-examination of the notion of style by semioticians themselves. Indeed, these concepts would allow for a definition of style as the closure of a coherent distortion to which bricolaged signs (bricolaged in order to establish a structure) are subjected. We have already seen, for instance, how the sign of the rainbow was distorted in a coherent way to contribute to the composition of the Apple logo: the different sequence of coloured lines; the horizontal display of these lines; the deletion of the arc form.

And we will recall that the coherence of that distortion was valued according to semiotic rules of differentiation by inverting the signifier while retaining the signified of a sign from another system, namely that of IBM. Coherent distortion could thus be identified in the analysis of the works as such – so the approach would remain fundamentally 'inside' the text, according to normal semiotic conventions – but it could not ignore diachrony or usage because the actual material of any bricolaged work is composed of those 'prestressed blocks' that we know as signs.

Two observations, then, to end this short reflection on style:

a. I have already mentioned the 'closure' of a coherent distortion. My intention there was to take into consideration the dimension of permanence inherent in the notion of style itself, to recognize its force of inertia (as we might say), and the fact that style presupposes the production of units of manifestation that are recognisable as such. This idea refers back to that proposed at the end of my examination of the notion of 'fact of style' in the previous chapter (on Chanel).

b. This approach to style, then, would also be consistent with Ricoeur's concerns and with his research on narrative identity defined in terms of the notions of character and control [*maintien de soi*]. Indeed, we have already seen (Chapter 1) that, for Ricoeur, narrative identity is designed to articulate the following:

 – 'Acquired identifications by which the other enters into the composition of the same', identifications testifying to the component of alterity taken on by the subject.
 – Innovation by 'self-control' [*maintien de soi*] and ethical goals.
 – 'Character', or the composition of a set of dispositions by which one can be recognized. (And is it not possible to recognize in these first three components the three logical moves in the elaboration of style as I tried to define it above?)
 – The selection of prestressed blocks, signs or motifs.
 – Coherent distortion, identifiable after the fact according to the structure of the work.

– The recurrence of such distortion so that it becomes visible and so that, eventually, it can be integrated into a certain typology of styles.

'A generalized lightness, punctuated by touches of living colour ...'

From what has already been said about home décor magazines and their advocacy of style-mixing (on the one hand) and the selections made by Terence Conran and his team (on the other), we could be led to conclude that the Habitat concept was part of a new end-of-the-century eclecticism. I for one am prepared to consider the possibility of such a movement actually existing during the 1980s and 1990s and that Habitat's success can be partly explained on this basis. Indeed, we can find in Conran's range of offerings a kind of nostalgia, if only for a quite recent past now threatened by technology; along with an encyclopaedic curiosity and a need (if not actually expressed then nevertheless perceived by buyers) for a certain kind of cultural baggage that constitutes the means by which Habitat shops can be seen as a micro-Expo of the aesthetics of everyday life – whereas anyone who belonged to a lower socio-cultural group might only see a motley of over-priced fake 'antiques'.

But once more, I am not concerned here with sociology or cultural history. My concern is much more specific and is limited to the analysis of particular visual identities and to the search for a certain conceptual logic that can be illustrated by such identities: namely bricolage – although I do not contend that this is the only possible conceptual logic. What I find of primary interest in the overall Habitat concept is that it proposes a structure to its customers; a structure that is both perceptible and intelligible, and which is elaborated via signs that are themselves perceptible and conceptual realities. This will be true of all structures grounded in bricolage; but the structure emerging from Conran's version of bricolage is quite particular in that it is a rhythmic structure with spatial and chromatic dimensions that, as such, enable a regulation of the quantity and intensity of domestic visual space. I would therefore, in this last part of the chapter, like to offer some clarification of the planes of expression and content of that signifying structure.

Here we must start again with the result of the bricolage we analysed above: with the Habitat shop itself. What are we given to see there? Displays of furniture, a wide range of utensils on trays and shelves: a space and its component objects that go to make up the world (or habitat) of the kitchen (Figure 13). Here we can find natural timber and calico cloth, earthenware and plaster, as well as brightly coloured (red, green and yellow) enamelled steel and china, but also blacks: black cardboard, black metal, black plastic, and so forth. These displays and their sequencing represent the spatial manifestation of

Figure 13

Habitat's discourse. The displays are manifestational units of variable size, referring to vastly different levels of discourse, just as the chapters and paragraphs of a text function in its overall composition. As for the world (or habitat) of the kitchen and that of the coloured materials, these can be considered as the basic raw material assembled by the semiotic form we know as the Habitat concept. Here, since I started out as a semiotic technician, I should be more precise. The world of the kitchen (its habitat) corresponds to what is called in semiotics the substance of the plane of *content*: the semantic material informed by the brand's ethical purpose [*le propos*] – and we will see below why this purpose is ethical. As for the coloured materials and solids, these correspond to the substance of the plane of *expression*. And these too are variables of realization: they are the material informed by Habitat's own perceptual approach. In summary, we have just distinguished between:

- the level of manifestation (journeys and displays);
- the substance of content (the world or habitat of the kitchen);
- the substance of expression (coloured materials and solids).

From here, we must analyse the following: the form of expression and the form of content that are established in the 'ambience' of the shop and via its product range – forms that constitute the invariant dimensions of the brand's identity.

The form of expression, established by the solids and materials deployed in the shop space, can be defined by a rhythm and a chromatic balance. The sequencing of trays and shelves and, at another level of derivation, the stacking, the superimposing and the juxtaposing of products: all these units compose a highly specific deployment of diverse coloured areas. The views and journeys generated by these diverse arrangements organize 'a generalized lightness, punctuated by touches of living colour ...' as Gilles de Bure appropriately put it.[23] Why does this description from de Bure's anniversary celebration of Habitat seem so accurate? In fact it is because the description is linguistic evidence of the double opposition used to organize the Habitat shop's deployment of colours. This deployment can be described via two categories: the category of quantity (or number) and the category of intensity (or accent). We can represent the above description, then, as follows:

Quantity:	'A generalized	vs.	'Touches
Intensity:	lightness ...'		of living colour'

I found what should be called the 'prosody' of Habitat's imagined domestic space to be as striking as de Bure did. From the point of view of expression (that is, from the point of view where we approach the perceptible), the brand's range is indeed less a range of colours and materials than it is a range of principles of spatial composition. It proposes a certain way of managing a totality and its parts, a way of reconciling homogeneity and heterogeneity.[24] It is appropriate to call this 'prosody' because we are dealing with a specific way of managing a set of accents and intensity–variations on the plane of expression. The Habitat concept is the Habitat shop, and this shop is a certain rhythmic profile or a 'rhythmic pattern', as Geninasca puts it.[25] The flash against the horizon, the counter-thrust against the thrust, the intense against the extensive, the tonic against the atonal: these, by their very duality, organize the masses, accumulations and volumes that quantify the colour deployment of the Habitat space. There is also something quite specific about the tonality of this colour-deployment: the tones are light, warm and soft where expanse and extension are concerned (a 'generalized lightness') while there is a proliferation of bright and intense tonalities when it comes to the localized or more circumscribed parts ('touches of living colour').

This 'general lightness' and these 'touches of living colour' are a reminder of

23. de Bure, *op. cit.*, pp. 19–20.
24. On this problematic of whole and part, see an article by the philosopher and semiotician J.-F. Bordron on the different semantic wholes: 'Les objets en parties (esquisse d'ontologie matérielle)', in J.-C. Coquet and J. Petitot (eds), *L'Objet: sens et réalité* (Paris: Larousse, 1991).
25. J. Geninasca, 'L'énonciation et le nombre: séries textuelles, cohérence discursive et rythme', in J. Fontanille (ed.), *La Qualité et ses modulations qualitatives* (Limoges and Amsterdam: Pulim and Benjamins, 1992).

what was said above *vis-à-vis* the epicurean ethic and its concern for better managing passions and affects – what semioticians of passion call 'thymism'.[26] We can recall that the Epicureans, attentive as they are to following natural desires, also find legitimate pleasure in satisfying those desires that are both natural and non-essential. It seems to me that such an approach to life and to pleasure works with the same tempo as that of the colour-deployment examined above. There is in this philosophy of life a similar way of managing and modulating intensity. In this instance, it is not the *perceptible world* that is made subject to that tempo so as to constitute the plane of *expression* of Habitat's language; rather the subject is now the *emotional subject* in his or her relationship to the world and whose 'states of mind' constitute the plane of *content* of that language. In other words the 'generalized lightness punctuated by touches of living colour' and the *aurea mediocritas* dear to the disciples of Epicurus would have comparable 'rhythmic profiles'.[27] Chromatism and thymism would be parallel:

- the scansion of lightness on the plane of expression; and
- the *aurea mediocritas* on the plane of content.

There is a difference, however. The *aurea mediocritas* is a paradigmatic definition of this double intense–extensive articulation while scansion is a syntagmatic definition. Rodis-Lewis, the historian of Greek philosophy, has also defined the epicurean ideal in terms of forces and rhythms: for the epicurean wise man, tranquillity is 'an equilibrium of forces, and the action of joyous and measured expansiveness'.[28]

Such a parallelism between epicurean thymism and chromatic prosody would then define the relationship between the form of expression and the form of content of the Habitat concept. And this could, moreover, support and illustrate an observation made by Claude Zilberberg at the *Linguistique et Sémiotique II* Conference held in Limoges in 1991:[29]

> Thymism would, on the plane of content, play a role comparable to that played by prosody on the plane of expression. What I mean is that just as prosody strives to establish, for want of a better word, a 'profile' through a set of modulations and the 'happy' distribution of accents, thymism strives to regulate the pointed and diffuse intensities which may surprise and assault the subject.

26. See J. Fontanille, 'Thymique', in A.-J. Greimas and J. Courtés, *Sémiotique, dictionnaire raisonné de la théorie du langage*, vol. 2 (Paris: Hachette, 1986), pp. 238–9; and J. Fontanille and A.-J. Greimas, *Sémiotique des passions* (Paris: Seuil, 1991).
27. As Bertrand quite correctly reminds us, the formula *aurea mediocritas*, often translated negatively as 'joyous mediocrity', actually means: the happy mean is golden. Let's point out here that the Bertrand article can be read as an approach to epicureanism as a form of life. See D. Bertrand, 'La justesse', in J. Fontanille (ed.), *Les Formes de vie* (Montreal: RSSI, 1993).
28. Rodis-Lewis, *op. cit.*, p. 303.
29. See C. Zilberberg, 'Défense et illustration de l'intensité', in J. Fontanille (ed.), *La Qualité*, pp. 102–3.

6

Opinel: intelligence at knifepoint

Why end this book with an essay on the Opinel? What is the relationship between such a popular knife and the notion of visual identity? Can one actually speak of identity – that is, of meaningful difference – in the case of such a basic knife, where form is so closely associated with function (to use Sullivan's famous distinction)?

We can answer these questions in two ways. First we can simply observe that a pocket knife always says something about its owner. Indeed, even in modern society we are still familiar enough with the various types of folding knives that we can attribute to their respective owners some trait or some hobby that could reveal their character, their status or their concern with their self-image. We can also refer to the fact that, in a number of countries, the Opinel (Figure 1) is called 'the French knife', and that it has been used as a symbol of 'French genius' (no less), or else as an 'object from France' that is particularly representative of French everyday life and material culture – an observation which is somewhat more reasonable and also more interesting.[1]

But we can also respond in a different way, and one that is more pertinent to this investigation. We can point out that a knife, even one as basic in appearance as the Opinel, actually displays certain formal qualities which are unique to it; for an Opinel is neither a Laguiole (Figure 2) nor a Swiss Army knife (Figure 3). And we can therefore readily observe that these qualities both condition and represent a specific use of the folding knife. I therefore believe it legitimate to imagine that the handle of a knife in fact extends into a certain way of doing things, one that ultimately speaks to a certain way of life or way of being. Approaching the topic this way, we are led to an analysis of the relationship between the form and the function of the knife. Moreover, we are trying to

1. See B. Chapuis and H. Herscher, *Qualités: objets d'en France* (Paris: Du May, 1987); and G. Duhamel, *Le Grand Inventaire du génie français en 365 objets* (Paris: Albin Michel, 1990).

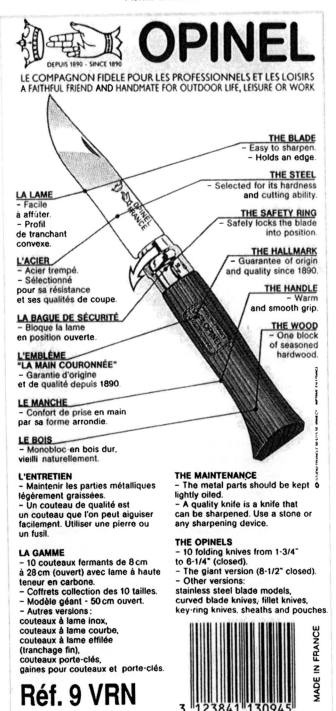

Figure 1

Figure 2

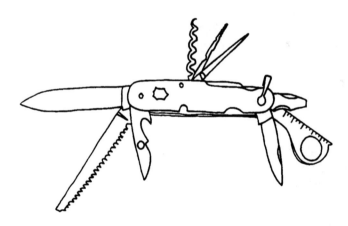

Figure 3

identify, if not a culture (perhaps an excessive word in this instance), then at least a way of thinking and a particular mode of interaction between self and world. This is how, without having any preconceived ideas about it, I found myself once more facing the concept of bricolage that is central to the present work. I must immediately stress that I still use 'bricolage' in the precise sense given to that signifying practice by Lévi-Strauss. To show this, I will later contrast this bricoleur's knife with that of the 'engineer'.

A blade, a handle, a collar

Let us now turn to the actual analysis of the Opinel. First, let us offer a short historical introduction to it. It was developed by the Savoyard, Joseph Opinel. His grandfather, Amédée Opinel, had build a workshop on the banks of the Arvan river at Albiez-le-Vieux, near Saint-Jean-de-Maurienne, where he made horseshoe nails and edge-tools for the local farmers. With his hammer he made axes, hedging bills and pruning knives, as well as traditional knives. Joseph Opinel, however, was more specifically interested in the manufacture of knives. In 1890 he designed the knife that would become *the* Opinel – the name now being so common that it can be found in dictionaries. This very practical, basic and robust knife, to which a collar or coupling ring [*une virole*] would later be added, met with early success. It even received a gold medal at the Turin Expo in 1911. It was distributed by door-to-door salespeople, a traditional occupation in the Savoy.

We should note here that the Opinel was always slightly on the margins: its manufacture was by no means widespread, as was the case in those days for other knives; and its mode of distribution was not through the traditional cutlery merchants who considered it of no commercial value to them. But this marginality would soon prove to be a significant advantage: it allowed for the speedy and constantly updated industrialization of its manufacture; and it also allowed it to be independent of a distribution network that eventually declined during the century.

Let us now raise a technical point. The quality of the blade has been a major contributing factor to the Opinel's success. The blade is cut from strip-iron. It is heated to 800°C and dipped into a linseed oil bath. In the next phase, called 'tempering', it is cleaned, reheated and air-cooled. Finally, it is sharpened and polished. The handle is made from battens of beech or wild cherry. Slotting, bevelling and ferruling [*virolage*] are all done mechanically with automated machine-tools developed at the House of Opinel. Once small trapeziums of soft steel have been cut and stamped, the collar is cut with a press. Finally, we should point out that, by 1900, the daily production run (now based in Cognin, Savoy) was 20,000 knives.[2]

Let us now turn directly to the analysis of the Opinel and, following good semiotic practice, we should start with its description and its subdivision into signifying elements. What are the constitutive elements of an Opinel? And by what traits does it differ from other folding knives? To carry out this description,

2. Translators' note: Floch's bracketed reference reads: *L'Almanach du vieux savoyard*, 45th year, 1990. For more details see footnote 6, below.

it may be useful to consider the way in which lexicographers attempt to define the lexeme, the dictionary entry, and recall the three components which, according to Greimas, must be present in any exhaustive definition of the lexeme.[3]

For instance, for the definition of the lexeme 'automobile' to be exhaustive it must include:

a. not only a configuration component, subdividing the object into its parts and recomposing it as a single form;

b. a taxic component, accounting via its differential traits for its status as an object among other manufactured objects;

c. but also its functional component, whether practical or mythic (prestige, power, escape, and so forth).[4]

It is this last component that will eventually be of primary interest to us. However, for the moment we are engaged in a prerequisite to the analysis: the description of the Opinel. We must therefore address the first two components, the configurational and the taxic. Let us start by subdividing the Opinel into its constitutive parts – that is, by identifying its 'configurative' component. We can identify three main knife components which have been constant since the Bronze Age: the blade, the handle and the blade–handle connection.[5]

1. Whether made of traditional carbon steel or, as more recently, of stainless steel, the blade of the Opinel is relatively short and wide. Upon it we can notice both the placement of the thumb-nail groove (which allows the knife to be opened) and the famous 'crowned hand' symbol (which is either stamped or printed depending on the quality of the steel).[6] We can also

3. Let us recall that Greimas was not only a semiotician; he was also a lexicologist and lexicographer. We are indebted to him, in the latter capacity, for two reference works. See A.-J. Greimas, *Dictionnaire de moyen français* (Paris: Larousse, 1969); and A.-J. Greimas (with T.M. Keane), *Dictionnaire de moyen français* (Paris: Larousse, 1992).

4. A.-J. Greimas, *Du sens, II: Essais sémiotiques* (Paris: Seuil, 1983), pp. 21–2.

5. The two-piece knife with a distinct blade and handle indeed dates back to the Bronze Age. See A. Leroi-Gourhan, *Milieu et techniques* (Paris: Albin Michel, 1973), p. 32. It is nevertheless true that there are still, today, certain types of monoblock knives, such as the Siberian knife (Figure 4).

Figure 4

6. In 1565, Charles IX ordained that each master knife-maker attach an emblem to guarantee the quality of materials and manufacture. In 1909, Joseph Opinel who had invented his knife some twenty years earlier chose as his emblem a crowned hand. The crown was a reminder that the Savoy region was a duchy. The hand is found on the coat of arms of the city of Saint-Jean-de-Maurienne – whose cathedral has held the relics of St John the Baptist since the sixth century: two fingers brought back from Alexandria by the Savoyard saint Thècle. And we should also note that the Opinel family originates from Albiez-le-Vieux, a village nearby (source: *L'Almanach du vieux*

see that the point is clearly rounded. The profile of the blade, or its curvature to be more precise, therefore relates it to the Yatagan knife (Figure 4). This curvature is particularly interesting in the case of wood engraving or other forms of woodwork, and we will return to this later. Let us note here that this curvature has been, according to Maurice Opinel himself, one reason for the knife's success.[7]

2. The handle of the so-called 'basic' versions of the Opinel is often made of beech which has been allowed to dry naturally and is protected with a special varnish.[8] It is pleasant and warm to the touch; and the way the shape bulges ensures a very good grip. We can also notice the particular shape of the heel [*talon*] which allows for the traditional 'Savoyard blow' [*le coup du Savoyard*]. Indeed, the first Opinel owners used to open their knives with this short sharp blow to the heel of the blade (Figure 7).

3. As for the blade–handle connection, it is (visually) composed of a swivelling collar made of soft steel. This locking system associates the Opinel with the old Nontron knife (Figure 8) which, as legend has it, was the weapon used by Ravaillac.[9] But the collar of the Opinel is quite original: 'It has a ring-shaped swelling which guides its rotation around the head of the pivot. Moreover, it is not perfectly cylindrical but slightly inclined towards the blade, thereby ensuring perfect locking even if the pivot should become loose through wear and tear.'[10]

cont.
savoyard (Annecy: 1990), p. 80). Nevertheless, by the end of this chapter, I am sure the reader will see, in this famous crowned hand, a eulogy (possibly unintentional) to the hand (Figure 5).

Figure 5

7. Maurice Opinel who presides over Opinel is the grandson of Joseph, the knife's inventor. I am indebted to him for certain information and clarifications: a grandson is often the best of confidants. I would like to thank him once more for his availability to me.
8. In some series, the handle can be coloured. And there exist also luxury Opinels where the handles (with rounded ends) are made of buff leather, horn or mircata. With its beech handle the basic Opinel is therefore a light knife (between 40 and 50 g.). This is not the least of its qualities: at the time of its invention the Savoyards were familiar with the Rumilly knife, a two-piece knife (blade and saw) whose handle was made of horn and which weighed not less than 90 g.
9. The Nontron is probably the oldest French knife. Since the fifteenth century, Nontron, a large town in the Dordogne, has been renowned for the quality of its knives. We should also point out that this knife has a blade said to be in 'sage leaf' form and a handle made of boxwood and branded with a double row of small dots and a horseshoe sign called a 'fly'.
10. See J.-N. Mouret, *L'Univers des couteaux* (Paris: Solar, 1992), p. 20.

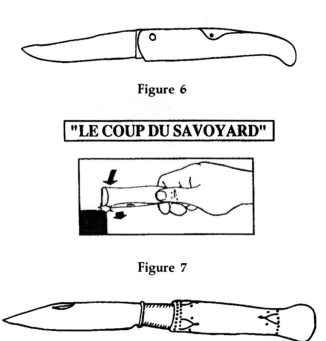

Figure 6

"LE COUP DU SAVOYARD"

Figure 7

Figure 8

So the Opinel displays the two major formal characteristics of simplicity and roundness: a simply designed blade, a one-piece handle, a ring slightly at an angle. Given this minimal number of elements and the choice of materials, one can explain why it is so often praised for its simplicity and its 'rusticity'. Roundness can be found in the curvature of the blade, in the handle-swelling and in the collar. The Opinel therefore differs significantly not only from the Laguiole knife (Figure 9) but also from the Swiss Army knife. As a knife inspired by the Spanish *navaja*, the Laguiole's shape is still that of a weapon, elegant and somewhat exotic; and one is inclined to notice the various decorative motifs of the 'true' Laguiole: the bee, the cross, the bushed spring [*le ressort guilloché*]. The Opinel displays no such motif. As for the ready-to-use Swiss Army knife, its form is highly variable and often rather complex. Everything depends on which tool or tools are chosen from the handle, and some tools can even have a dual function: screwdriver and can-opener, or ruler and compass, for example.

Let us now turn to the taxic element of the Opinel, to the examination of the differential traits that enable us to define it as one product among others. From the outset, we should recognize that there is a certain vanity in attempting any truly exhaustive description, especially in the short space of this chapter. To do so one would have to dedicate a whole volume to such a definition, even if it

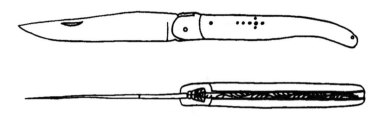

Figure 9

were restricted just to contemporary folding knives. This said, however, it is possible to enlist help when attempting such a description because, once again, the semiotician can benefit broadly from findings in other disciplines. Here we will be particularly indebted to anthropology and to the works of prehistorian André Leroi-Gourhan. Indeed, in his two works *L'Homme et la matière* and *Milieu et technique* he has devoted numerous pages to the taxonomic description of the main human techniques of manufacture, acquisition and consumption.[11] This provides us with some different ways of distinguishing classes of tools and hand weapons, and allows us to develop a taxic definition of the Opinel adequate to our purpose.

1. First, the Opinel is a knife(!); its blade is short – distinguishing the knife from both the short-sabre and the sabre-proper, which have medium-length and long blades respectively (Figure 10).

2. The Opinel is also a knife because its blade has a single cutting edge. The dagger, although it can be just as short as the knife, has a blade with two cutting edges, as do the short-sword [*le glaive*] and the sword proper (Figure 9), which have the same lengths as the short-sabre and the sabre-proper respectively.

3. The Opinel works essentially by lengthwise impact. Its point obviously precludes any diffuse impact and the rounded shape of the point is not conducive to direct impact – even if it is still possible to stab a piece of Beaufort cheese with an Opinel! By allowing lengthwise as well as transverse impact, the knife proves to be a very useful tool for precise and delicate woodwork. It can be used both to pare back a wood shaving and to cut it off perpendicular to its plane of separation.

4. Furthermore, the Opinel works with an impact that is 'positioned' [*posée*] rather than swung [*lancée*], unlike the axe, the machete or the adze for instance (Figure 12). Moreover, its lightness means the knife would be a poor throwing weapon. This kind of impact – linear and positioned – brings out the value of the cutting quality and therefore of the steel. And it is indeed for these qualities that the Opinel is renowned.

11. A. Leroi-Gourhan, *L'Homme et la matière* (Paris: Albin Michel, 1943 and 1971); *Milieu* (1945 and 1973).

Figure 10 **Figure 11**

5. Another differential trait is that the impact is produced without hammering, by contrast with the chisel or the engraving tool (Figure 13).

6. The Opinel is also distinguishable from many other knives by the fact that it is a folding knife, which actually means that it could not have existed before the early fifteenth century; for it was only then that the first folding knives began to appear.

7. The last differential trait we require, to appreciate the specificity of the Opinel, is its locking mechanism. A folding knife obviously requires a hinging mechanism that is well-crafted and particularly reliable, and most folding knives have more than one such mechanism. But there are a number

Figure 12 **Figure 13**

of different locking mechanisms: the soft spring (the Laguiole), the spring with an unlocking button (switch-blades: Figure 14), the external spring which unlocks by pulling a ring (Figure 15), and so forth. We saw above that the locking mechanism of the Opinel uses a collar or coupling ring. This ring is quite specific (its design is patented under the name 'Virobloc') and provides the final difference between the knife designed by Joseph Opinel in 1890 and the much older Nontron.

Let us now end this discussion of the taxic element by noting that the Opinel is distinct from all the 'tool knives', of which the Swiss Army knife is only one example. Indeed, the Opinel includes no tool other than its blade; it includes neither reamer nor corkscrew, unlike most of the Laguiole models. We can therefore see that the Opinel is not designed to punch leather or slit the bellies of sick sheep but rather to cut or carve wood. And we have already seen that the curvature of its blade offers a great deal of freedom and precision when working in such hard material. Also, since the Opinel does not include a corkscrew (although the corkscrew was common from 1880 owing to the commercial spread of bottled wines), it is rather obvious that it was initially designed as a tool for work and leisure. The Opinel 'speaks' of one's relationship to oneself and between oneself and the world. It makes no reference to those moments of relaxation, eating or conviviality when a corkscrew is a must.

A hero of quantification

Once again, any truly 'taxic' definition of the Opinel would require more space and more time, and especially greater competence. I also noted above that, in the context of this work, I was interested in the third, functional, component of any definition of the Opinel. So we must now consider this component, recalling that, according to Greimas, it can be as much practical as mythical.

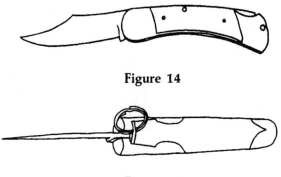

Figure 14

Figure 15

But we must first note that Greimas proposed a further distinction that permits an even better examination of this functional component. This distinction is between three 'dimensions' of culture. As far as the analysis of the functional component is concerned, I consider these to be more subtle and more suggestive than the simple practical/mythical opposition. In his collection of essays on aesthetics, *De l'imperfection*, Greimas uses the 'description of the Dogon lock' in order to distinguish the three dimensions of culture: the functional, the mythical and the aesthetic.[12]

> Here we have one of those things with an obvious utility: locking a house. But it is also a deity that protects the house and, in addition, a work of beauty. Combining the three dimensions of culture – functional, mythical and aesthetic – this thing becomes an object of syncretic value. Such an object, imbued with collective and individual memory, carrying a meaning with many strands and weaving networks of complicity with other objects, is one that fits into everyday life, giving it substance.

This last sentence could very well apply to our Savoyard knife.

The analysis of the Opinel will thereby combine the threefold distinction required for a dictionary entry description proposed by Greimas in 1973 (as semiotician-lexicographer) with the threefold distinction proposed by him in 1987 (as semiotician-ethnologist). We can visualize the combination of these two distinctions as follows:

- 'Configurative component'
- 'Taxic component'
- 'Functional component' (practical/mythical):
 - 'Functional' dimension
 - 'Mythical' dimension
 - 'Aesthetic' dimension

One final remark prior to tackling the analysis of the functional dimension of the Opinel is that I have proposed a further articulation of the 'functional component' which I developed from the practical/mythical opposition proposed by Greimas in 1973: establishing such an opposition in semantic categories and projecting these on to the semiotic square. I then proposed, in my book *Sémiotique, marketing et communication*, an 'axiology of consumption values' which is reused in the present work at the start of the previous chapter (on Habitat). Greimas's functional component (of 1973) thereby comes to be articulated in *four* dimensions rather than three: the practical, the ludic (and today

12. A.-J. Greimas, *De l'imperfection* (Périgueux: Fanlac, 1987), pp. 90–1.

I would be more inclined to say the 'ludico–aesthetic'), the utopian and the critical. To distinguish between two, then three and now four dimensions may appear rather arbitrary. But I do not believe it is. By calling upon such a structuration based on the semiotic square, we simply try to extract the theoretical and practical consequences of establishing the 'functional component' as an articulated semiotic world.

To cut or to carve, of course, but also to slice, to loosen, to scrape, to scratch, to peel, to prune, to expose the wire of an electrical cable or to clean an animal's hooves, and so on. But also: to apply, to spread, to butter and also to pick up and to raise to one's lips. These are some of the thousand minor 'performances' of knives in general and of the Opinel in particular. I use the term 'performance' deliberately: for one must acknowledge the heroic status of the knife – and if not, at least its status as subject. Indeed, the knife is a secret hero, in the same way as the domestic iron. They do not display a useful suffix like the vacuum clean*er*, the (electric) blend*er*, the pour*er* or the separat*or*, but they too 'perform'. And they too should be recognized as subjects of narrative programmes that can be simple but also relatively complex.

The analysis of the narrative programmes called upon by all the minor 'performances' listed above can make their quantitative nature recognizable. The Opinel divides, subtracts and removes but it can also aggregate. It is therefore the actant subject (as understood in narrative semiotics) of a number of operations involving cutting, sorting or mixing which represent an essential element of the figurative syntax explored some time ago by Françoise Bastide.[13] In a different respect, it plays a role in the production of many another object; and this raises the question of the relationship between whole and part, between homogeneity and heterogeneity, between subdivision and compilation, between unity and multiplicity (to borrow Wölfflin's terminology for the category of quantification in the classical versus the baroque).

With this said, even if the Opinel can be used to stab a piece of meat or cheese and to raise it to one's lips, and even if it is used to butter or to spread, it is still obvious that acts of partition and disjunction are essential to its use. These acts can constitute simple narrative programmes – to cut a shoelace or a twig – or relatively complex ones – for instance, to raise a wood shaving and then, with a cut perpendicular to the plane of its separation, remove it from the original piece of timber. But all such narrative programmes, no matter their degree of complexity, are inscribed in a much wider programme: one of production (manufacture or repair) where the subject is indeed the owner and the user of the knife. The Opinel should therefore be seen as a delegated

13. F. Bastide, 'La traitement de la matière: opérations élémentaires', *Actes sémiotiques: Documents,* **89**(9), 1987.

subject [*un sujet délégué*], just as water and fire should be in cooking or in metallurgy.[14]

Thus one must accept that a structure of manipulation (in the semiotic sense of 'causing to do' [*faire-faire*]) is being instigated, involving both the user of the knife and the knife itself: the person, using a certain 'flick of the wrist', causes the knife to perform one of these quantitative operations for which its shape and its cutting edge have rendered it useful or even 'competent'. Like any other subject that is manipulated so as to become delegated, the knife has a mandate in accord with a specific contract, and a trust can even emerge between itself and its owner. The knife promises to keep a sharp blade, a lasting solidarity between blade and handle, and so on. The *quid pro quo* of the owner is to ensure the knife is properly serviced; to dry it and sharpen it with a steel or a whetstone.

Furthermore, when it is a folding knife, light enough to be a pocket knife that one can take anywhere, a knife with a collar to lock the blade and to ensure total solidity between handle and blade, even if the hinging mechanism is worn from use, such a knife can come to be personified on account of its participation in a human action; it can even be considered by its owner as a 'loyal companion'. It is perfectly appropriate then for the Opinel to be presented as one's 'loyal companion in work and leisure'.

When comparing the knife with fire and water, which are also possible delegated subjects, I referred to Greimas's analysis of the 'programmatic discourse' of the pistou recipe.[15] In *Du sens, II*, Greimas demonstrated that these two natural elements were the subjects of the initial culinary act (making vegetable stock). The second broad programme (making the pistou as such) then requires the presence of a human subject: it involves triturating, lacing, and so on. But if water and fire are also manipulated by humans, they are, unlike the knife, manipulating subjects in their own right. Fire *brings* water to the boil. Water *causes* the vegetables to cook. This comparison (between fire and water on the one hand and the knife on the other) suggests that the use of the knife establishes a direct relationship between the perceptible and the human worlds or – and this comes back to same point – that the knife intervenes further upstream in the construction or restoration of an object of value. Here it is enough to think of manufacturing, repairing furniture, decorating a stick, and so on.

We will return to this idea of a 'closest' contact between the human and the world below. But, for now, I will take advantage of the above comparison to make the following three observations:

14. One should add the element of air, 'which aids combustion, which dries and cleans' (as Leroi-Gourhan notes in *op. cit.*, p. 19).
15. A.-J. Greimas, 'La soupe au pistou ou la construction d'un objet de valeur', in *Du sens, II*, pp. 157–69.

1. There is a curious paradox: as a fundamental cultural object (anthropologists and pre-historians consider it to be *the* tool bearing witness to human history), the knife is a subject that is manipulated, but it is not in itself a manipulating subject. Everything happens as if it thereby enabled a more direct contact with the perceptible world than that afforded by, say, water and fire, which are natural elements but are also both manipulated and manipulating subjects. In fact, this may well be the paradox of any contact with the world that is, at the same time, an initial transformation of the world. It is obvious that the knife is involved from the start in the transformation of nature by humans. And, if one accepts that the construction of an object, of a product or a work, is not only a question of syntax (of operations or states) but that it also involves, by correlation, a semantics (of invested values), we can say that the pocket knife in general (and the Opinel in particular) is often involved in those phases of a job that represent a 'denaturing' or a 'semi-culturing', as Greimas would say – a passage from nature to non-nature, if, again, we refer to the semiotic square generated from the axiological category of nature versus culture.[16]

2. Considering that, by contrast with fire and water, the knife is not involved in operations of a qualitative nature but in operations of a quantitative nature, it would be interesting, on the basis of the category of quantitative versus qualitative, to initiate joint research efforts between semiotics and anthropology to address the issue of the figurative syntax of transformations of states of matter. Such a syntax would then allow for the development of a typology of 'elementary technological processes' of which the combinatory aspect would, according to Greimas, 'cover the set of acts of production leading to cultural objects'.[17]

3. Finally, I will stress the potential interest of a semio-narrative approach to design. Such an approach would not only be concerned with discerning and hierarchizing the various narrative programmes of which the subject is the product but would also define as accurately as possible the values embodied in the subject, or with the help of the subject. It would significantly enhance the far too narrow functionalist idea of the product that is still accepted by many designers today; designers who are too eager to think in terms of 'function' in the singular, via a literal reference to Sullivan's maxim: 'form follows function'.

Such a semio-narrative approach could bring designers, product managers, heads of R&D and marketing departments to understand that an 'object' can be a subject. Such a change in point of view about an iron for instance – or a spout (another hero of quantification, but in this case of consumption) – could prove stimulating in the context of the analysis of a product-world or even just in the

16. *Ibid.*, p. 163.
17. *Ibid.*, p. 167.

context of product development. This is my experience, at least, as a consultant. In this way the product is less likely to be seen as a fine-art object or as the falsely unexpected receptacle of some far-fetched connotations.

'This thin veneer of objects that human furniture constitutes'

Let us now address the idea of 'closest' contact between the world and the person, as made possible and sustained by the pocket knife. We considered this idea earlier when examining the notion of the 'delicacy' [*délicatesse*] of alpine fennel — both visually and in terms of taste — in our study of Michel Bras' identity (see Chapter 3). There we looked at the contact between the alpine fennel and the gastronomic palate. We could call this a contact of *consumption*. But in the case of the knife we should think instead of a contact of *production*; and one which occurs in the mode of touch. Tool, technique, bricolage and/or love of fine work will be seen as so many different ways not only to recount the search for contact — for 'fine contact' [*bon contact*], as others talk about 'safe distance' [*bonne distance*] — but also to recount the pleasure of touching.

We can consider that the knife, more than the adze or even the chisel, as testifying to the ancient character or even the primitive character of this search for 'fine contact', and even as testifying to the search for delicate contact. It goes without saying that we are talking here about the knife as tool rather than as weapon. In fact the hunting knife has as its own specific shape; and it is the hunting knife that resembles the Opinel because it too is a pocket knife.

How can the contact that the knife enables be considered delicate? First, because the knife is the complete opposite of the maul, the hammer or the mallet: all tools that imply diffuse impact. The knife displays a cutting edge; and, as we noted above, it is a tool for linear impact. Second, because this impact is *positioned*. And positioned linear impact can be applied to the delicate work of scraping, of sculpting wood (or other fibrous materials such as horn) and to the slicing of soft masses (meat, cheese, bread). A projectile linear impact is generally reserved for rougher working of timber (or soil, as with the hoe). It is thus the shape and the use of the knife that enable its possible delicacy of contact.

But, as we saw with the analysis of the 'configurational' aspects of the Opinel, it distinguishes itself from other knives, including the classic 'alpine knives', by the broad rounding of the tip of its blade (Figure 16). Such a blade is particular in that it presents a curved cutting edge along a significant portion of its length. It can thus work with the grain in cuts of variable widths and will cause less splitting when used against the grain. In the case of a positioned transverse impact (see p. 152), the Opinel is comparable to a chisel, and in particular to a gouge or hollow chisel (Figure 17).

Figure 16

Figure 17

Finally, we must take note of the fact that the 'grip-area' of a knife takes in its centre of gravity, as experts in technology have noted. To clarify this: in the Opinel, the handle balances the blade; and as the blade is relatively short, the hand is never far from the material. According to whether the action is perpendicular or oblique, it is quite common for the palm or the fingers to brush or touch the piece of wood when it being carved or engraved by the point.

Some of Leroi-Gourhan's writings about the knife and the proximity between the perceptible world and humans display a sharpness and a beauty that are by no means strange when one considers the 'rather keen' interest he has expressed for manual work. This is how he came to hold that impact — linear, pointed or diffuse — is the only means available to us for any purpose that occupies the best of our technical intelligence: splitting, hammering, cutting, polishing, dividing matter in order to reassemble it, and so on. We are faced here again with the fundamental dimension of the quantitative in this figurative syntax.

But, in other parts of his writing, the anthropologist and prehistorian analyses not only the 'violent' aspect of the action of humans on matter, as he puts it himself; he also talks about the sensory aspect of this action, in its initial moment. I would even refer to this as an aesthetic aspect.

> Impact [*la percussion*] has been proposed as the fundamental technical action because the search for contact, the search for touch, can be found in almost every technical act. ... The worker's will to action is first conceived as a contact. When one's purpose with a piece of wood is to make a cut that causes, according to its width and depth, a split or a sliver, attention is focused first of all on the instrument of contact which possesses the positive qualities for which the cut constitutes the negative: that is, the cutting edge. That humans first found this

cutting edge in naturally split flintstone and later produced it artificially is of little importance. The first question always asked by the worker confronted with matter is: how to make contact?[18]

However, although he will gladly admit to a taste for manual work and although he may derive a certain aesthetic pleasure from it, Leroi-Gourhan also analyses tools in his capacity as an expert in technologies and their history. It is from this point of view that he comes to consider tools as part of the 'thin veneer of objects that human furniture constitutes'.[19] Of course one can doubt that the objects that make up the furniture of today – in the literal sense of the term, of course – create only a thin veneer. Rather the fashion for so-called 'nomadic' objects might lead us to think the opposite. But we should not dwell on the figurative and somewhat metaphorical aspect of the expression 'thin veneer'. This is because Leroi-Gourhan offers a precise definition: he says that it materializes at the point of contact between the interior environment 'which contains the mental traditions of each ethnic unit' and the exterior environment 'composed of the traits of geographical, zoological or botanical locale'. The thin veneer of objects therefore represents both the sensory and the intellectual termini of the path of a 'trend' which, in turn, can be defined as 'that very special quality of evolution that in some way makes it possible to predict the outcome of the action between the interior environment and the exterior environment'.[20] Here 'trend' is opposed to 'fact' which is unpredictable and specific; fact is 'just as much the encounter between trend and the thousands of coincidences of the environment (that is, invention) as it is the unconditional borrowing from other people. It is unique, inextensible. It is an unstable compromise established between trends and the environment'.[21] Fact and trend should therefore be seen as two aspects (the first concrete, the second abstract) of the same phenomenon of evolutionary determinism. We will return to this problematic of evolution at the end of the present chapter because it will lead logically to that of identity.

Soldier or farmer, engineer or bricoleur

In his analysis of the various kinds of impact, Leroi-Gourhan points out that only ten terms (such as 'linear', 'diffuse', 'pointed', 'longitudinal', 'transversal', and so on) are needed to 'follow closely' [*serrer de près*] the properties of tools; but he adds:

18. Leroi-Gourhan, *Milieu*, pp. 384–5.
19. *Ibid.*, p. 339.
20. *Ibid.*, p. 336.
21. *Ibid.*, p. 27.

The use of these terms urgently requires that we first and foremost take into account the question of handling: a knife can, depending on how it is held, have impacts that are:

- positioned-perpendicular-linear (to cut food);
- positioned-oblique-linear (to scrape wood);
- positioned-perpendicular-pointed (to pierce leather); or
- swung-perpendicular-pointed (to stab an animal);

and one could easily find other positions.[22]

So, if the anthropologist uses the example of the knife, it is because of its great simplicity – and indeed the many drawings he uses to illustrate his works are a good enough indication that he considers knives to be composed only of a blade, a handle and a hinge. But he goes on to say: 'Since the dominant characteristic of the simplest tools can be found in the multiplicity of their possible uses, it is only when these are taken into consideration that their systematic position can be defined.'

We saw earlier in this chapter that the broadly rounded tip of the blade further increased the manifold uses of the Opinel knife. It is a natural progression then to compare the Opinel to another highland knife, and even more precisely with an alpine knife whose multiplicity of uses is also renowned world-wide: namely the Swiss Army knife. The comparison is even more alluring if we remember that these two knives were invented around the same time, during the last years of the nineteenth century. The Swiss Army knife was first created in 1891. The Swiss Army had placed a tender with the Swiss association of master cutlers for the manufacture of a regulation pocket knife that was to include a blade, a reamer, a can-opener and a screwdriver. Charles Elsener won the contract. The knife, with the addition of a small blade and a corkscrew (a tool strangely omitted from the Army tender) was registered under the brand name Victorinox. Today two brands vie for control of the Swiss Army knife, Victorinox and Wenger.

The Opinel and the Swiss Army knife are therefore two pocket knives that have come to be known throughout the world. Moreover, these two knives share a common historical and geographical origin: the Alps at the end of the nineteenth century, the golden age of the pocket knife. They are nevertheless radically different in 'spirit', if we may use this term in such a context. And after all, why not? For, indeed, there are those who will refer to the soul of a knife, or at least to its character. This is how Busquère, one of the greatest French collectors, came to believe that 'a knife is the trace of the heart. In a knife one can feel intelligence and goodness, stupidity or even wickedness.'[23]

22. Leroi-Gourhan, *L'Homme*, p. 52.
23. Cited in Mouret, *op. cit.*, p. 127.

Personally I do not know enough about the world of knives to prove or disprove such a characterology. And I actually doubt that semiotics can, in this instance, do anything more than highlight the purely connotative nature of such taxonomies. Nevertheless, I will argue for and illustrate the idea that the Opinel and the Swiss Army knife testify to two opposite ways of doing things and perhaps even two opposite ways of living. I will do this via a semiotic rather than a sociological approach; for we could easily believe that the explanation of their differences stems from the sociological identities of the respective buyers and users of these two knives. The Opinel was designed for farmers and craftspeople while the Swiss Army knife was designed for infantrymen. It should also be noted that farmers are quite distinct from the military: they don't care about regulation. No one is there to kit them out [*fournit*] with their knives; they simply buy them.

Of course, an explanation based on historical destination is not without interest but it would not be sufficient to account for the international success of the two knives, and neither can it account for their current market (that is, their respective forms of distribution and 'targets'). Essentially, then, we should realize that such an explanation is not pertinent from a semiotic point of view. Indeed, as far as the semiotician is concerned, the aim is to characterize each of the knives via its use and to identify the user 'constructed' by this use – just as the semiotician might do when identifying who is enunciated by [*l'énonciataire de*] a text or a picture, the competent subject constructed by that statement [*l'énoncé*]. What subject is 'made' by this object? What competency does an object (in the common meaning of the word) demand of its user – or even what competency does it confer upon the user?[24] These are the rather paradoxical questions that concern both semioticians and those who engage semioticians as consultants.

To answer these questions, we must once again turn to anthropology for those elements which I consider most pertinent and suggestive. Here we will return, then, for the last time to the contrast between the logics of the bricoleur and the engineer as proposed by Lévi-Strauss – for this is the main intention behind my including an essay on the Opinel in this work on visual identity as it is constructed through bricolage. Let us say that the Opinel is the bricoleur's knife while the Swiss Army knife is that of the engineer. And let us revisit the passages of *La Pensée sauvage* mentioned above:

24. I stress the fact that the semiotic approach proposed here suggests an integration of (a) the problematic of utilization (of an object or a tool) with (b) the far more general problematic of enunciation. Utilization would correspond to the instance of 'capture' (in the semiotic sense). We are talking here of an instance that has not been sufficiently explored via a truly generative investigation, particularly where non-verbal semioses are concerned.

The bricoleur is capable of performing a wide variety of diverse tasks but, by contrast with the engineer, does not subject any of these tasks to the availability of materials or tools conceived and procured specifically for the job. The instrumental world of the bricoleur is closed and the name of the game is always to make do with the 'means at one's disposal' [*moyens du bord*]; this means, at any specific moment, a finite set of tools and materials, and a heteroclitic set to boot – because the composition of that set is not related to the project at hand, nor to any other specific project for that matter. The set of means available to the bricoleur can therefore not be defined by a project (as this would indeed imply, at least in theory, as with the engineer, that there are as many instrumental sets as there are projects). It is defined only by its instrumentality. Or, to put this another way and to use the actual language of the bricoleur, it is defined because the elements are gathered and preserved via the principle that 'this could come in handy some day'. Such elements are thus semi-specified: specified enough for the bricoleur not to need the equipment or knowledge of all the relevant professions, but not enough to cause each element to be constrained to a single and determined use.[25]

As developed by Lévi-Strauss in *La Pensée sauvage*, the opposition between bricoleur and engineer makes particular reference to the materials being transformed. This is because the anthropologist's purpose is to show how the bricoleur uses signs or 'pre-stressed' elements. But, as illustrated in the passage quoted above, this opposition also refers to the instrumental component of these two logics of conception and production. And therein we can recognize the three differential traits that specify the Opinel:

- a knife with a blade rounded at the tip, the Opinel allows its users to perform 'a great many diverse tasks';
- a pocket knife, and for most of the time the only tool he needs to take with him, the Opinel is the satisfactory 'means at his disposal' for the bricoleur: it is in itself its own 'finite set of tools'. It participates in the inscription of the highlander's work and leisure in a 'closed world' culture;
- finally, and regardless of the extent of its use, the Opinel remains 'limited' by its history, by the 'pre-stressing' of its uses as performed by the fathers and uncles who have already owned 'alpine knives' – comparable to the sign-materials used by the bricoleur.

As the bricoleur's knife, the Opinel is also the tool for those projects that always get put aside [*décalés*]. Because it alone is the finite set of means available to the highlander–bricoleur, it forces its user to make astute choices and sacrifices; it becomes the instrument of compromises and conciliations which will 'speak' the bricoleur–subject, and which will 'sign off' [*signeront*] his work.

25. C. Lévi-Strauss, *La Pensée sauvage* (Paris: Plon, 1962), p. 27.

Because of the diversity of its uses but also because of its simplicity, the Opinel becomes an instrument conducive to the expression and the realization of self. In projects that are never completed according to plan, users have no choice but to include something of themselves. At the same time – and in what only *appears* to be a paradox – this simple 'folding knife' made of beech and steel will testify to its user's knowledge and culture: 'more know-how is required to use a simple tool than a complex one', as Lévi-Strauss rightly put it in his recent work *Regarder, écouter, lire.*[26]

But the Opinel, the tool of deferred [*décalés*] projects, not only testifies to the know-how and the personality of its owner. It is actually because of the deferral of the project that it is also responsible for the aesthetic emotion felt by the producer (or by the beneficiary of the work he or she performs). This is indeed so if we accept, following in the anthropologist's footsteps, that 'aesthetic emotion originates in the combination of the order of the structure and the order of the event, a combination at the heart of things created by a person – and also virtually by the spectator who discovers this possibility through the work of art'.[27] According to the author of *La Pensée sauvage*, the event is only a kind of contingency which can manifest itself at three distinct but cumulative points of creation: the opportunity to perform, the technical production and the destination of the work. In technical production, contingency manifests itself intrinsically: 'with the size and the shape of the piece of wood available to the sculptor, with the direction of the fibres and the quality of the grain, with the imperfection of the tools used, with the resistance offered by the material'.[28] As a tool involving the closest possible contact with the sensible world, and one particularly well adapted to woodwork, the Opinel indeed becomes the metonymic representation of such an aesthetic experience.

On the other hand, what can we say about the multi-tooled knife, and in particular about the best known of them, the Swiss Army knife? We have said that this was the engineer's knife. Indeed, the engineer is the one who sets out to access as many instrumental sets as there are types of projects. Here the tool is given or provided at the level of the project itself. This is indeed the case for the instrumental set of the Swiss Army knife. Each tool corresponds to a very specific end: to slice, to uncork, to measure, to remove a cap from a bottle, to drive a screw, or even to find one's bearing with a compass. By using such a knife, reality becomes more transparent, less opaque.[29] We may therefore think

26. C. Lévi-Strauss, *Regarder, écouter, lire* (Paris: Plon, 1993), p. 45.
27. Lévi-Strauss, *La Pensée*, p. 37.
28. *Ibid.*, p. 40.
29. A number of these tools found on the Swiss Army knife are relatively difficult to manipulate or prove to be relatively poor in performance, as is often the case with the corkscrew on the Laguiole. It's difficult to put one's fingers through the scissor-handles; it's difficult to get to the end of the cork with the corkscrew. Reality cannot be put aside so easily.

of each part of the Swiss Army knife as corresponding to a fixed gestural syntagm, to a quasi-automated programme of action. In other words, the know-how, or rather the many ways-to-know-how, 'are' part of the knife, and not of its user who ultimately only provides effective energy. This is distinct from the Opinel or any simple pocket knife, which requires from its users a certain level of astuteness and a certain number of ways of handling: that is, a certain culture.

Finally, this distinction between the Swiss Army knife and the Opinel suggests something of further relevance to a semiotic approach to design. If we again consider the services that a knife can render as narrative programmes, it is by no means impossible to think of the simple pocket knife as an actor (in the semiotic sense of the word) and as one that includes a large number of actantial roles – even if these still remain limited in number. The Swiss Army knife, by contrast, comes across as a limited set of actors, each of which is allocated but a single actantial role. We can visualize the opposition between these respective 'actorializations' of the Opinel and the Swiss Army knife by returning to the schematic presentation offered by Greimas in his article 'Les actants, les acteurs et les figures', as follows:[30]

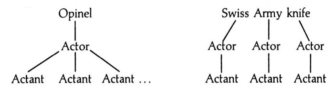

It is therefore possible to recognize, in the analysis of objects and tools, semiotic phenomena associated with 'actorialization'. Together with spacial-ization and temporalization, this is a problematic located at the level of discursive syntax – I refer here to the 'generative course [*parcours*] of signification', introduced earlier (in footnote 5 of Chapter 1). With respect to contemporary product design, we may ask whether it is one of design's essential tasks to ensure the discursive component of a product; or to take account of an 'idea' or a 'specification' [*cahier des charges*] (which would represent the semio-narrative component of the product); and therefore to conceive of their spatiality and their temporality as well as the actor or actors that ensure the aggregate [*la globalité*] of the narrative programmes that define the product's functionality.

It should be clear that this discursive component, central to the work of the designer, is also charged with tasks for 'designing' the semantic side. To be less ambiguous, let us say that the designer must not only conceive the

30. A.-J. Greimas, 'Les actants, les acteurs et les figures', in *Du sens, II*, p. 49.

spatialization, the temporalization and the actorialization of the product but also its figurativization.[31]

The Opinelists' 'inner world'

Above, inscribing the knife within the 'thin veneer of objects that human furniture constitutes', I noted that I would return to the concepts of 'trend' and 'fact' as elaborated by Leroi-Gourhan, and wrote there that this analysis would return us to the question of the relationships between bricolage and identity. Indeed, the very nature of 'trend', associated with technical determinism,[32] is that of a general movement putting the inner world [*le milieu intérieur*] into increasingly closer contact with the outer world [*le milieu extérieur*]. However, we should not think that this movement 'comes' in some way from the outer world; rather it belongs to the inner world. There is no such thing as a trend belonging to the outer world, as Leroi-Gourhan has pointed out:

> The wind does not determine the specific roof that a house comes to have; rather a person tends to decide the most appropriate shape for a roof. The outer world behaves as a totally inert body against which a trend works. It is at the point of impact that we find material evidence.[33]

And this 'point of impact' must become multiple even for us to be able to imagine a surface. As we have seen on p.161, it is indeed at such points of contact between the inner world and the outer world that we find the 'thin veneer' of objects that human furniture constitutes – or else, with Leroi-Gourhan,

31. We should recall here how, in the generative course of signification, the syntactic and semantic components (on the one hand) and the semio-narrative and discursive structures (on the other) are articulated, and where we find the structures to which we have just referred: actorialization, spatialization, temporalization and figurativization.

Plane of manifestation

	– Actorialization	– Figurativization
Discursive structures	– Spatialization	– Thematization
	– Temporalization	

Plane of content

Semio-narrative structures

- -

Syntactic	Semantic
Component	Component

For a more comprehensive representation of the generative course, see A.-J. Greimas and J. Courtés, *Sémiotique, dictionnaire raisonné de la théorie du langage*, vol. 1 (Paris: Hachette, 1979), p. 160.

32. See the elaborations that Leroi-Gourhan gives over to technical determinism towards the end of *Milieu*, pp. 313–26.

33. *Ibid.*, p. 339.

we can refer to a 'technical envelope' when it comes to the specific question of tools.

One must therefore consider 'trend' as a tendency towards conformity – or as a quest in that direction, if we think of the human spirit [*l'esprit humain*] as being a subject. We thereby approach a conformity between form and function – but to such an extent that the phrase 'form follows function' is no longer just Sullivan's phrase but one that could well have been uttered by this trend itself. But then we have to face the fact that this movement does not happen directly, as a disembodied law or a pure spirit, as it comes into contact with the outer world. It goes through what Leroi-Gourhan calls the 'inner world washed over by the mental traditions of each human group'. It acquires specific properties 'just as a ray of light acquires distinct properties as an effect of the different bodies it traverses'.[34] I believe, therefore, that I am not betraying Leroi-Gourhan in proposing a hierarchy for his three levels of approaching technique corresponding to the three levels of semiotic modes of existence. Thus:

– the 'technical trend' corresponds to the virtual mode;
– the 'technical world' corresponds to the actual mode; and
– the 'technical envelope' corresponds to the realized mode.[35]

Such a presupposed hierarchy sets out to describe the technical object as the result of a course [*parcours*] running from a very deep level (perhaps even a universal level) to a level of concrete and historical realization. It can be interpreted as a dynamic process of constituting an object as an object of meaning, as perceptible and intelligible evidence of a given culture. I therefore believe this dynamic hierarchy suggests a homology between the logical sequence of levels (as defined by Leroi-Gourhan) and the generative course of signification used by semioticians to represent the semiotic production of signifying objects.

Regardless of the accuracy of this homology, we should note that such a hierarchy must be understood as Leroi-Gourhan's first approach to the rule of 'functional approximation' that he came to formulate some twenty years later in *Le Geste et la parole* – a first approach that is of interest here because of its generative aspect. Leroi-Gourhan used the notion of 'functional approximation' to account for the fact that each object is 'an answer to the contradictory requirements of mechanical performance and the imprint of the inner world of

34. *Ibid.,* p. 339.
35. It is during the 'realization' – that is during the passage between the actualized and the realized – that we find, I believe, the double problematic of innovation and borrowing. Indeed, even if this appears totally paradoxical, borrowing and innovation are never anything but two solutions to the same problem posed to an 'interior milieu'. Borrowing can only take place under the condition that someone is receptive. See *ibid*, pp. 393–401.

the group'.[36] Such an approximation is the 'normal rule', not only because effective forms are subject to the constraints of time and space determining the progressive stages of different techniques, but also because there is always 'a certain level of freedom in the interpretation of relationships between form and function'.[37] It is in this 'play' between form and function, in the 'narrow margin that form allows function',[38] that there is space for the 'decorative veil' enveloping every object – a veil which can only be created by a specific culture, no matter how vast and widespread it may be. I propose, then, to consider this veil as an embodiment of the aesthetic and mythic dimensions as defined by Greimas (see p. 155).

But let us return first to the idea of a 'technical envelope' or a 'thin veneer of objects' because it is to this idea that our object, the Opinel, belongs. It is also at this level that we can consider it as an expression of a collective rather than an individual identity. Each group, that is, has a specific technical envelope of its own.

We might even be led to believe that the Opinel is actual proof that form can follow function, because of its formal simplicity (or more correctly its configurative simplicity) and that it constitutes the realization of the folding knife as such. But I hope that what we have seen with respect to the relationships between technical determinism and a specific technical tool will have proved this not to be so. If the Opinel looks so simple, it is probably because it is not ornate [*décoré*], in the common meaning of this word – it is only embossed and stamped by its inventor. There is no obvious decorative motif as there is with the Laguiole (a bee) or with the Nontron (flies). It nevertheless remains true that including the Opinel in a group of folding knives – even if they are as simple as the Nontron or the Douk Douk (Figure 18) – is enough to emphasize a shape that cannot simply be associated with functional determinism. The Opinel also displays a very specific decorative veil, even if that veil is more transparent than others. It is indeed by perceiving this veil, more or less consciously, that we can come to see the Opinel as a 'rustic' knife, or that we can recognize it as a pleasing variation on the 'alpine knife'.

To which social group does the Opinel then belong? What is the identity revealed by its overall configuration?[39] To further my analysis, I would answer

36. A. Leroi-Gourhan, *Le Geste et la parole: la mémoire et les rythmes* (Paris: Armand Colin, 1964–5), p. 130.
37. *Ibid.*, p. 129.
38. *Ibid.*, p. 132.
39. One might accept, as my analysis suggests, that the configuration of such a technical object makes it into an anaphoric or cataphoric image of its usage. Let us recall that cataphore (in opposition to the anaphore) is characterized by the fact that the term under consideration precedes (and does not repeat) the term being expanded – in this instance the gestural technique that the Opinel permits. Is this a classic example for linguistics? 'This', in the phrase 'I'm going to tell you this', is cataphoric; 'that', in the expression 'that being said', is anaphoric.

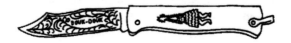

Figure 18

by saying that this group is in fact the group of bricoleurs generally; that it is no longer the particular group of the farmer–craftspeople of the Maurienne. This is of course a large group, even a trans-national one, and its identity is fundamentally cognitive and semiotic. Bricolage is a way of thinking as well as a way of making and producing meaning. Following Lévi-Strauss, many researchers (including myself) have shown that bricolage can be found in verbal and non-verbal productions of apparently quite distinct myths (in the special meaning of this term) and, moreover, in modern as well as ancient myths. Bricoleurs therefore make up a kind of fraternity or network across historical eras and geographical regions. The limits to the expansion of this network (of resistance, perhaps) are in fact the limits of the engineers' empire.

Without returning to the 'deep' definition of the bricoleur, I would like to conclude by emphasizing a couple of traits which, to my mind and based on that definition, characterize the 'inner world' of Opinel users as they are defined by the Opinel itself. First, there is the idea (acquired and repeated with every 'positioned' impact made by the knife) that the world is both close and sensory. It is sensory in that it is made of matter, textures, forms and lines; but it is also sensitive in that it 'reacts' to intervention – it can be soft or resistant. The world is also close – the warmth of a wooden handle, the smoothness of a good wide blade, or the precision of a well-maintained cutting edge, the handle's not being long enough for the hand ever to be distant from the surface of things: all of these stress the sense of touch.

On the other hand, the Opinel user knows from experience that projects do not always come out the way they were initially intended and that one cannot constantly be 'beyond' what one is doing. As if to balance this, the user can experience aesthetic emotion (or cause it to be experienced). In this instance, this emotion involves the pleasure of direct or indirect performance. The engraver of a butterdish or a tool-box (Figure 19) – to take just two examples of the community crafts of the Savoy region – can indeed enjoy the combination of contingency and necessity, as described by Lévi-Strauss. The owner of an Opinel is more of a producer than a 'communicator'. The Opinel has neither the unstated elegance of the Laguiole nor the chic of the sharp thwack when it is opened up. Moreover, when it is left on the table, this is so as to use it and not to say (or to suggest) that the owner is an authentic Savoyard. The Opinel is more about production than seduction or menace. It is, then, an object of the 'third function' in terms of Dumézil's three functions: of power, of war and of production.

Figure 19

Finally, with the Opinel, we know that in most circumstances one can simply make do or get by. We have already shown that the Opinel is the bricoleur's knife. Now, 'to make do with the available means [*moyens du bord*]' is to accept that one has already embarked on a journey within a closed world where resources are not inexhaustible. So the bricoleur becomes an ecologist in action. The bricoleur acts in the knowledge that his or her world is not limitless. With this said and all things considered, that world will appear totally sufficient to him or her, for it contains not only raw materials but also signs: previously produced objects are also approached and treated as material. This only requires us to be curious and not to be so respectful or conservative (as in the French *conservateur*, where we can almost use the term in its museological sense) that we stop ourselves from carrying out our project. From this point of view, bricolage can be understood as a form of conciliation between borrowing and innovation, moving towards a full realization of identity and ultimately aiming at 'an uninterrupted movement of divergence'. This is how Leroi-Gourhan has referred to evolution and the ever-increasing specialization of beings. It does not seem unreasonable to me, then, that we should recognize this same movement – which, according to Leroi-Gourhan, carries living beings and human groups along in its flow – in the life project of an individual subject or, using Ricoeur's notion, in that subject's narrative identity. So much so that the interplay of relationships between identity and bricolage, which we have attempted to analyse here, can confer meaning and value on the history of an individual or on the history of a group.

References

Translators' note: the original French volume contains a Selected Bibliography. In this present list, in accordance with British and American conventions, we have included only the works *actually referenced* in the text.

L'Almanach du vieux savoyard. Annecy, 1990.

Arrivé, M. and Coquet, J.-C. (eds), *Sémiotique en jeu*. Paris and Amsterdam: Hadès and Benjamins, 1987.

Barthes, R. 'Des joyaux aux bijoux', *Jardin des modes*, April 1961.

Barthes, R. *Système de la mode*. Paris: Seuil, 1967.

Bastide, F. 'La traitement de la matière: opérations élémentaires', *Actes sémiotiques: Documents*, **89**(9), 1987.

Baudrillard, J. *Système des objets*. Paris: Gallimard, 1968.

Bertrand, D. *L'Espace et le sens: Germinal d'Emile Zola*. Paris and Amsterdam: Hadès and Benjamins, 1986.

Bertrand, D. 'La justesse', in J. Fontanille (ed.), *Les Formes de vie*, Montreal: RSSI, 1993.

Bras, M., Boudier, A. and Millau, C. *Le Livre de Michel Bras*. Rodez: Rouergue, 1991.

Chapuis B. and Herscher, H. *Qualités: objets d'en France*. Paris: Du May, 1987.

Coblence, F. *Le Dandysme, obligation d'incertitude*. Paris: Presses Universitaires de France, 1988.

Coquet J.-C. (ed.), *Sémiotique: l'Ecole de Paris*. Paris: Hachette, 1982.

Coquet, J.-C. and Petitot, J. (eds), *L'Objet: sens et réalité*. Paris: Larousse, 1991.

Courtés, J. *Introduction à la sémiotique narrative et discursive*. Paris: Hachette, 1976.

Courtés, J. *Sémantique de l'énoncé: applications pratiques*. Paris: Hachette, 1989.

Courtés, J. *Analyse sémiotique du discours, de l'énoncé à l'énonciation*. Paris: Hachette, 1991.

de Bure, G. *Habitat 20 ans de quotidien en France*. Paris: Michel Aveline, 1993.

Delay, C. *Chanel solitaire*. Paris: Gallimard, 1983.

Design, miroir du siècle. Paris: Flammarion/APCI, 1993. (Exhibition catalogue.)

Détienne, M. *Les Jardins d'Adonis*. Paris: Gallimard, 1972.

Détienne, M. and Vernant, J.-P. *Les Ruses de l'intelligence: la métis des Grecs*. Paris: Flammarion, 1974.

Duhamel, G. *Le Grand Inventaire du génie français en 365 objets*. Paris: Albin Michel, 1990.

Floch, J.-M. 'Des couleurs du monde au discours poétique: analyse de la dimension chromatique des *Falaises de marbre* de E. Jünger', *Documents*, **6**(1), 1969.

Floch, J.-M. 'Quelques positions pour une sémiotique visuelle' and 'A propos de *Rhétorique de l'image* de R. Barthes', *Bulletin* (ILF-CRNS), **4/5**, 1978.

Floch, J.-M. 'Des couleurs du monde au discours poétique', *Actes Sémiotiques*, **6**, 1979.

Floch, J.-M. *Petites Mythologies de l'oeil et de l'esprit*. Paris and Amsterdam: Hadès and Benjamins, 1985.

Floch, J.-M. 'Vie d'une forme: approche des sonates peintes par M.K. Ciurlionis', in H. Parret and H.-G. Ruprecht (eds), *Exigences et perspectives de la sémiotique*, vol. 2. Amsterdam: Benjamins, 1985.

Floch, J.-M. *Les Formes de l'empreinte*. Périgueux: Fanlac, 1986.

Floch, J.-M. 'La contribution d'une sémiologie structurale à la conception d'un hypermarché', *Recherche et applications en marketing*, **4**(2), 1989.

Floch, J.-M. 'Du bon usage de la table et du lit, et d'une approche possible du design', in A. La Baconnière (ed.), *Espaces du texte*. Neuchâtel: n.p., 1990.

Floch, J.-M. *Sémiotique, marketing et communication*. Paris: Presses Universitaires de France, 1990.

Fontanille, J. 'Thymique', in A.-J. Greimas and J. Courtés, *Sémiotique, dictionnaire raisonné de la théorie du langage*, vol. 2, Paris: Hachette, 1986.

Fontanille, J. (ed.), *Les Formes de vie*, Montreal: RSSI, 1993.

Fontanille, J. and Bertrand, D. Opening proceedings of the *Séminaire intersémiotique de Paris*, 1992-3, unpublished conference address.

Fontanille J. and Greimas, A.-J. *Sémiotique des passions*. Paris: Seuil, 1991.

Geninasca, J. 'L'énonciation et le nombre: séries textuelles, cohérence discursive et rythme', in J. Fontanille (ed.), *La Qualité et ses modulations qualitatives*. Limoges and Amsterdam: Pulim and Benjamins, 1992.

Graphis Corporate Identity vol. 1, Zurich: Graphis, 1989.

Greimas, A.-J. 'La Mode en 1830, essai de description du vocabulaire vestimentaire d'après les journaux de mode de l'époque', unpublished dissertation, 1949.

Greimas, A.-J. *Dictionnaire de moyen français*. Paris: Larousse, 1969.

Greimas, A.-J. *Du sens, II: Essais sémiotiques*. Paris: Seuil, 1983.

Greimas, A.-J. 'Sémiotique figurative et sémiotique plastique', *Actes sémiotiques: Documents*, **60**(4), 1984.

Greimas, A.-J. *De l'imperfection*. Périgueux: Fanlac, 1987.

Greimas, A.-J. 'Interview with François Dosse', *Sciences humaines*, **22**, November 1992.

Greimas, A.-J. and Courtés, J. *Sémiotique, dictionnaire raisonné de la théorie du langage*, vol. 1. Paris: Hachette, 1979.

Greimas, A.-J. and Courtés, J. *Sémiotique, dictionnaire raisonné de la théorie du langage*, vol. 2. Paris: Hachette, 1986.

Greimas, A.-J. and Fontanille, J. *Sémiotique des passions*. Paris: Seuil, 1991.

Greimas, A.-J. (with T.M. Keane). *Dictionnaire de moyen français*. Paris: Larousse, 1992.

Hénault, A. *Les Enjeux de la sémiotique*. Paris: Presses Universitaires de France, 1983.

Hénault, A. *Histoire de la sémiotique*. Paris: Presses Universitaires de France, 1993.

Jakobson, R. *Essais de linguistique générale I*. Paris: Minuit, 1963.

Jakobson, R. *Une vie dans le langage*. Paris: Minuit, 1984.

Jobs, S. 'Computers and people, July–August 1981', in J.S. Young, *Steve Jobs, un destin fulgurant*. Paris: Micro Application, 1989.

Landowski, E. 'Formes de l'altérité et styles de vie', in J. Fontanille (ed.), *Les Formes de vie*. Montreal: RSSI, 1993.

Landowski, E. 'Quêtes d'identité, crises d'altérité', in S. Artemel and D. Sengel (eds), *Multiculturalism and the crisis of difference: proceedings of the colloquium 'A common European identity in a multicultural continent'*. Istanbul: Bogaziçi University, CECA, 1993.

Landowski, E. 'Quêtes d'identité, crises d'altérité', *Sigma*, **2**, 1994.

Leroi-Gourhan, A. *L'Homme et la matière*. Paris: Albin Michel, 1943 and 1971.

Leroi-Gourhan, A. *Milieu et techniques*. Paris: Albin Michel, 1945 and 1973.

Leroi-Gourhan, A. *Le Geste et la parole: la mémoire et les rythmes*, 2 vols. Paris: Albin Michel, 1964–5.

Leroi-Gourhan, A. *Les Racines du monde*. Paris: Belfond, 1982.

Lévi-Strauss, C. *Anthropologie structurale*. Paris: Plon, 1958 and 1974.

Lévi-Strauss, C. *La Pensée sauvage*. Paris: Plon, 1962.

Lévi-Strauss, C. *La Voie des masques*. Geneva and Paris: Skira and Plon, 1975 and 1979.

Lévi-Strauss, C. *De près et de loin*. Paris: Jacob, 1993.

Lévi-Strauss, C. Interview with Pierre Bois, *Le Figaro*, 26 July 1993.

Lévi-Strauss, C. *Regarder, écouter, lire*. Paris: Plon, 1993.

Leymairie, J. *Chanel*. Geneva: Skira, 1987.

Lhote, A. *Les Invariants plastiques*. Paris: Hermann, 1967.

Marion, G. *Mode et marché*. Paris: Liaisons, 1992.

Merleau-Ponty, M. *Le Primat de la perception et ses conséquences philosophiques*. Grenoble: Cynara, 1989.

Morand, P. *L'Allure de Chanel*. Paris: Hermann, 1976.

Mouret, J.-N. *L'Univers des couteaux*. Paris: Solar, 1992.

Mucchielli, A. *L'Identité*. Paris: Presses Universitaires de France, 1986.

Panofsky, E. *Essais d'iconologie*. Paris: Gallimard, 1967.

Parret, H. *Le Sublime du quotidien: phénoménologie et critique du quotidien et de la sublime*. Paris and Amsterdam: Hadès and Benjamins, 1988.

Parret, H. and Ruprecht, H.G. (eds), 'Exigences et perspectives de la sémiotique', in *Recueil d'hommages pour Algirdas Julien Greimas*, 2 vols. Amsterdam: Benjamins, 1985.

Pastoureau, M. *L'Etoffe du diable*. Paris: Seuil, 1991.

Ricoeur, P. *Soi-même comme un autre*. Paris: Seuil, 1990.

Rodis-Lewis, G. *Epicure et son école*. Paris: Gallimard, 1976.

Serres, M. 'Discours et parcours', in *L'Identité* (seminar directed by C. Lévi-Strauss, assisted by J.-M. Benoist). Paris: Presses Universitaires de France, 1983.

Tiné, C. Editorial, *Marie Claire Maison*, October, 1992.

Wölfflin, H. *Principes fondamentaux de l'histoire de l'art*. Brionne: Monfort, 1984.

Young, J. S. *Steve Jobs, un destin fulgurant*. Paris: Micro Application, 1989.

Zemsz, A. 'Les optiques cohérentes', *Actes sémiotiques: Documents*, **68**(7), 1985.

Zilberberg, C. 'Défense et illustration de l'intensité', in J. Fontanille (ed.), *La Qualité et ses modulations qualitatives*. Limoges and Amsterdam: Pulim and Benjamins, 1992.

Zilberberg, C. 'Présence de Wölfflin', *Nouveaux Actes sémiotiques*, 23–4. Limoges: Pulim, 1992.

Index

Translators' note: This index is based on Jean-Marie Floch's original indexes, and indicates the relative significance of persons and concepts as he first saw them. Floch tends to list the main, and/ or definitional, references to names and terms. Where possible, we have expanded this with respect to both number of entries and number of pages for particular entries. Most of the extra entries were added with a consideration for English-speaking readers and those unfamiliar with semiotic terminology. In addition, some contrastive pairs (marked by *vs*) are repeated in reverse order where relevant to Floch's original index entries. For example, French grammar places nouns before their adjectives, thereby keeping related items in alphabetical order (*milieu extérieur* and *milieu intérieur*), a contrastive arrangement that is lost in English. In some cases (marked by 'or') we have signalled variant translations.[1]

abstract level 13, 50–1, 60
actant
 actant-subject *vs* actant object 128
 vs actor, 166
actorialization 166
actualization 40, 55, 118
Adonis 76–8
 opposed to Demeter 78–9
aesthetics 8, 74, 105, 110, 114
 aesthesis 68
 aesthetic dimension 155
 as 'the evaluation of nuances' 69
 and semiotics 6
affect 103–4, 113
alpine fennel [*la cistre*] (*Meum athamanticum*) 64–75, 159
ambience 122
aplomb 93–4
Aristotle (384–322) BC 53
Aubrac (region) 63, 69–70, 74
aurea mediocritas 144
axes of balance and imbalance 78–82
axes of system and process 33
axiological category 158

axiology 70, 75, 118, 120–1, 124, 128–9, 136

Bachelard, Gaston 127
baroque vision 95–106
Barthes, Roland 7, 12, 86, 93, 114
 on Coco Chanel 108 n.26
basic values *vs* use values 58, 119–25
Bastide, Françoise 156
Baudrillard, Jean 122
Beatles, the 55
Bertrand, D. 138
biblical imagery 55, 60
Bonatti, Walter (retired mountaineer) 31
borrowing *vs* invention 6, 168
Boy Capel (Chanel's lover) 112–13
Bras, Michel (chef) 7, 63–84, 133, 159
bricolage/bricoleur/bricoleuse 1–8, 32, 82–4, 108, 118, 133–41, 144, 147, 159, 161–7, 170–1 and *passim*; *see also* engineer
 bricolage and *chine* 133
 bricolage as a 'drawbridge' 138–9
 bricolage style 136
 bricoleur-as-enunciator 138

1. Although it is beyond most conventions to have a footnote to an index — let alone an acknowledgement — I would very much like to thank Dr S.J. Hemelryk who helped and advised via several long-distance calls in early May 2000. [AMcH]

Lightning Source UK Ltd.
Milton Keynes UK
29 November 2010

163615UK00006B/56/P